Moments Without Proper Names

GORDON PARKS

Moments Without Proper Names

A Studio Book The Viking Press New York

TO ROY STRYKER AND NICOLAS DUCROT

First published in 1975 by The Viking Press, Inc.
625 Madison Avenue, New York, N.Y. 10022
Published simultaneously in Canada by
The Macmillan Company of Canada Limited
Printed in Japan

LIBRARY OF CONGRESS CATALOGING IN PUBLICATION DATA
Parks, Gordon, 1912-
 Moments without proper names.
 (A Studio book)
 Poems.
 1. Photography, Artistic. I. Title.
TR654.P297 779'.092'4 75-9547
ISBN 0-670-48472-5

IN MEMORIAM

For John Vachon 1914–1975

No, it was not for you
To be assigned some hole
 of measured dark
And give yourself back
Hair by hair to the earth.
That is your difference:
To spurn the grave
To commit yourself to fire
To absolutely be no more—
Leaving your enigma
In the silent ashes,
Your secrets kept, awaiting
The flames to curl you
 up and over
These towering islands.

I do not mourn you.
Your vacancy will be filled
By those hours wound down
Along the stubborn road we walked,
Killing our thirst at those crossways
Where from aged hands
We drank the rain of truth.

I shall put my fingers
To your burial fire, that
Fire of all fire, which
For the last time will

Allow me to touch you.
And I will not wince.
Your wisdom was our blood,
The protector of the dreams
 we lived
Inside bigger dreams unfulfilled
Of battles waged against
Those assassins of small prayers.

No, I will not mourn you.
I am more anguished
By your stranding me here
In this void alone.
And now more than ever
I cherish the beliefs we shared.
They sharpen my watch over
Vows we so painfully set.

I will go on as before
Steeled against those enemies
 yet unborn
Who would come one day
To water down my blood
Into some wintry fluid.
I know their scent and
Recognize their whispering
In the distant fog.
I will keep watch.

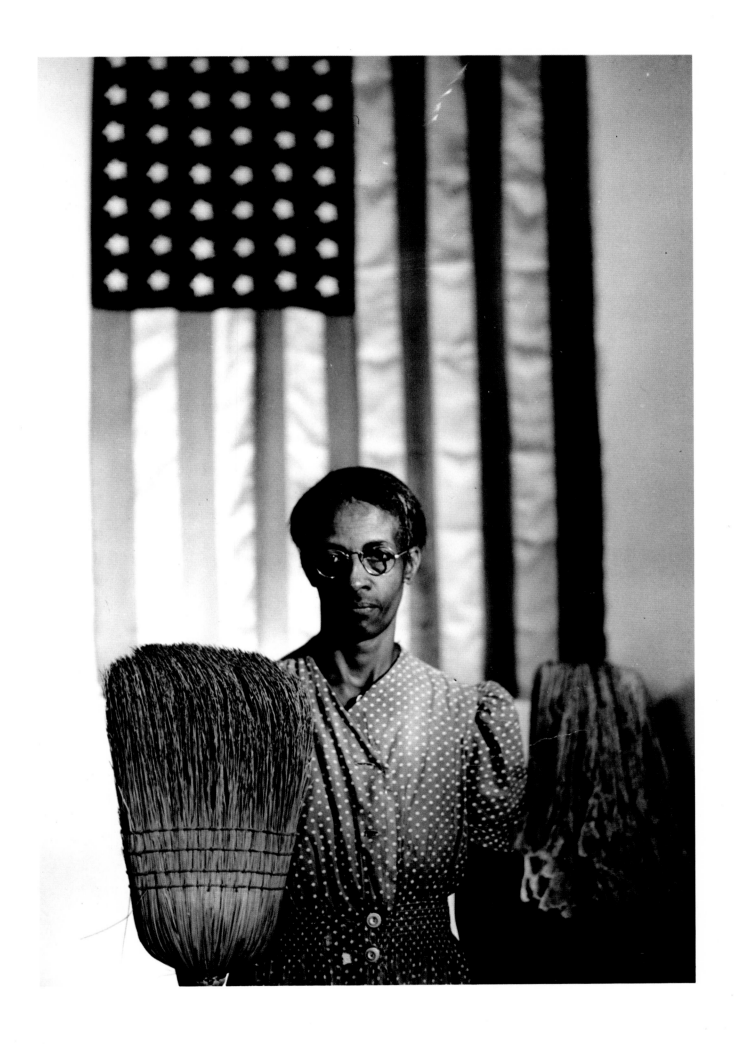

PROLOGUE

Covering some of the stories of the past three decades was like reporting from the darkness. During that period I saw men in incomprehensible actions against their fellow men. I witnessed jagged moments of brutality and terror. I came to understand the implications of bigotry, poverty, and war. During some unbelievable hours I doubted that another morning would arrive; each day seemed sufficient to bring the world to a stop.

Nonetheless I have been in awe of what remained to be admired. For while evil and corruption suited certain men, there were others inclined toward greatness, good men who refused to be squashed under the heels of others. These were men who, when the sky threatened to fall upon us, raised their voices and guaranteed another sunrise. And there were beautiful things to see—so beautiful they defied description. I recall an aged Norwegian guide pointing from a mountaintop down toward the splendor of a fjord, saying simply, "God did a good job on that one."

This collection, I hope, speaks for itself, the photographs and verse echoing one another. I like to think of it as an inward look. For I feel it is the heart, not the eye, that should determine the content of the photograph. What the eye sees is its own. What the heart can perceive is a very different matter. For me at least, the camera is a technical device, used as a writer uses his typewriter or as a painter uses his brush.

I was born to a black childhood of confusion and poverty. The memory of that beginning influences my work today. It is impossible for me now to photograph a hungry child without remembering the hunger of my own childhood. Time has taught me that it is not enough to look, condemn, or praise—to be just an observer. I must attempt to transcend the limitations of my own experience by sharing, as deeply as possible, the problems of those people I photograph. There are still a lot of deplorable things happening around me. If, when I see these things happening, nothing happens inside me, I will know I have touched bottom. I hope always to feel the responsibility to communicate the plight of others less fortunate than myself, to show the abused and those who administer the abuses, to point up the pain of the underprivileged as well as the pleasures of the privileged—somehow to evoke the same response from a housewife in Harlem as I would from a seamstress in Paris or a butcher in Vladivostok.

In helping one another we can ultimately save ourselves. We must give up silent watching and put our commitments into practice. We need miracles now, I am afraid. If only we could understand the needs of our past, then perhaps we could anticipate our future. We cannot get too comfortable in our houses. Wolves still roam the woods. The hawk still hangs in the air. And restless generals still talk of death in their secret rooms.

Gordon Parks
New York
August 1974

7

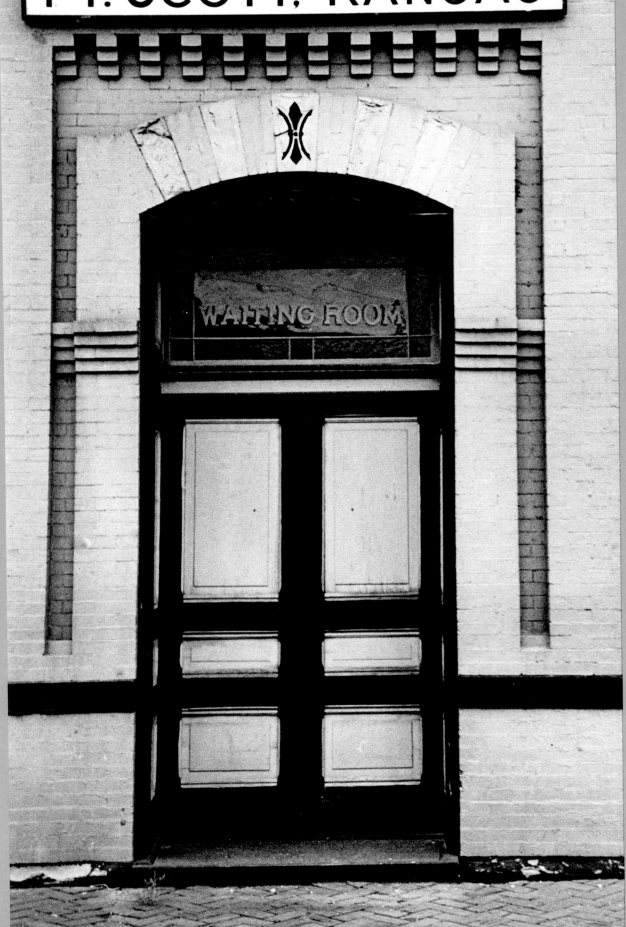

8

KANSAS LAND

I would miss this Kansas land that I was leaving.
Wide prairie filled with green and cornstalk;

 the flowering apple,
Tall elms and oaks beside the glinting streams,
Rivers rolling quiet in long summers of sleepy days
For fishing, for swimming, for catching crawdad beneath

 the rock.
Cloud tufts billowing across the round blue sky.
Butterflies to chase through grass high as the chin.
June bugs, swallowtails, red robin and bobolink,
Nights filled with soft laughter, fireflies and restless stars,
The winding sound of crickets rubbing dampness from their wings.
Silver September rain, orange-red-brown Octobers and

 white Decembers with hungry
Smells of hams and pork butts curing in the smokehouse.
Yes, all this I would miss—along with the fear, hatred

 and violence
We blacks had suffered upon this beautiful land.

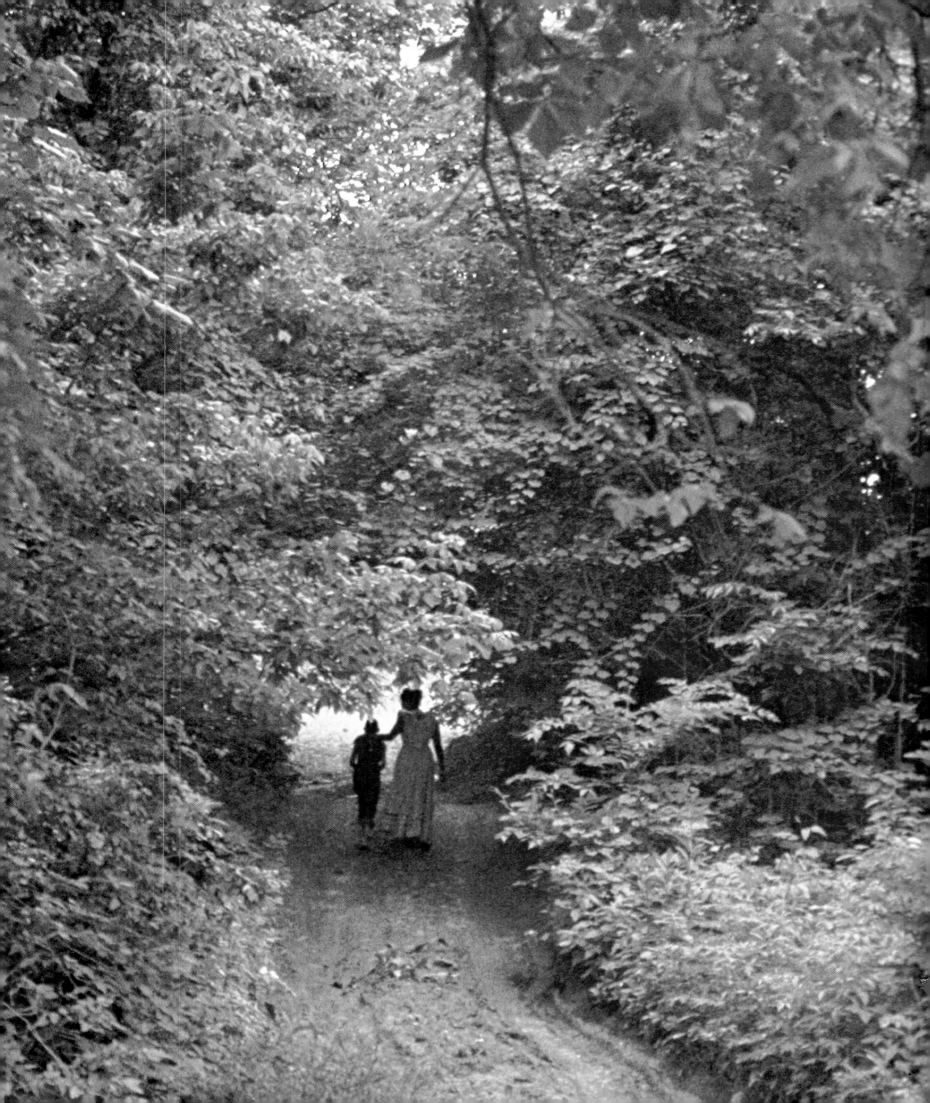

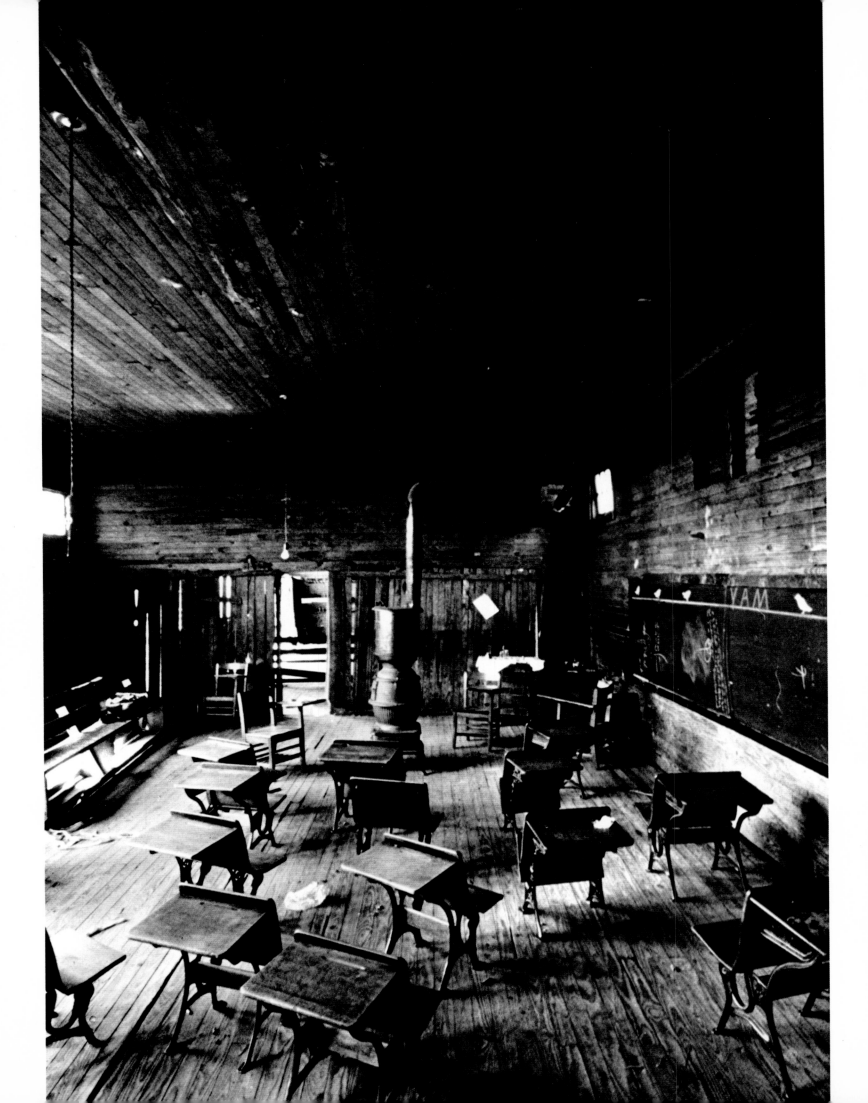

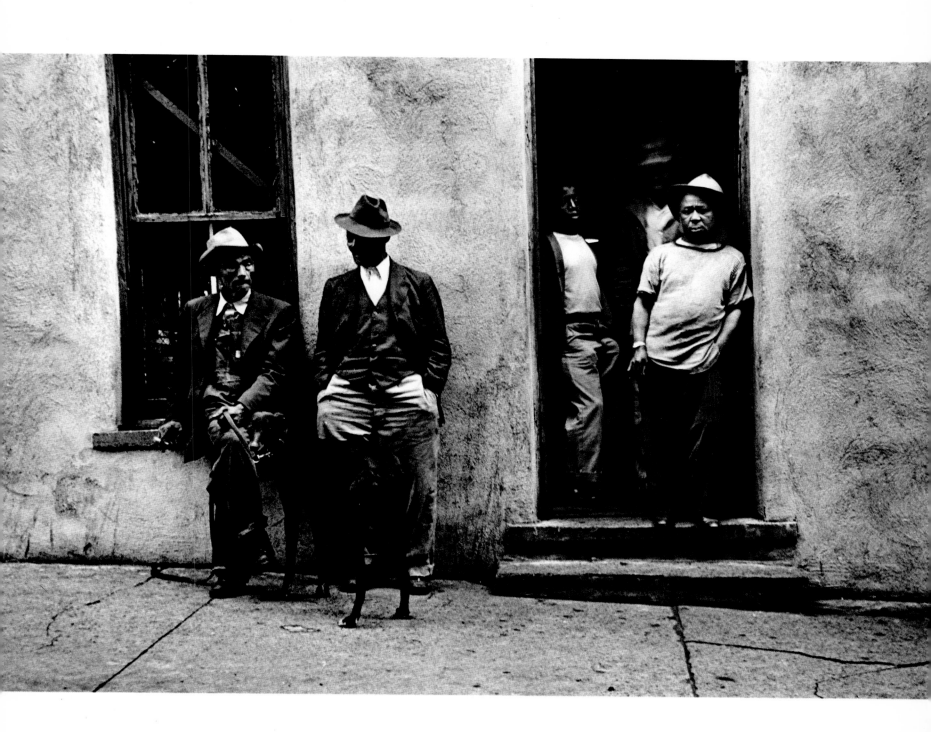

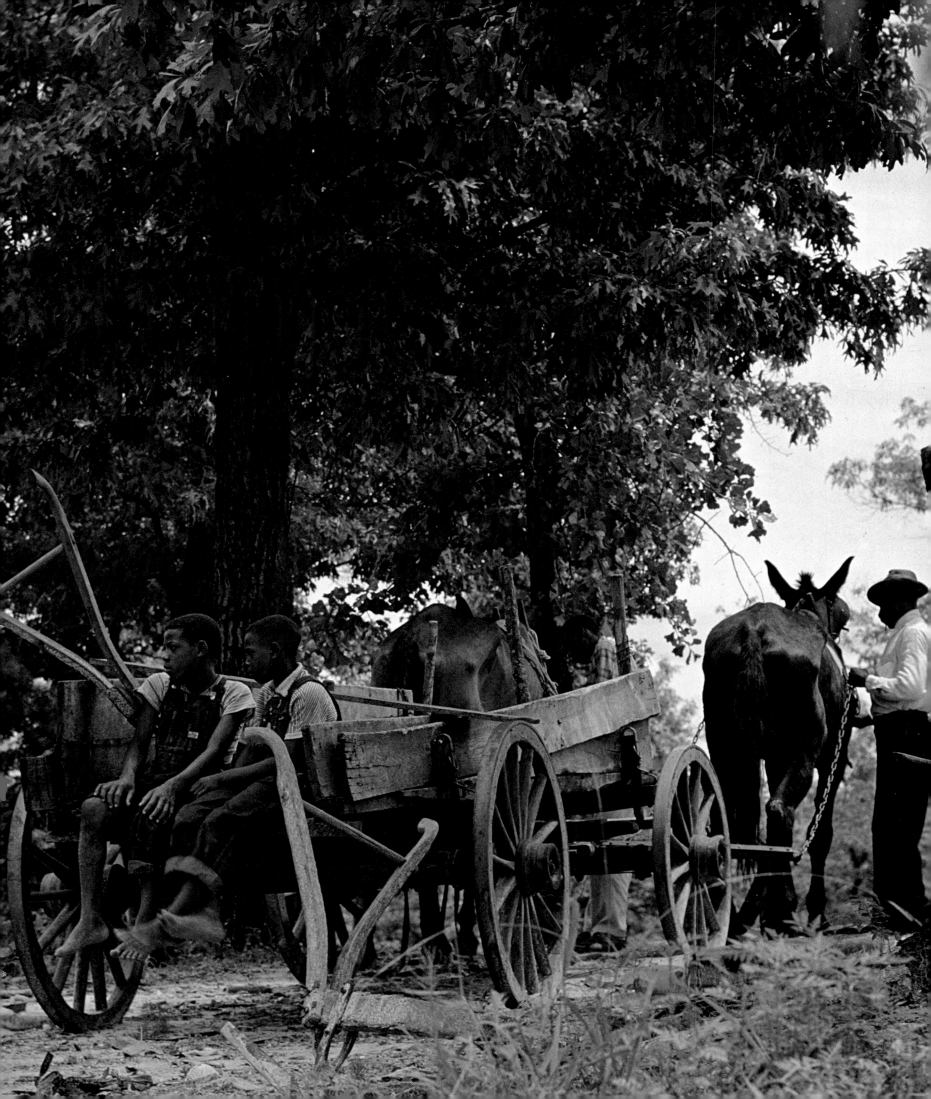

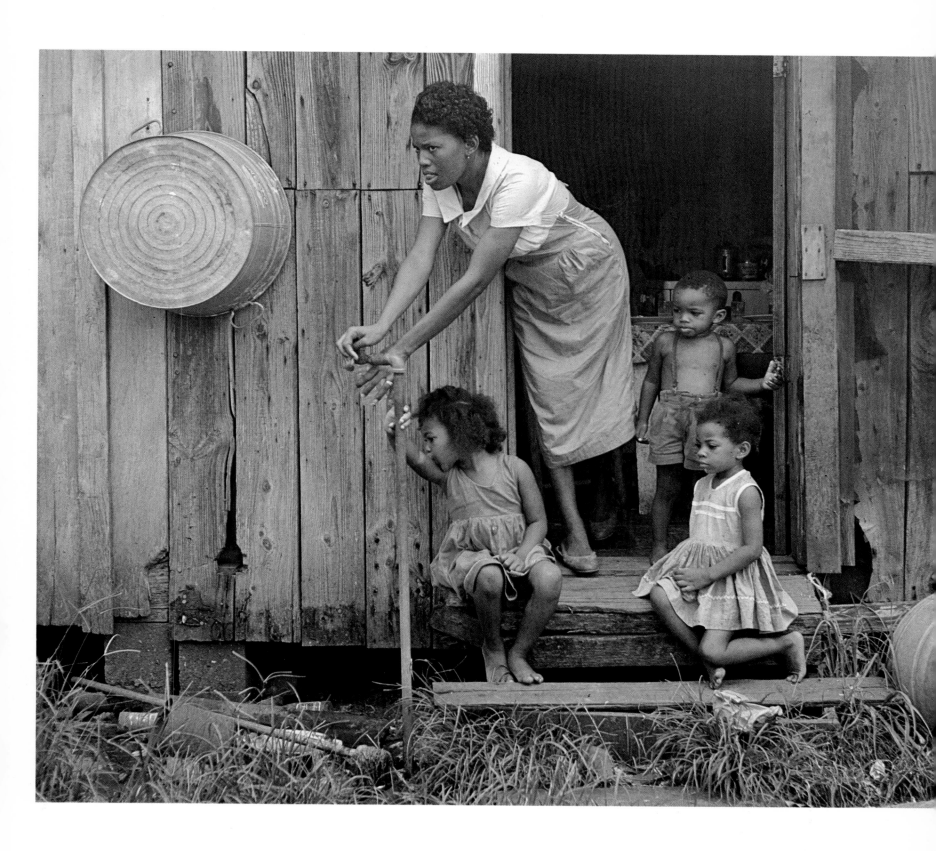

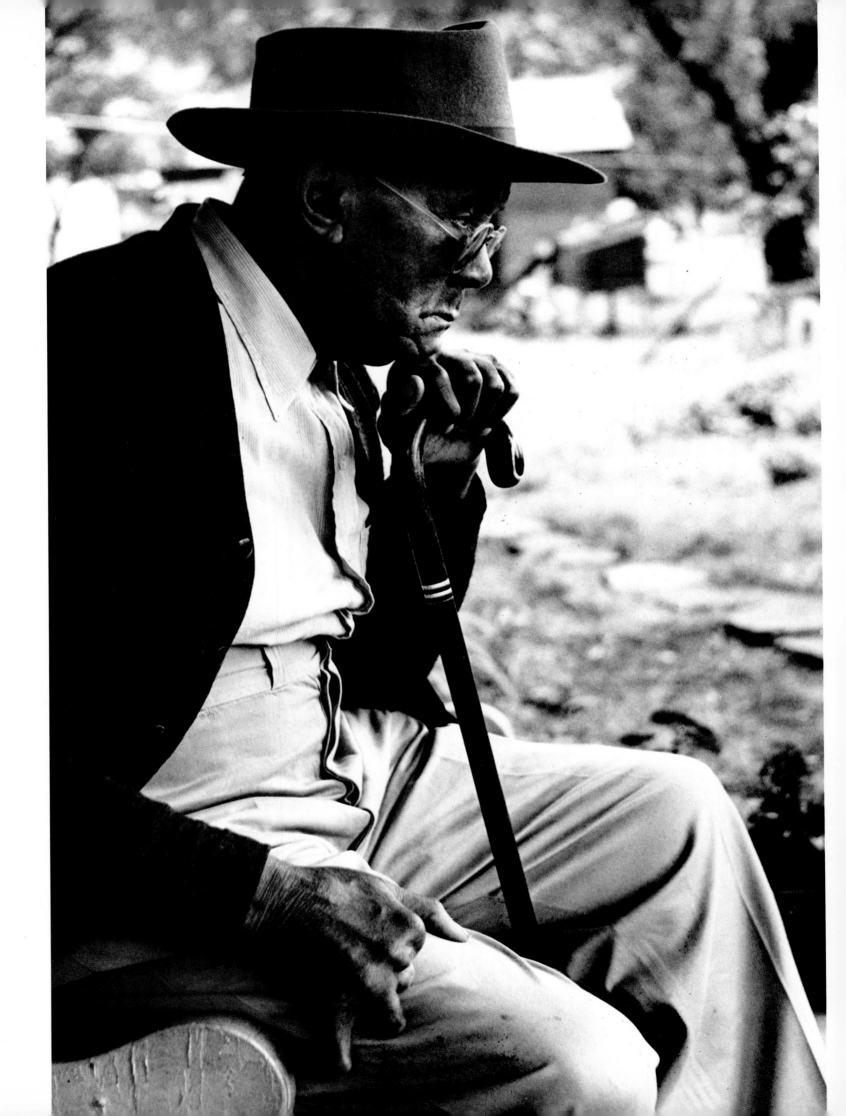

16

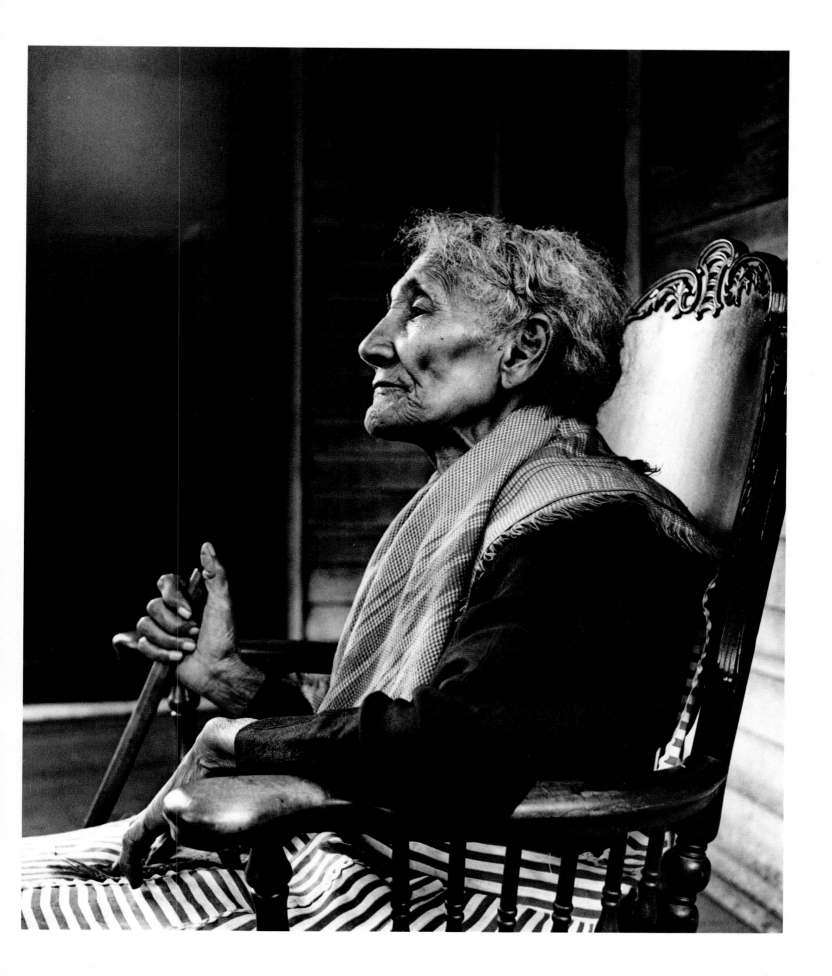

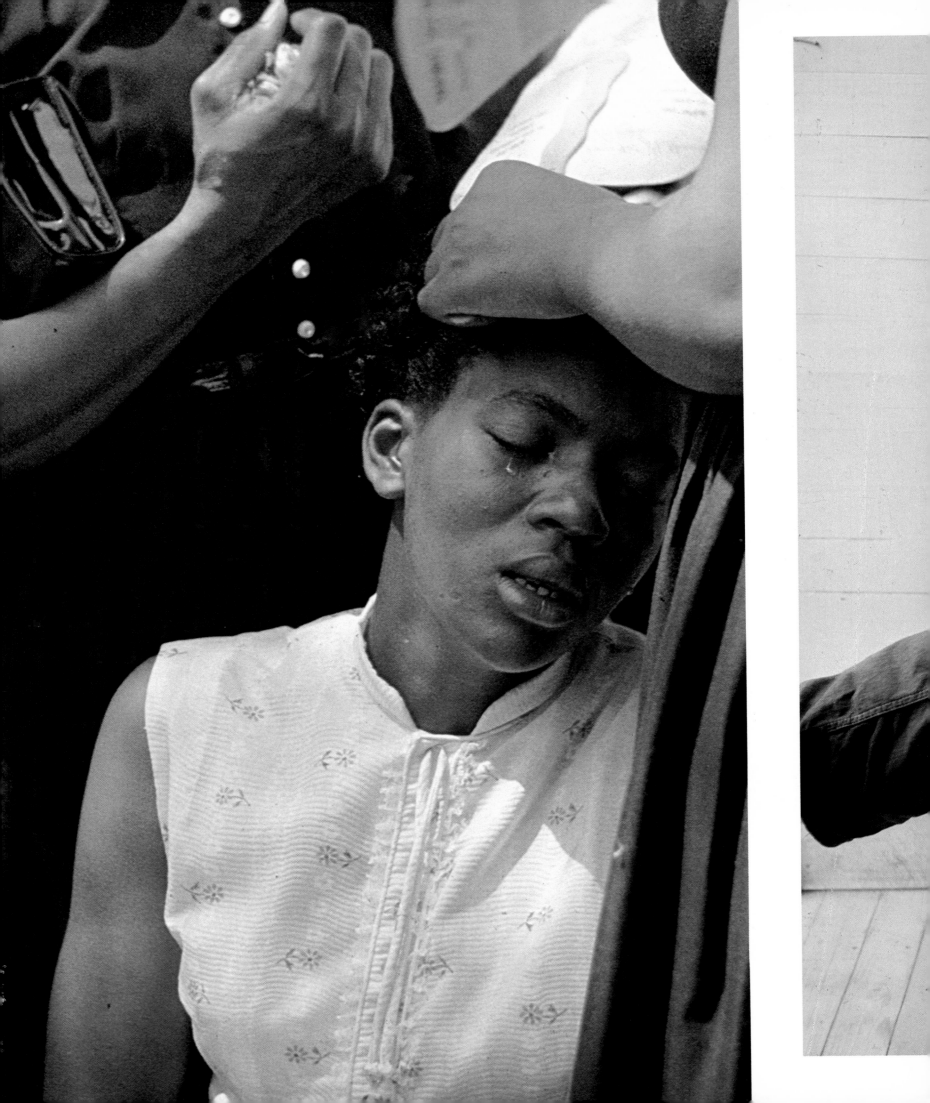

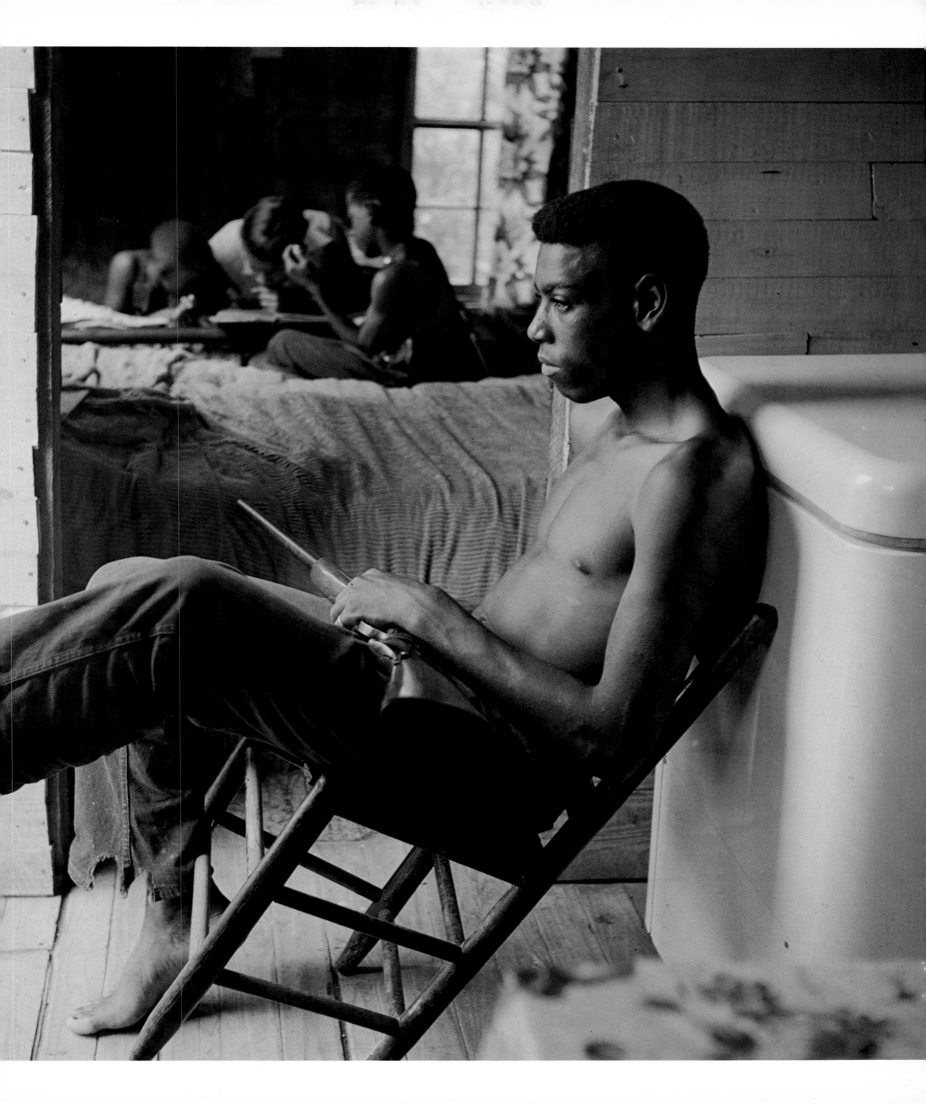

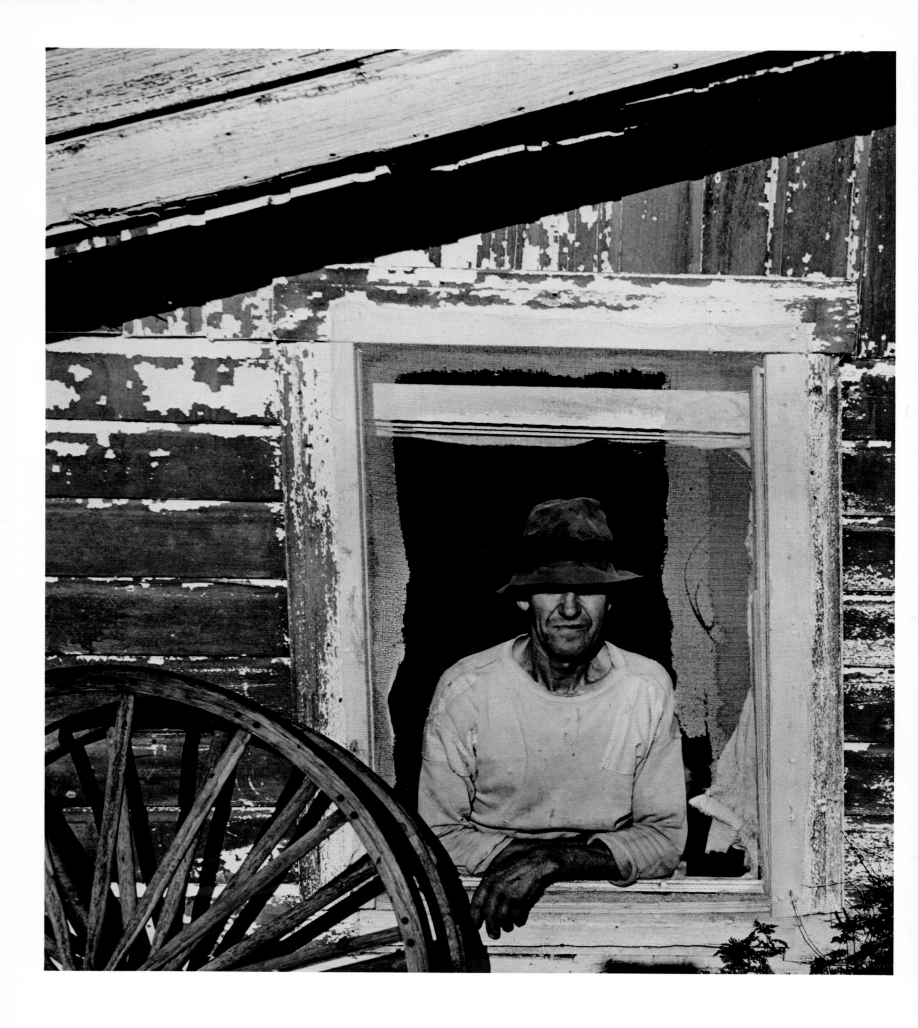

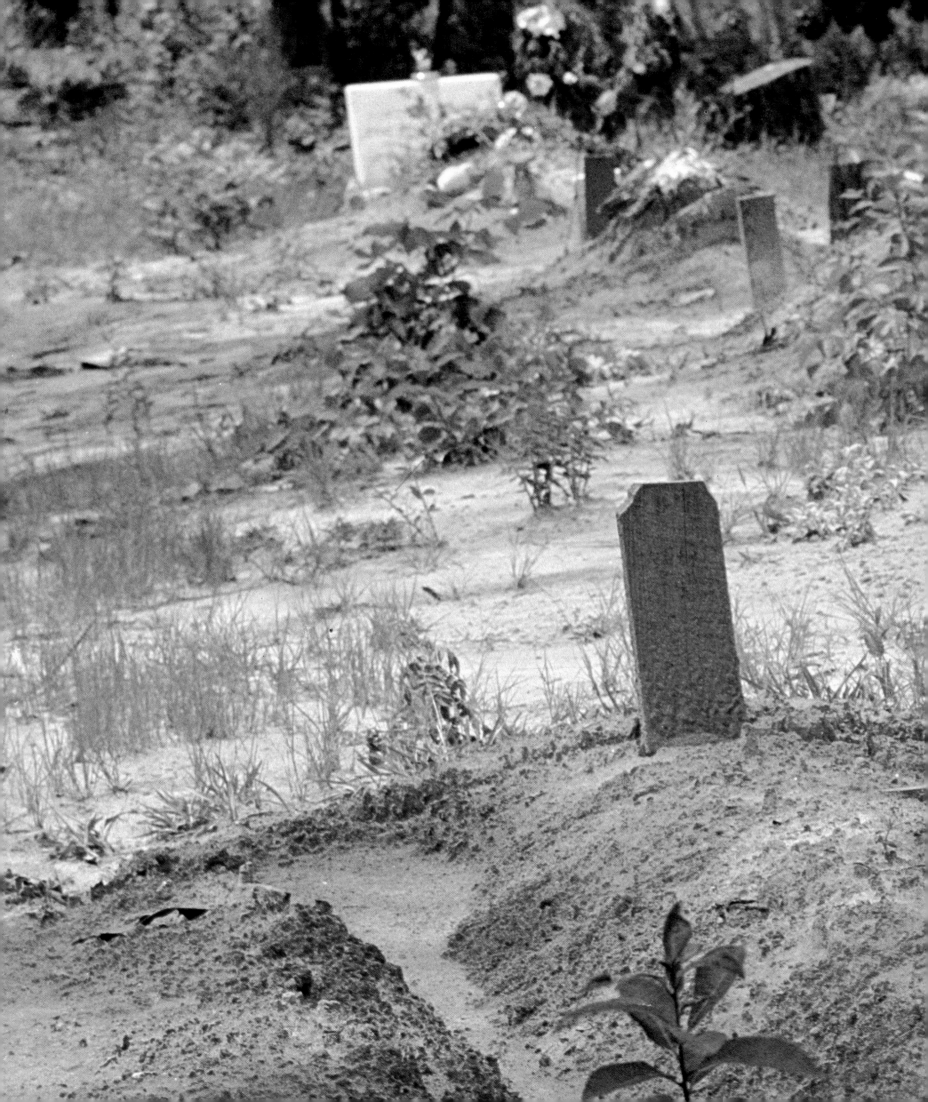

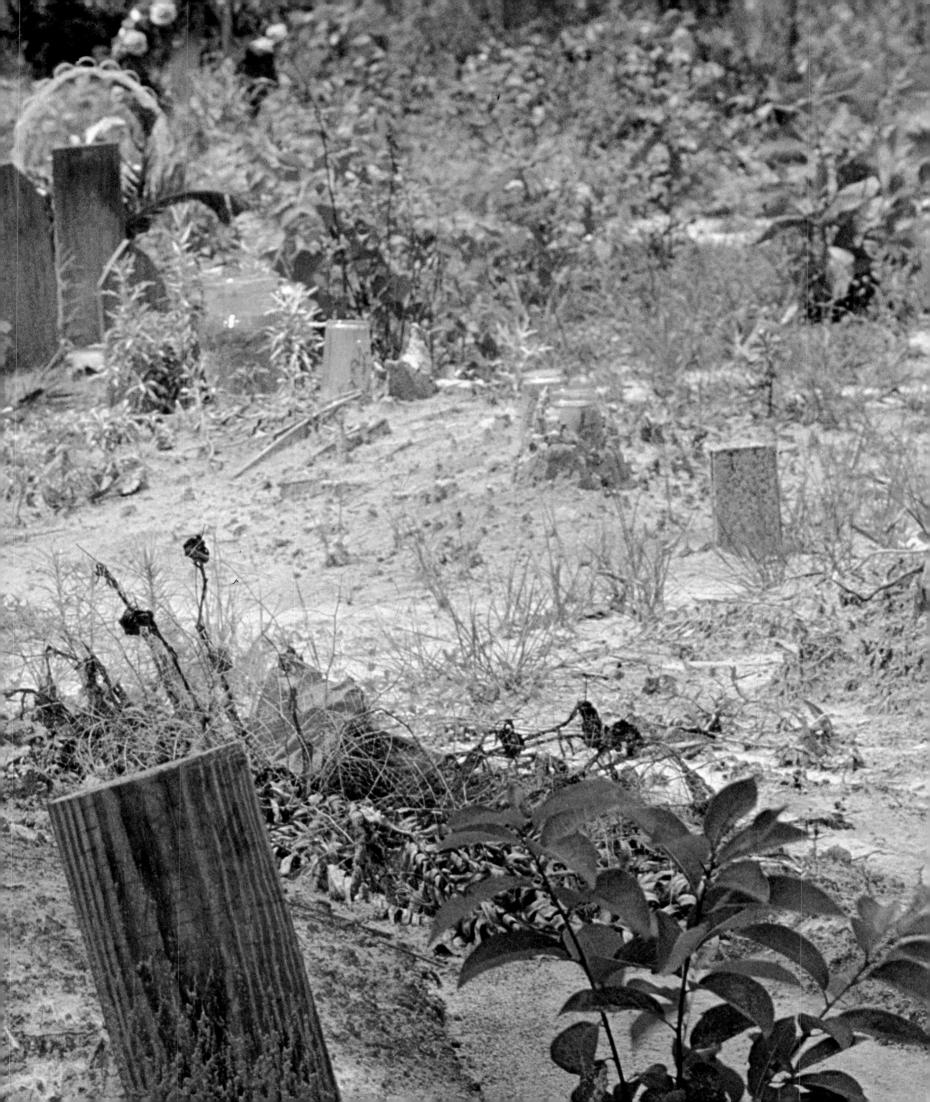

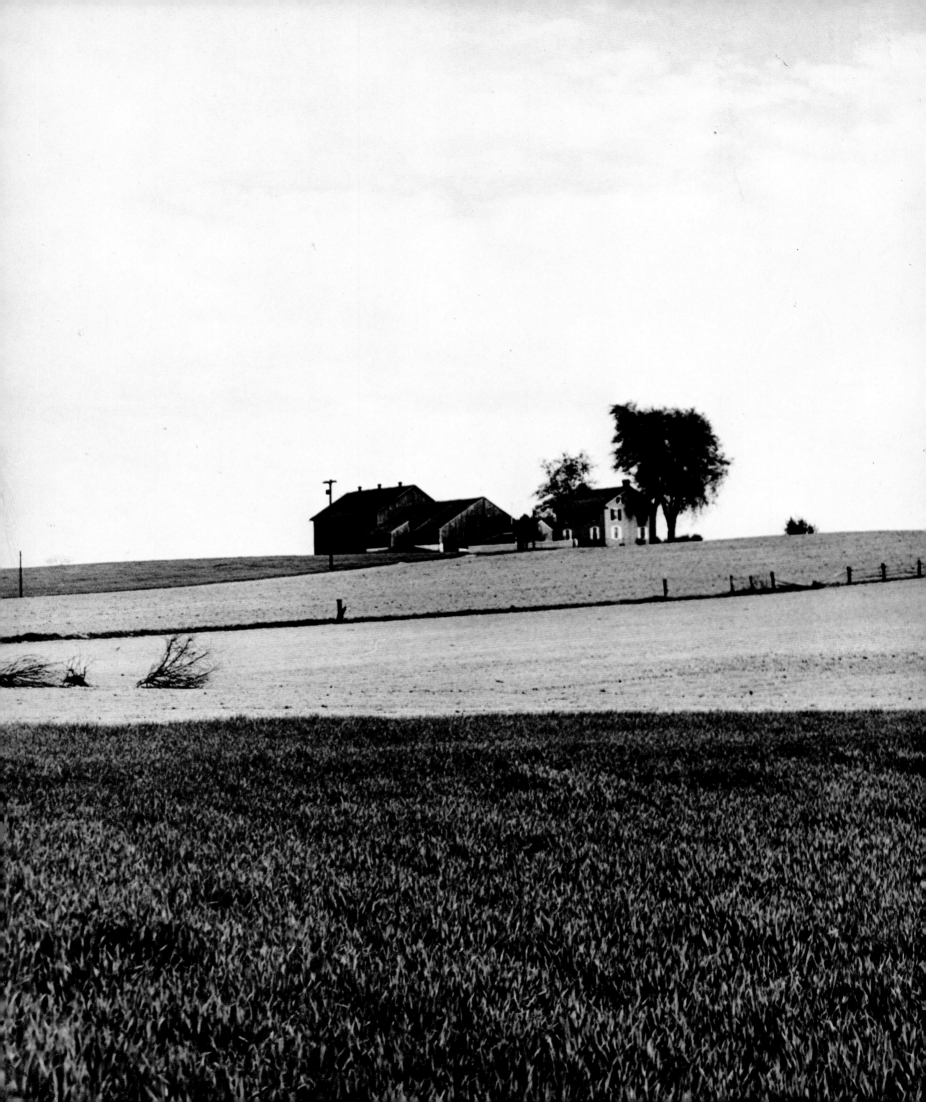

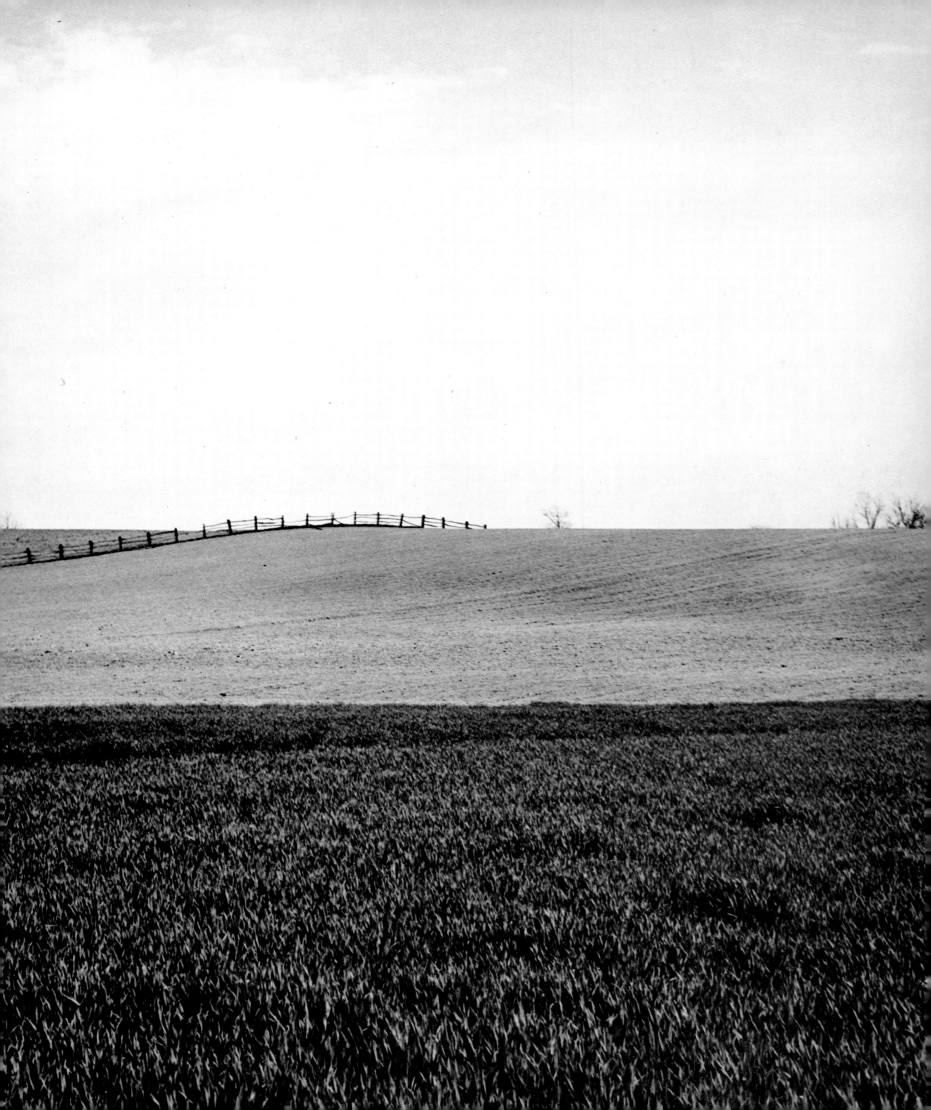

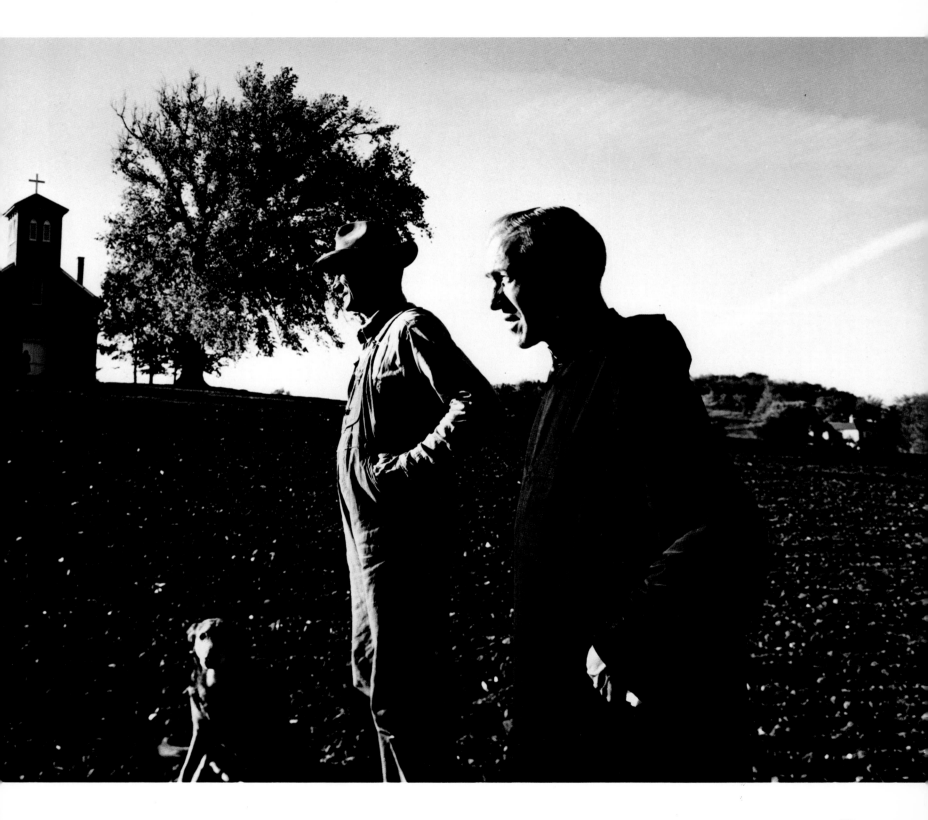

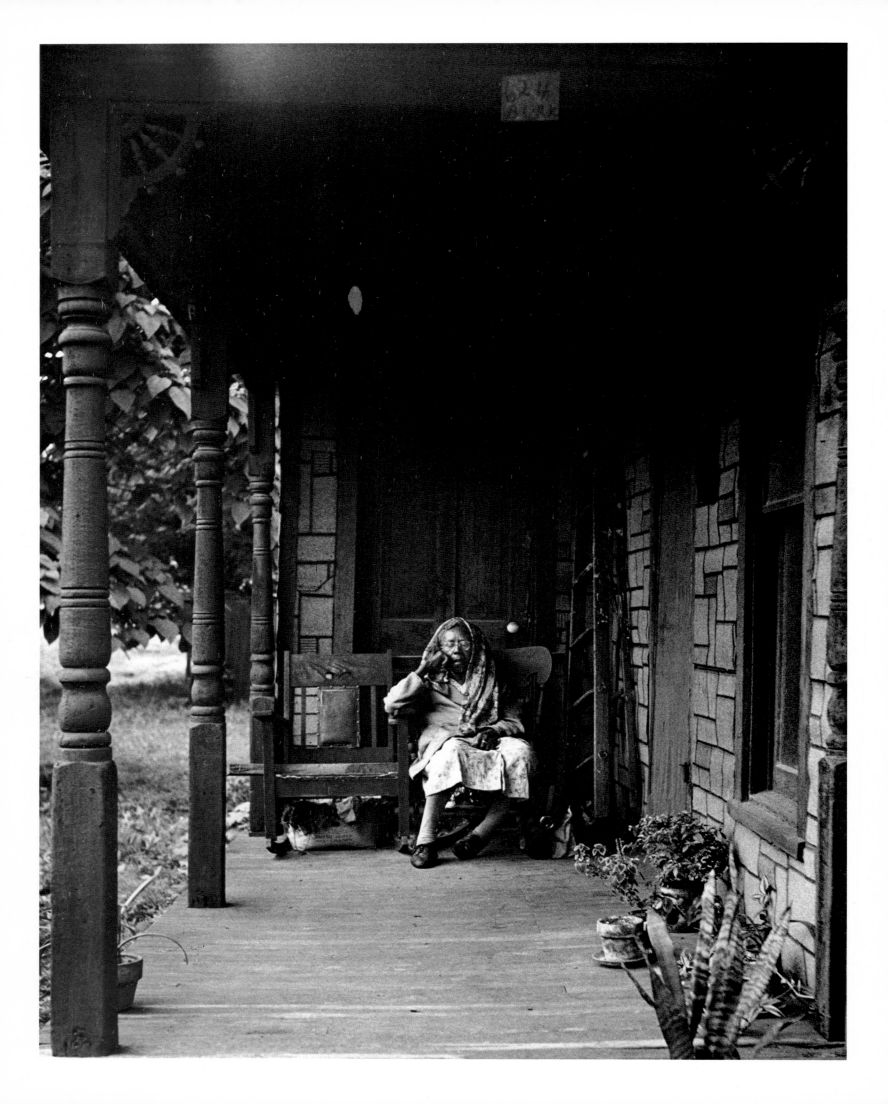

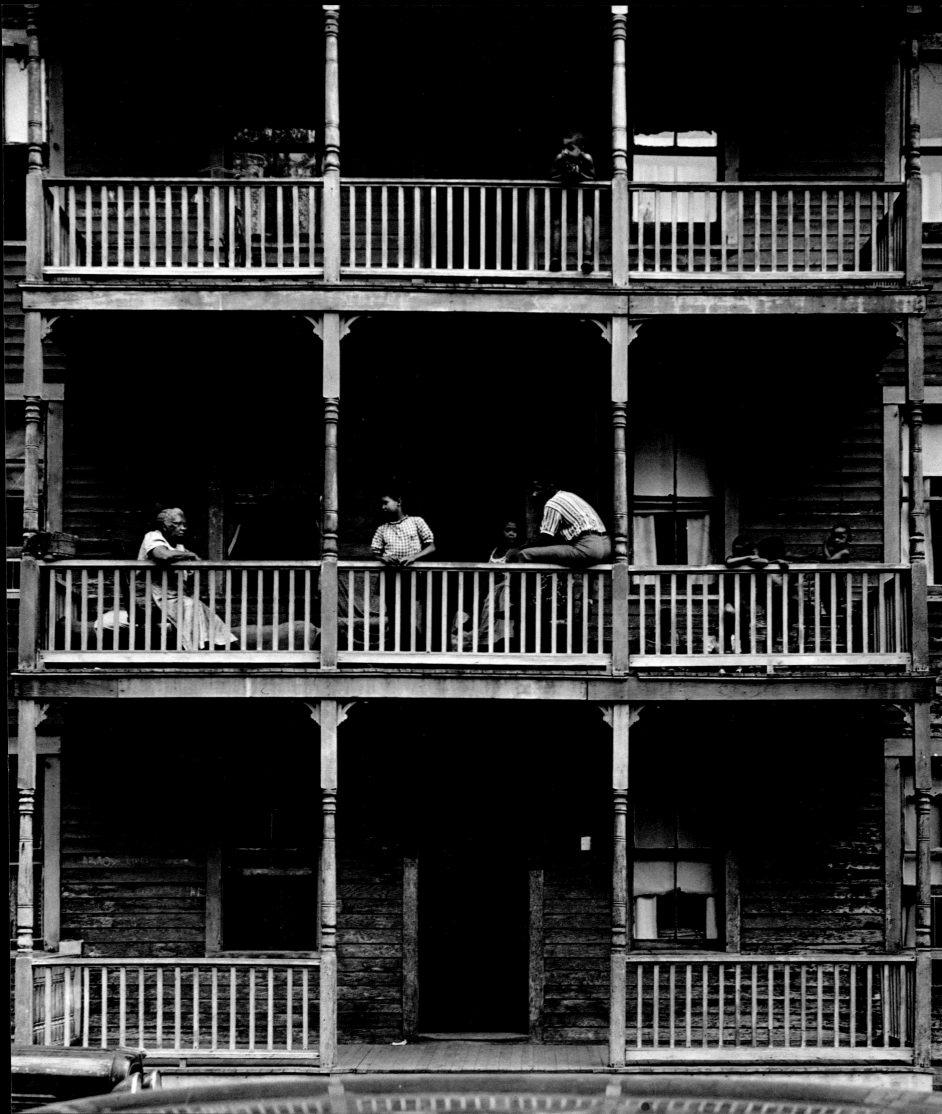

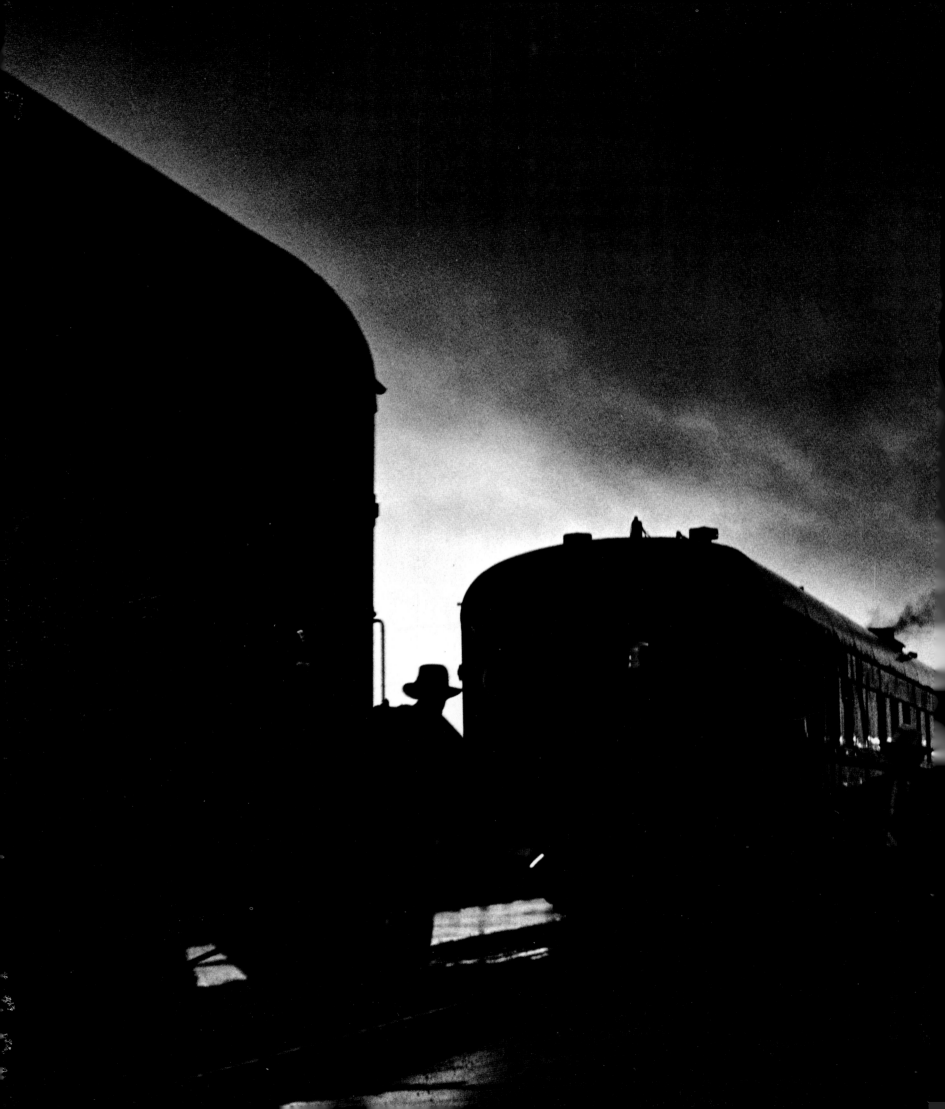

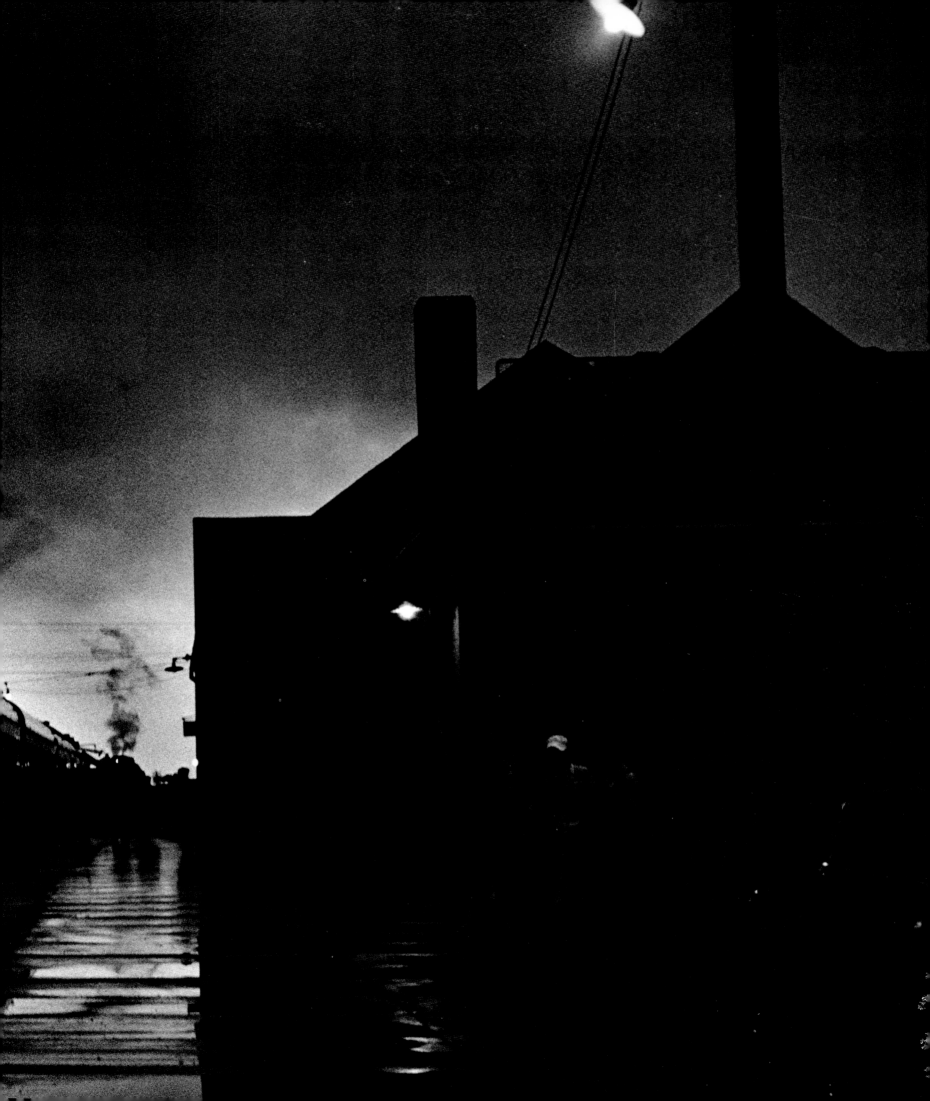

THE SHADOW SEARCHER

A man pulled me drowning from the sea one night. He stood, for a curious moment, pale and drawn, gazing down at me. I gained my breath and thanked him. He sighed, then without a word, turned and ran off into the darkness.

Many times since I have seen him,
Pale, trembling, and searching hard
As if for something he had lost.
When passing once, I spoke. He scowled.
And when I waved another time,
He smiled, then frowned a frown.
Then off he ran again,
Running with the pain
Of thinking as his father thought.
Along the narrow path he ran,
Lacking strength to kill the ache
Of doing as his past had taught.
Once, having gathered in all the facts
That came so slow with altered time,
He had longed to fight the darkness.
But the turning price was far too high—
Those generations, long since sleeping
Grave-deep under Confederate skies,
Could not in good conscience be ignored.
So two things he brought himself to do

sigh and run . . .

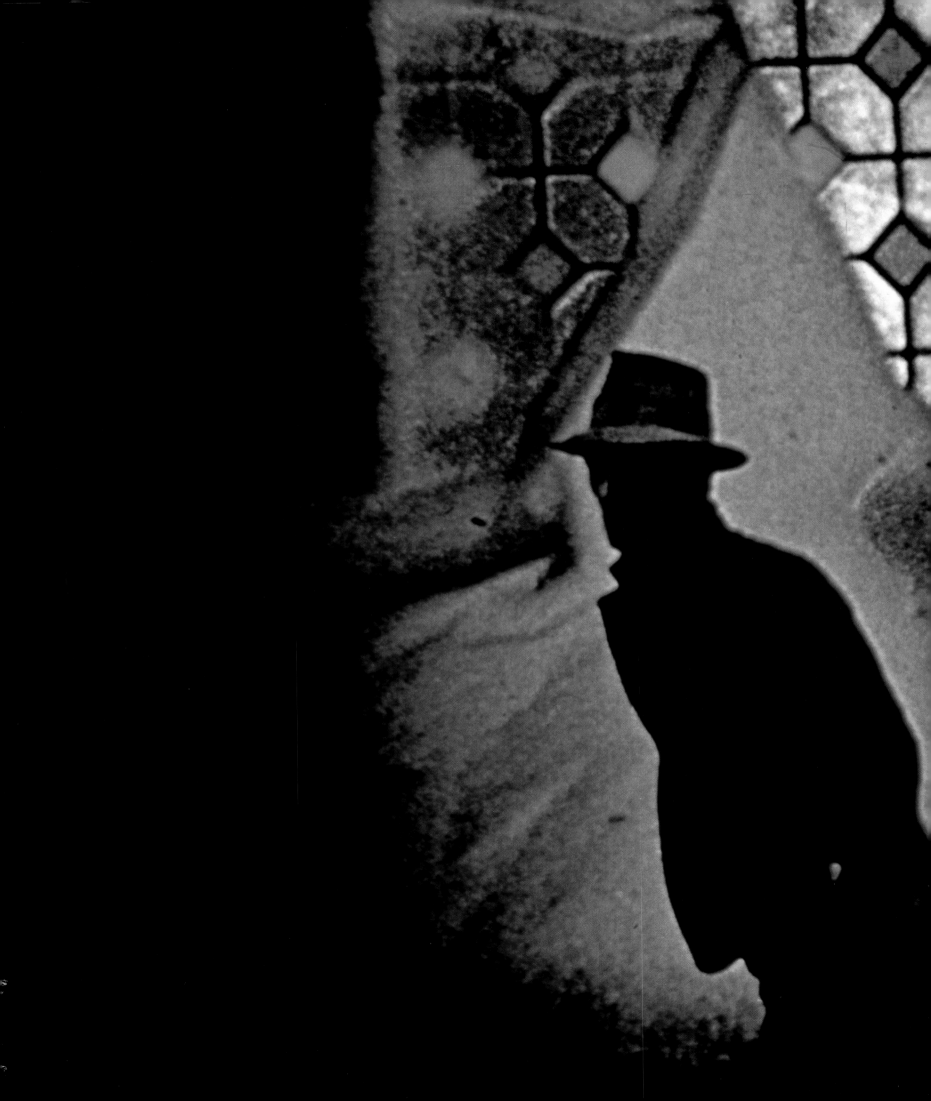

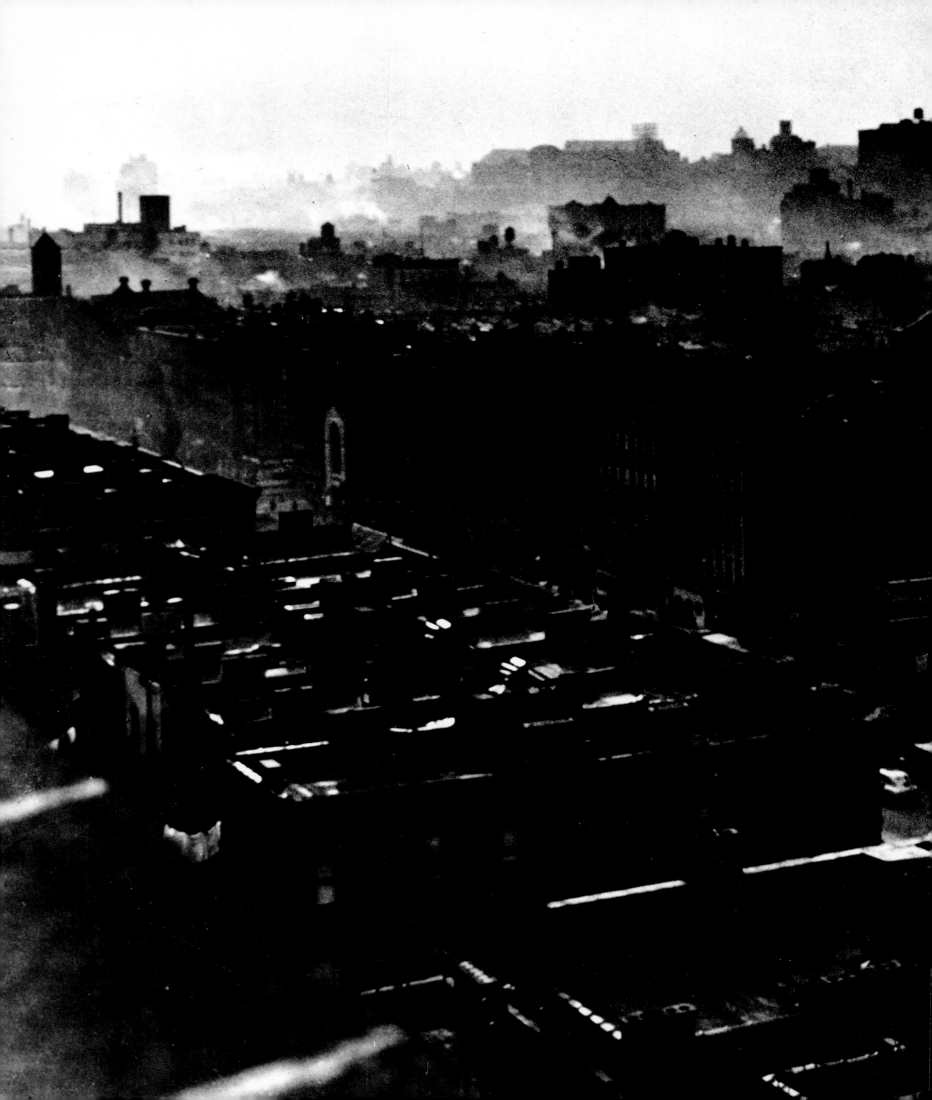

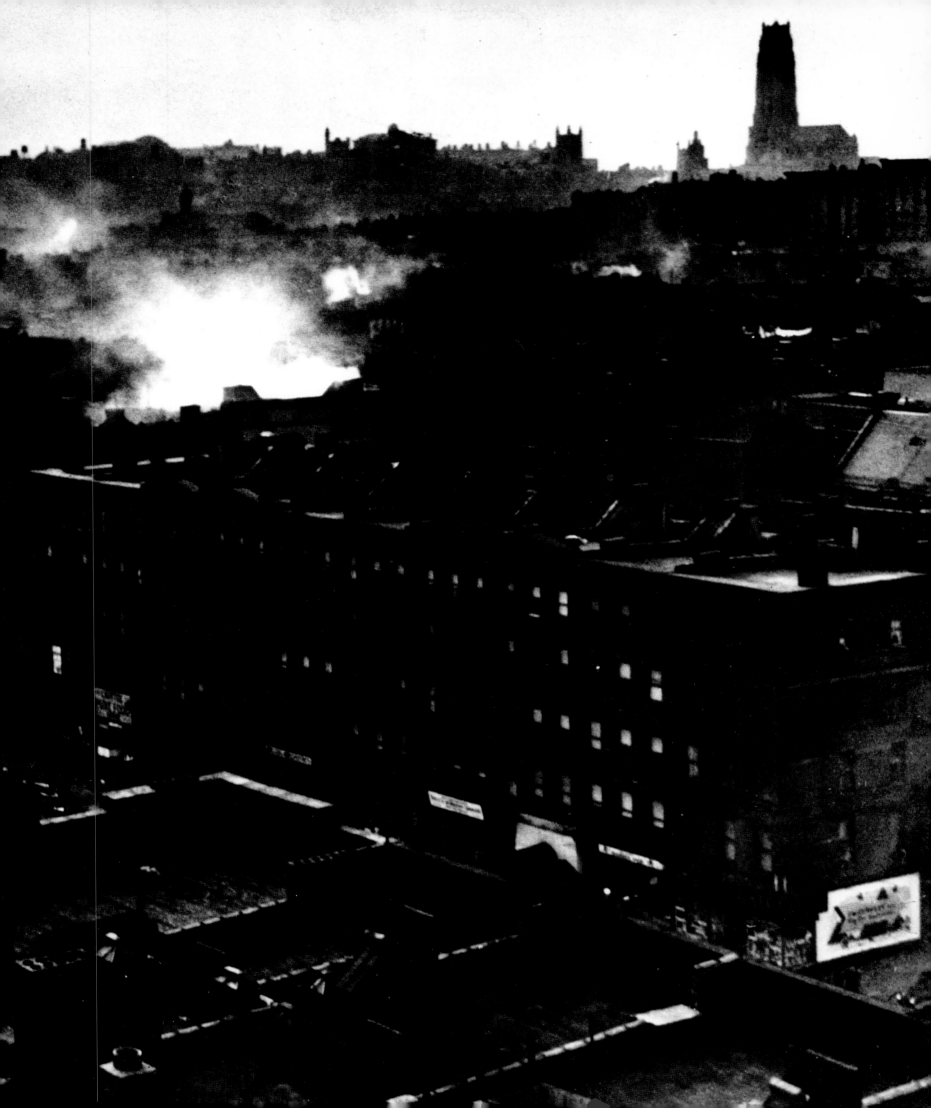

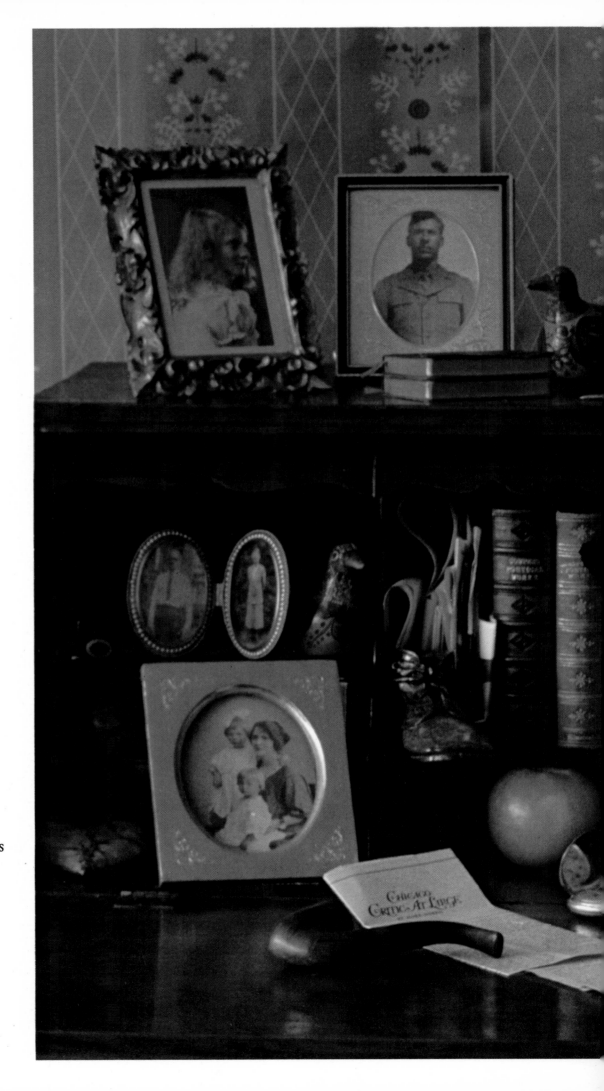

Now in this north city of windowed tombs
He races the shadows searching hard
For something he never did possess.

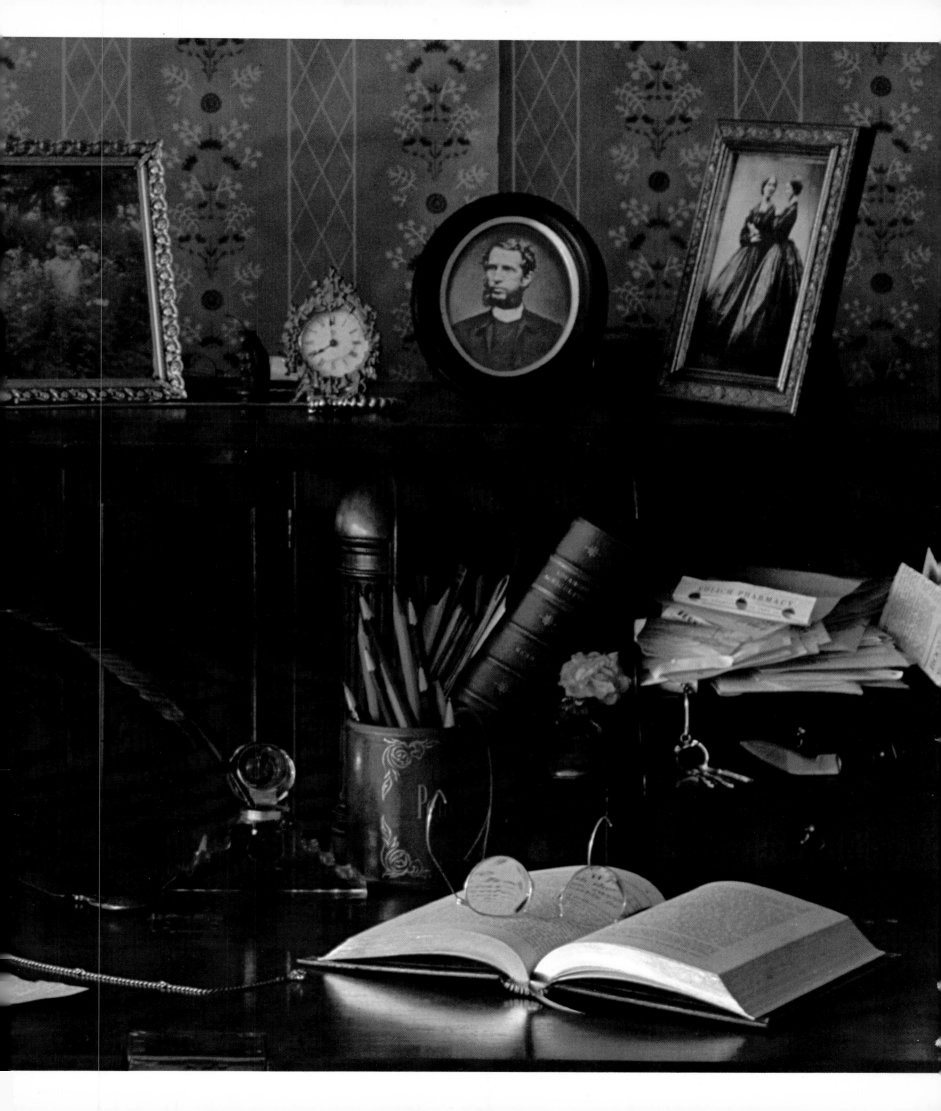

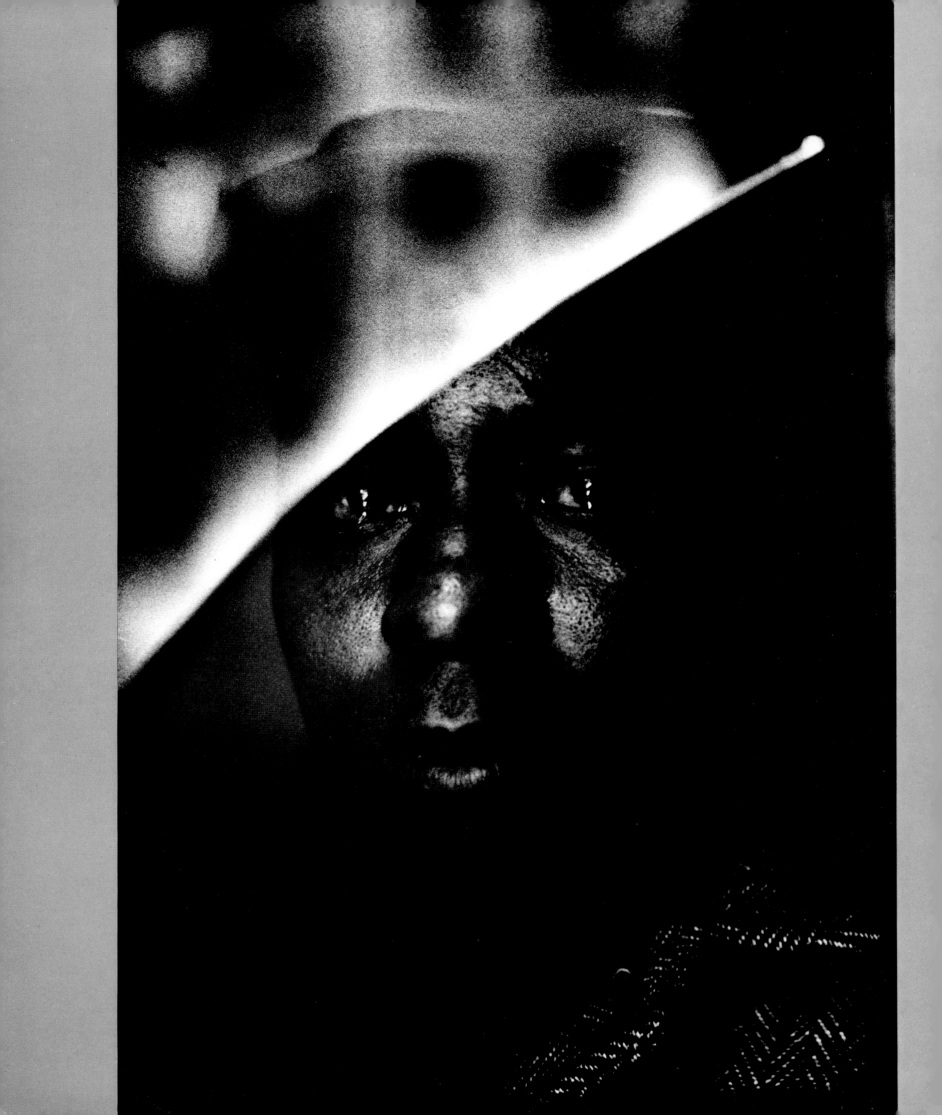

If I were an old man dying now,
I would tell of long cruel winters
And as many cruel springs,
Of ages I have watched leaves turn
Brown and back to green again,

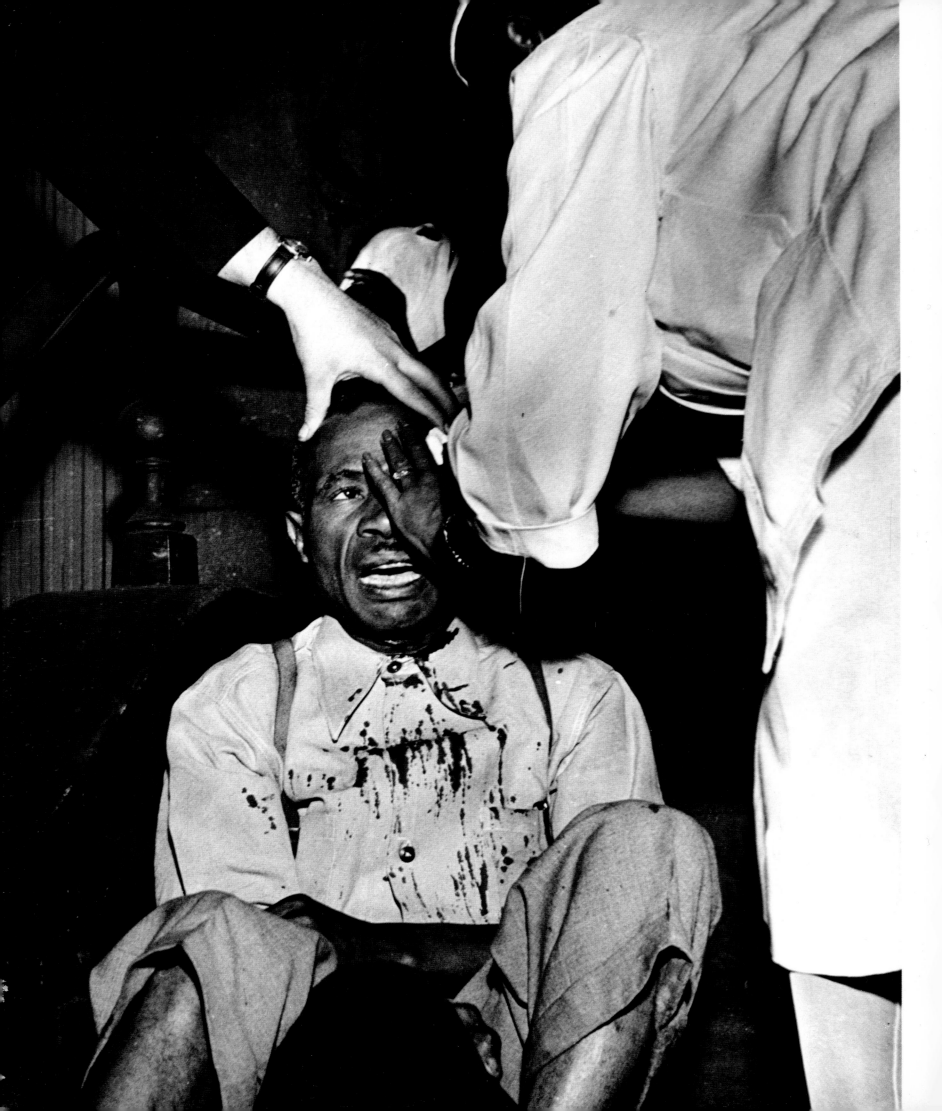

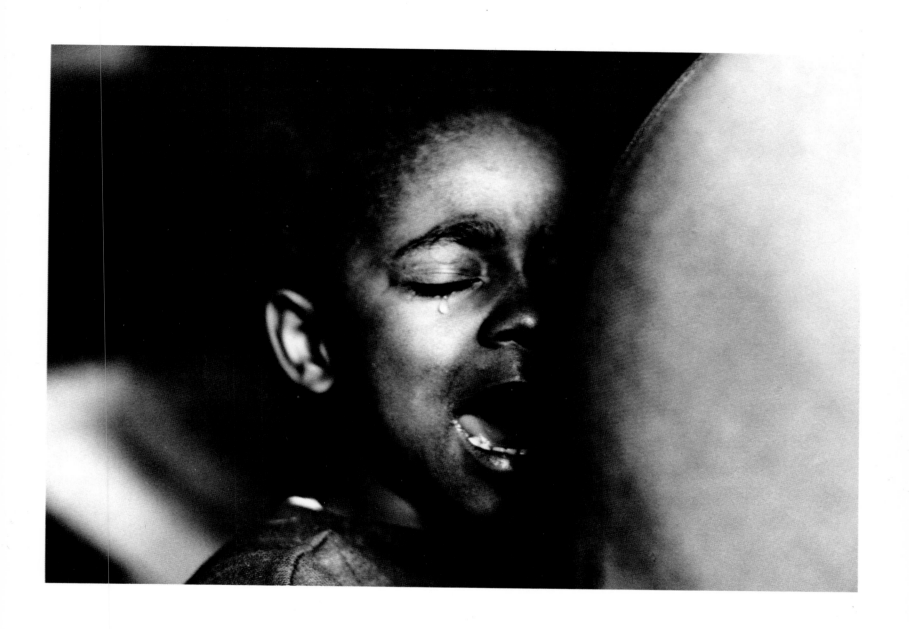

Of time sucking life from old men
And breathing despair into infants,

Of judgments that defile holy commandments,
Of ancient rivers drying up before me
As idly I watched their sandbeds
Kneaded into tall steel and stone
That slowly rose and imprisoned me.

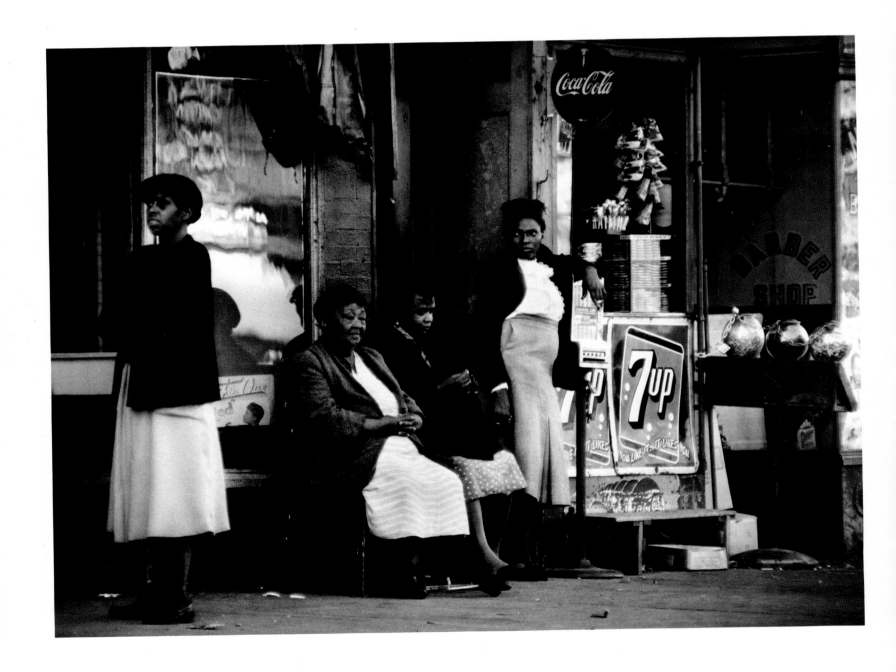

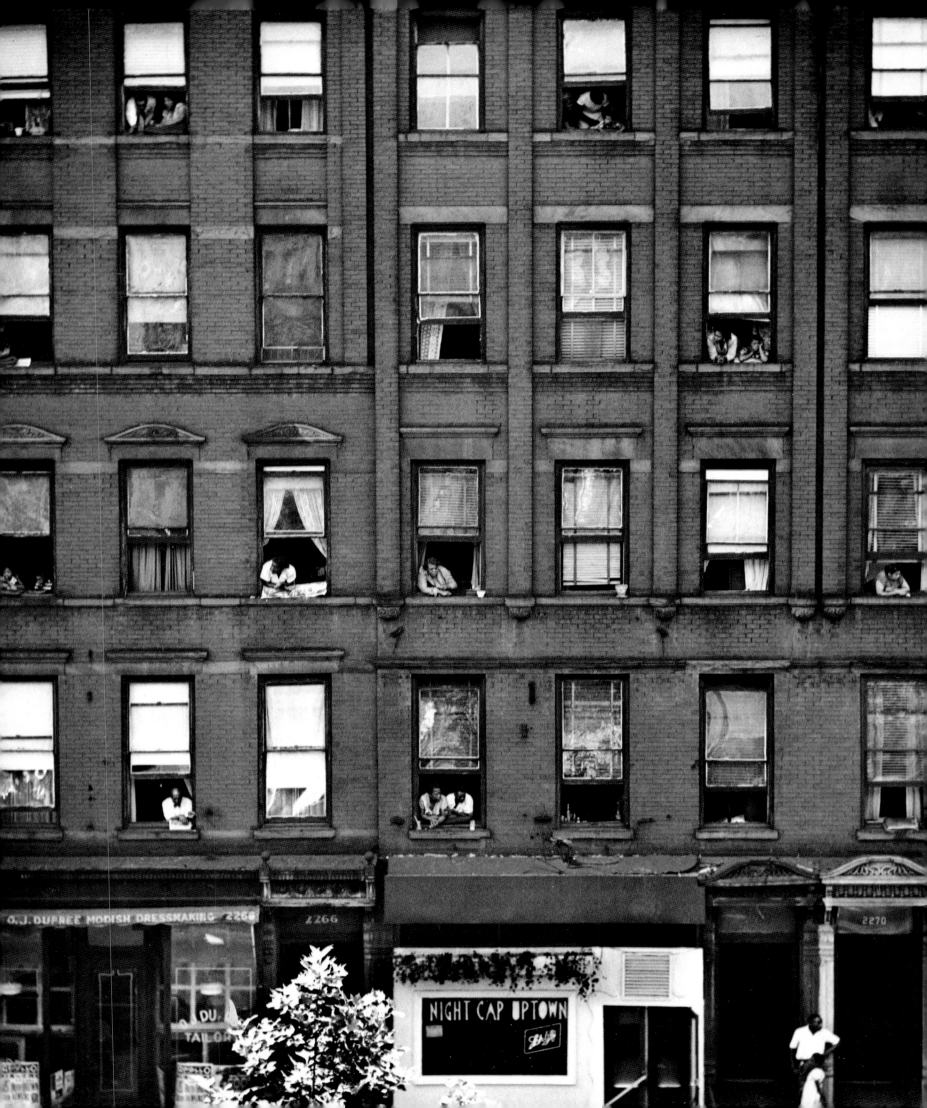

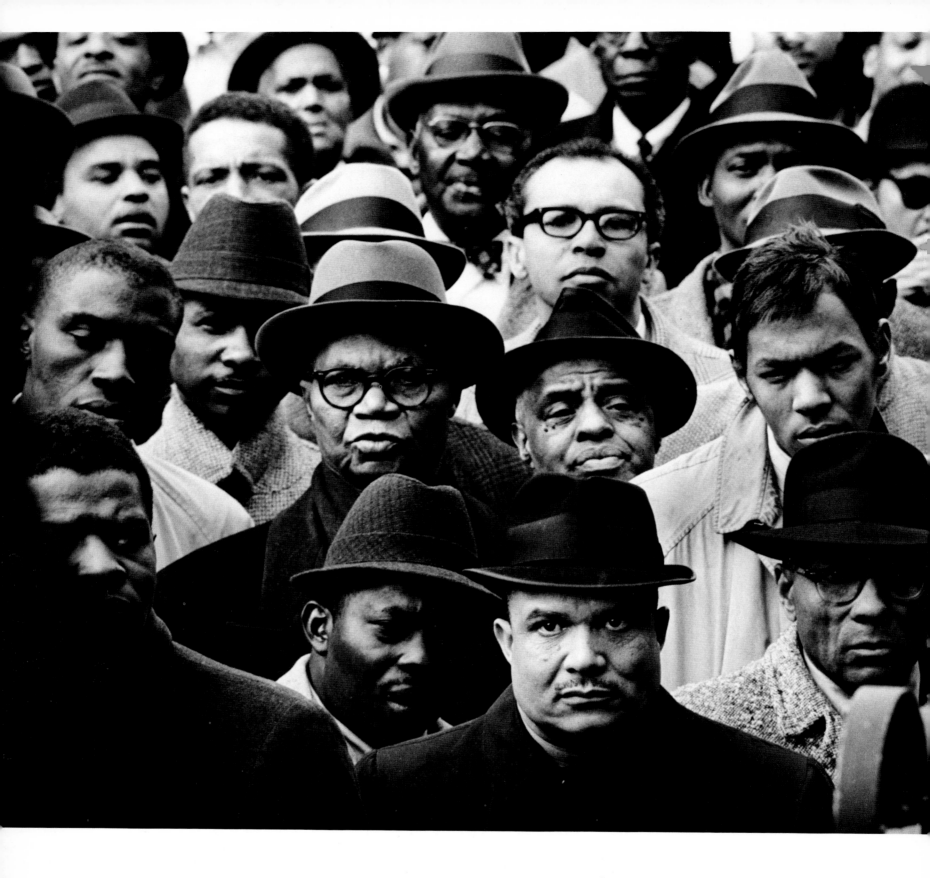

And I would speak of summers lived
Through the lash and sickened mobs,
And caution against promises coming
Smooth through guilt-laden voices.

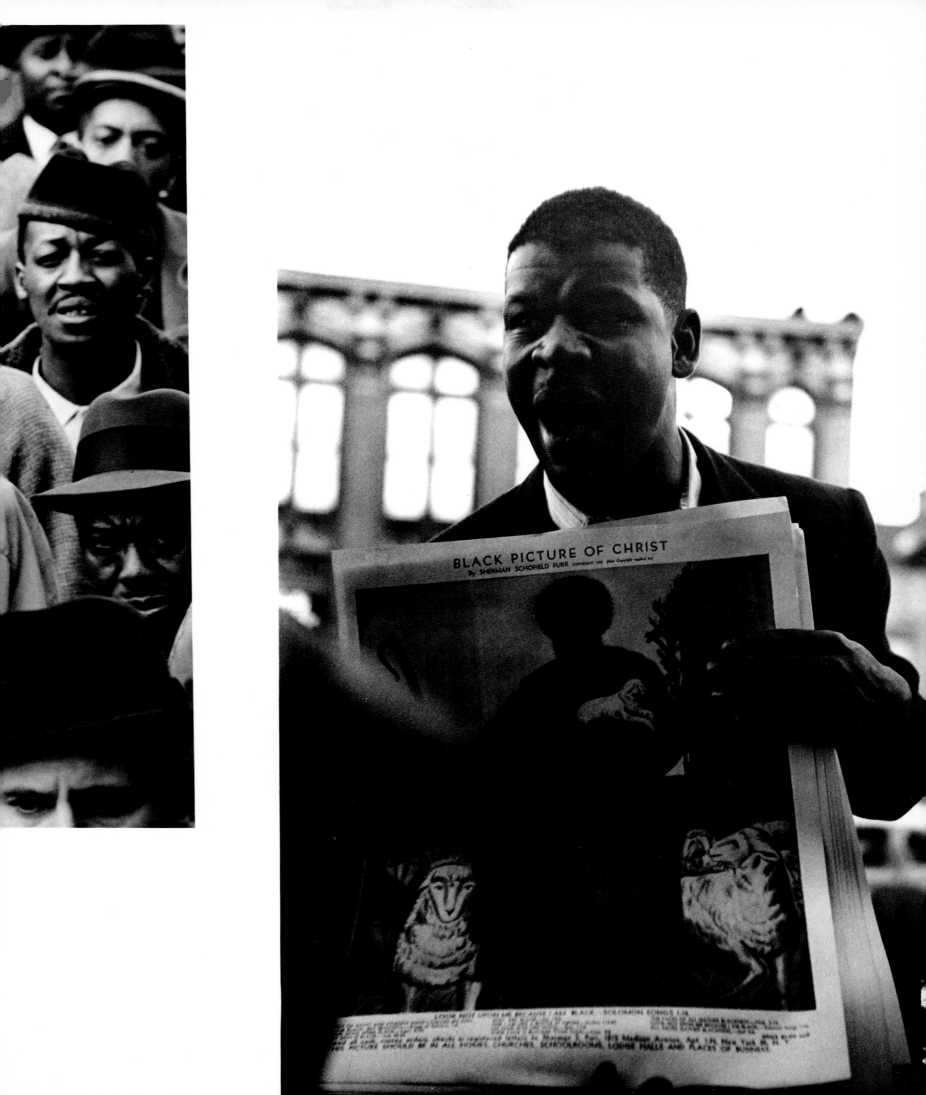

And I would speak long of a native soil
From which I was borne to a hostile land
Where my bent back gave order to that land

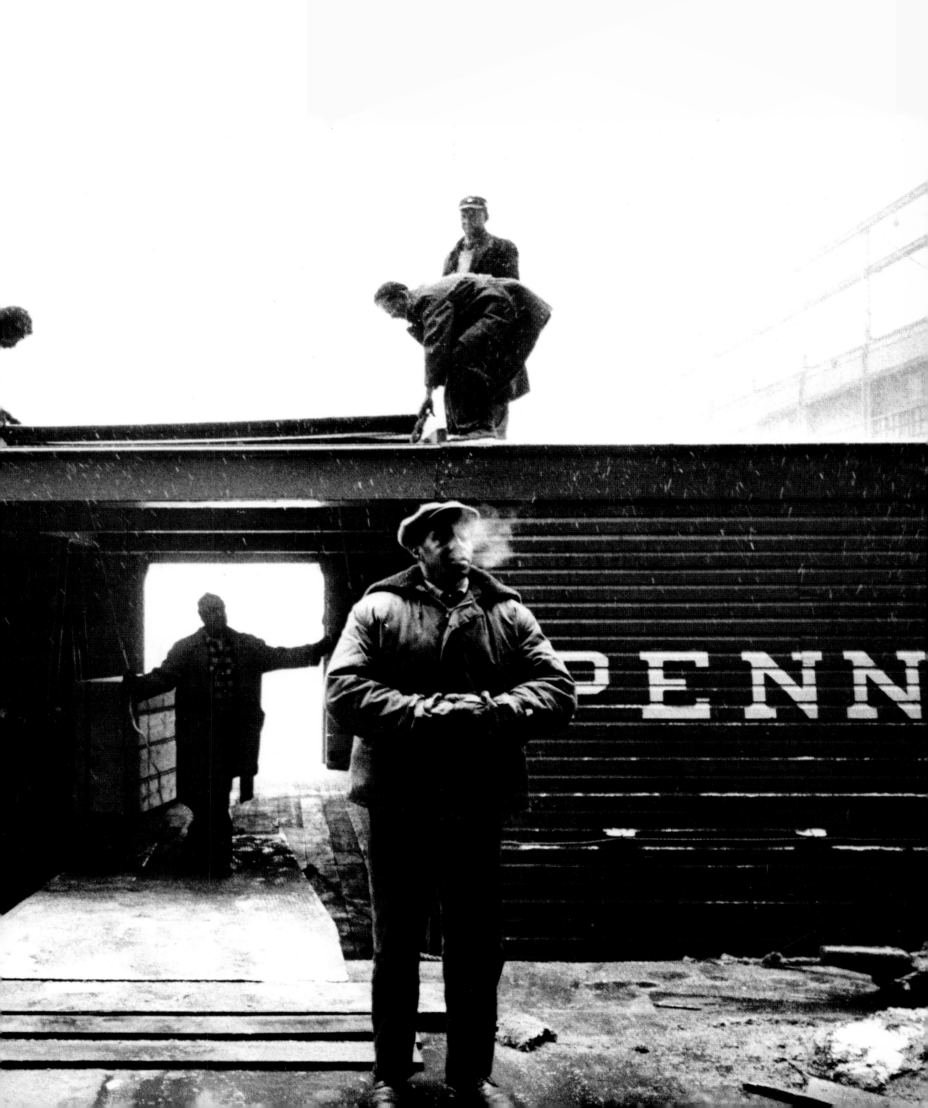

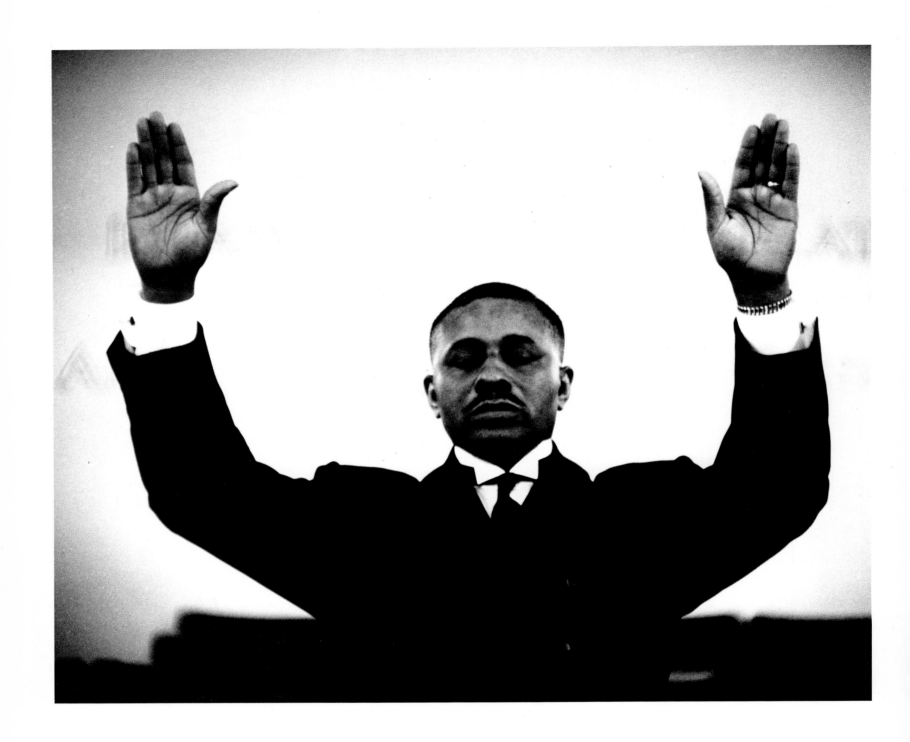

and
Where I was told to pray and be saved
And where I prayed beneath broken flesh
Swinging black from a southtree branch,

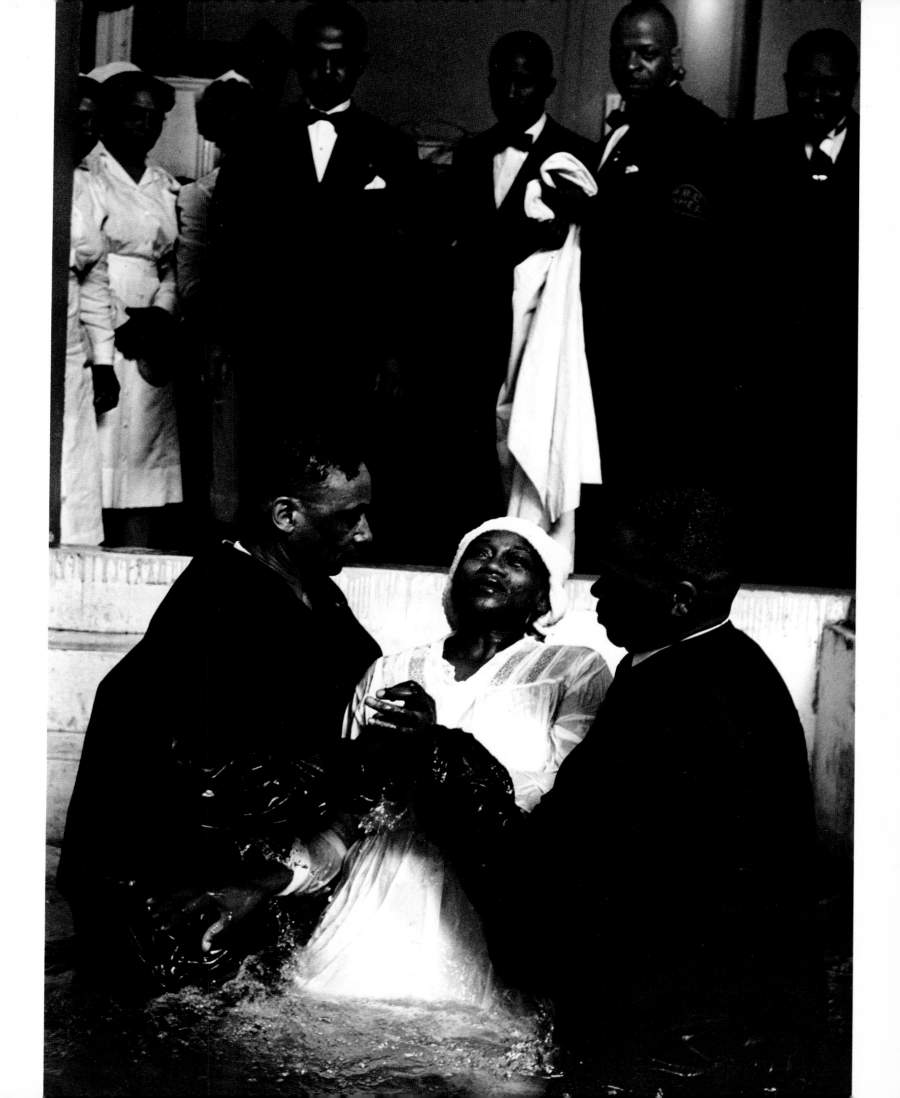

Where I was told to love and conquer
and
Where I loved and bowed to fear and hate.

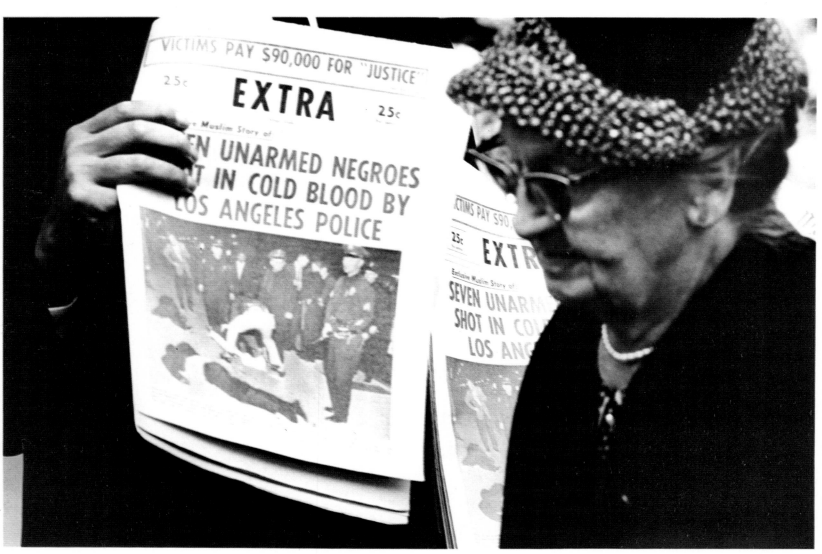

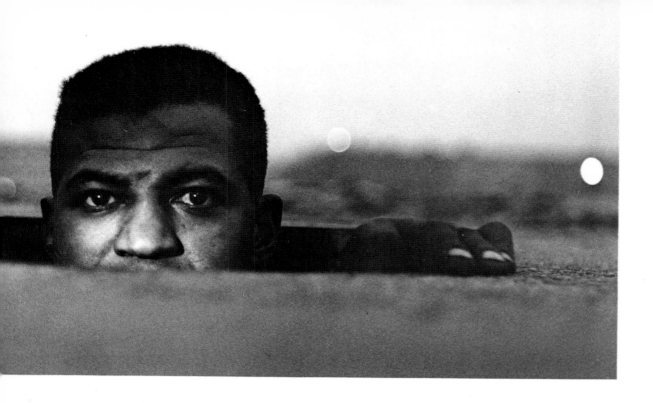

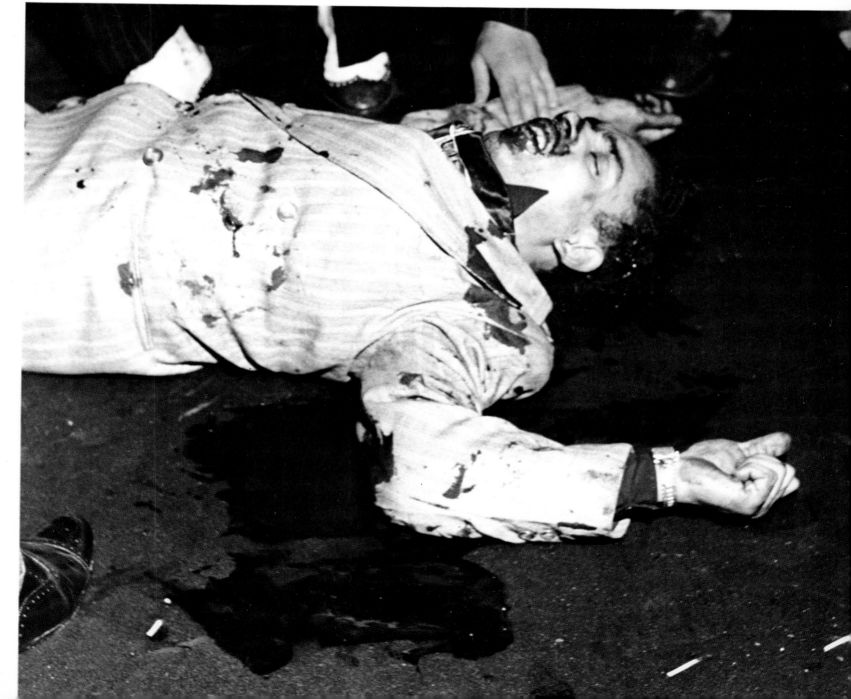

If I were an old man dying now,
I would tell of black jungles
Where on asphalt meadows
Stood my prison home, crumbling
In mortal chaos around me

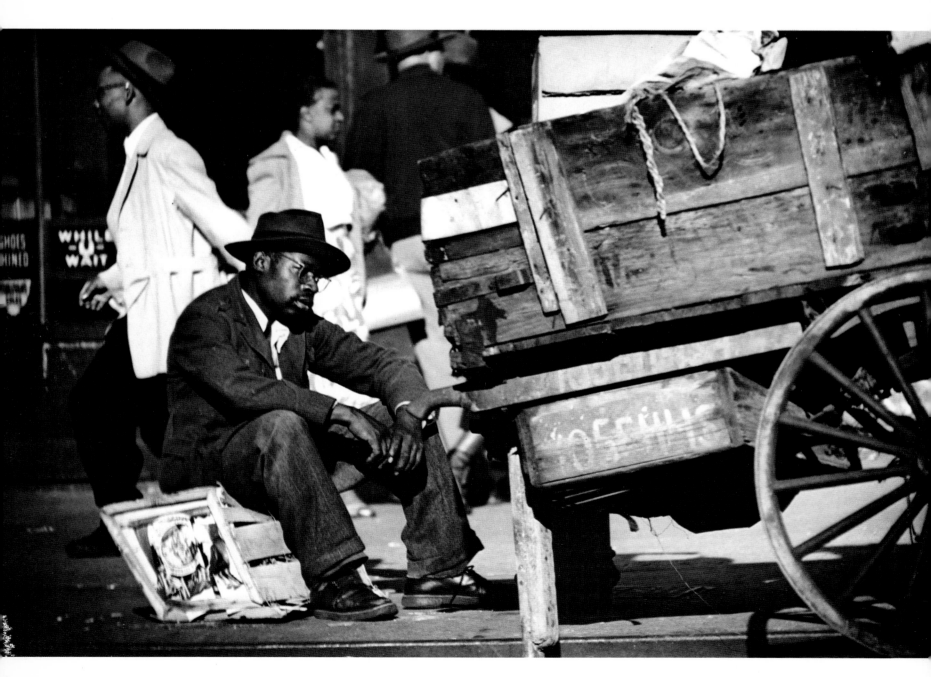

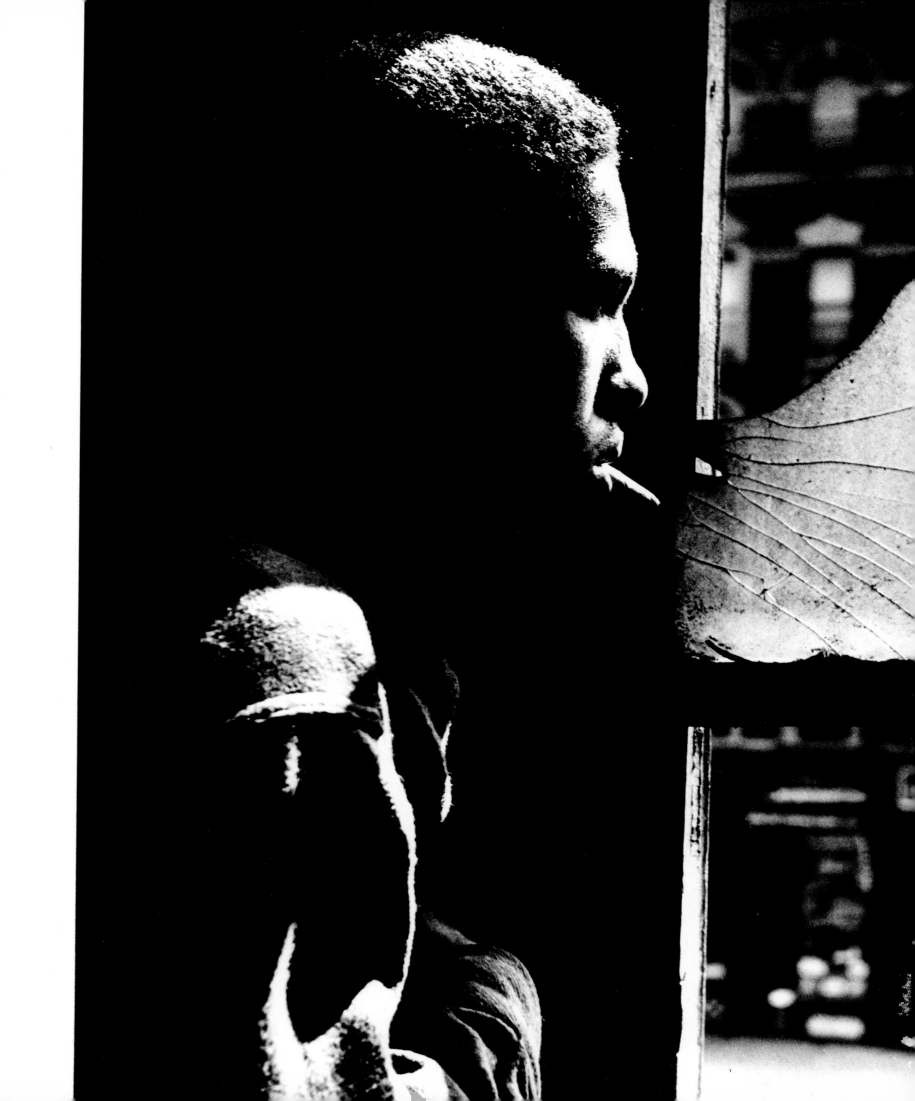

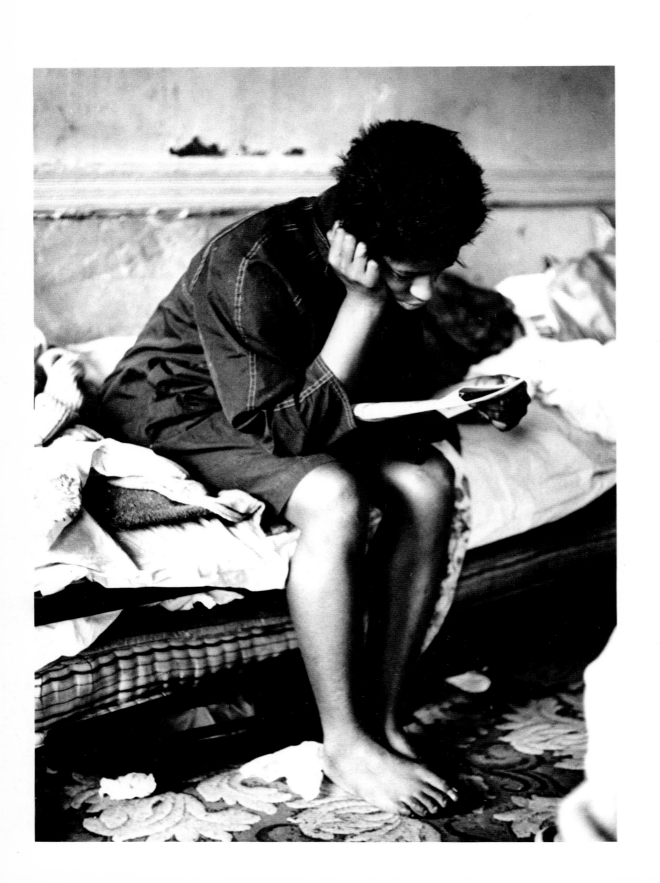

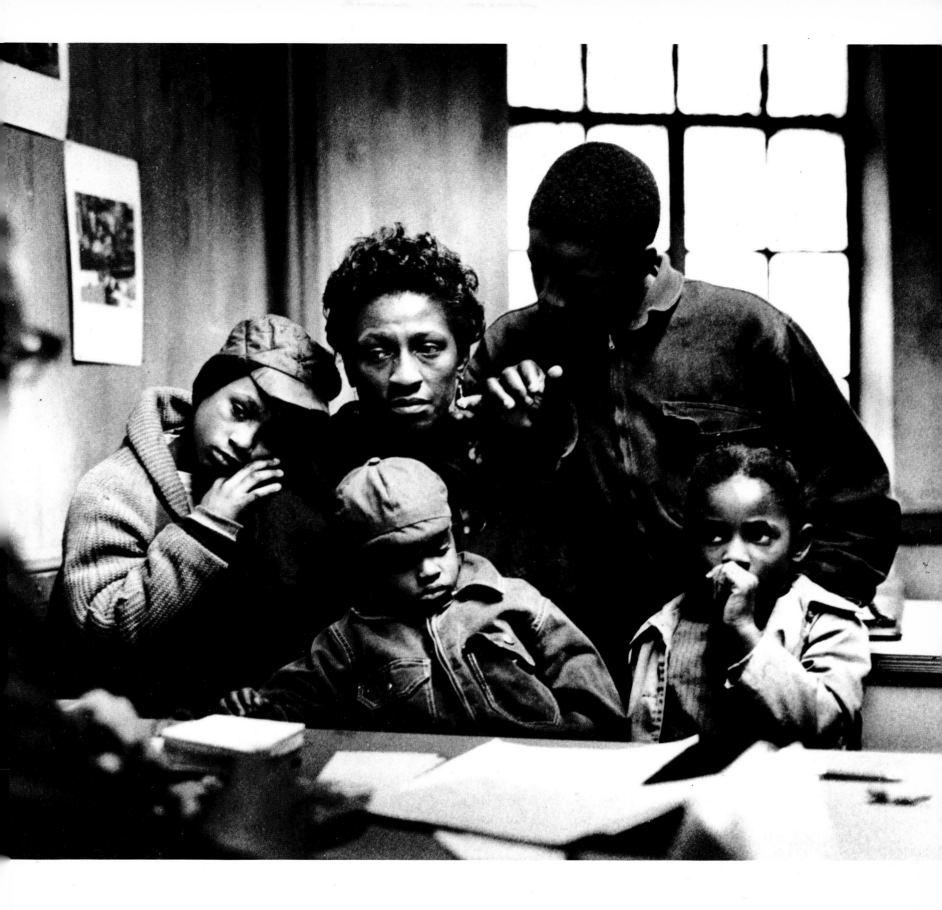

As I pinched penny and bread alike,
And awaited death without trial—

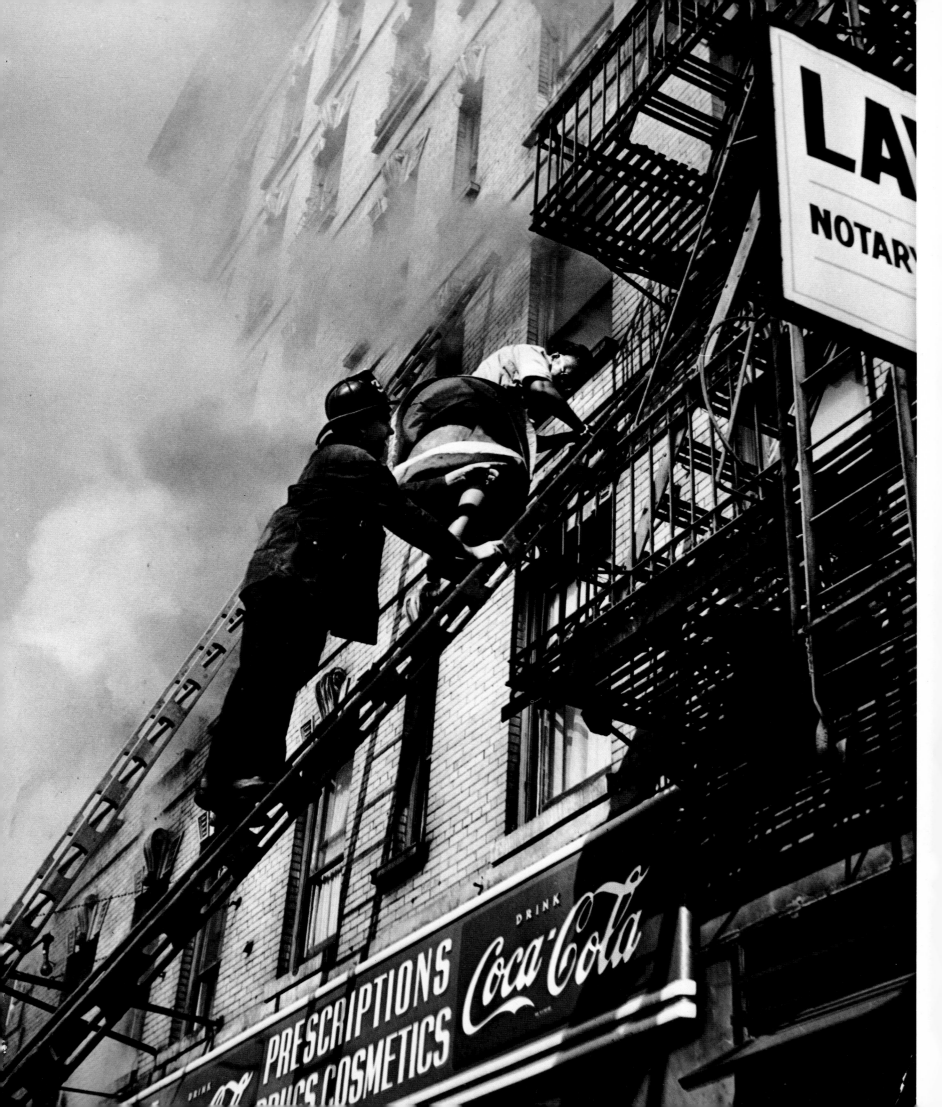

Smothered in violent summer smoke,
Frozen under the hawk of long winter.

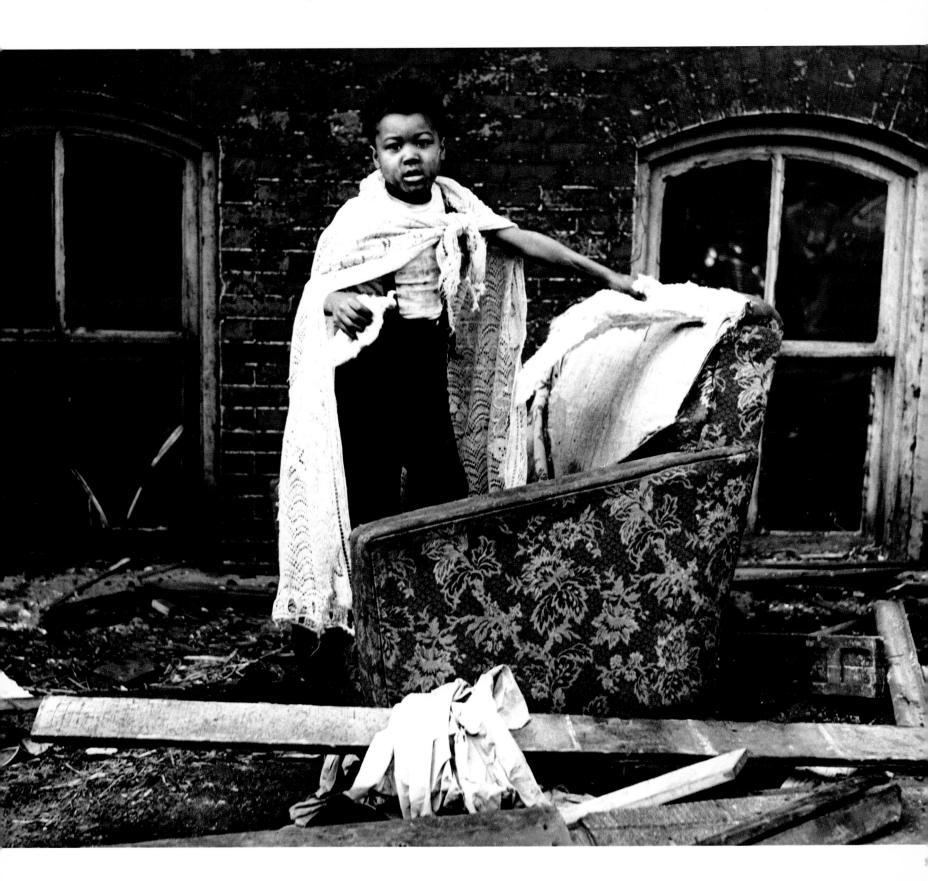

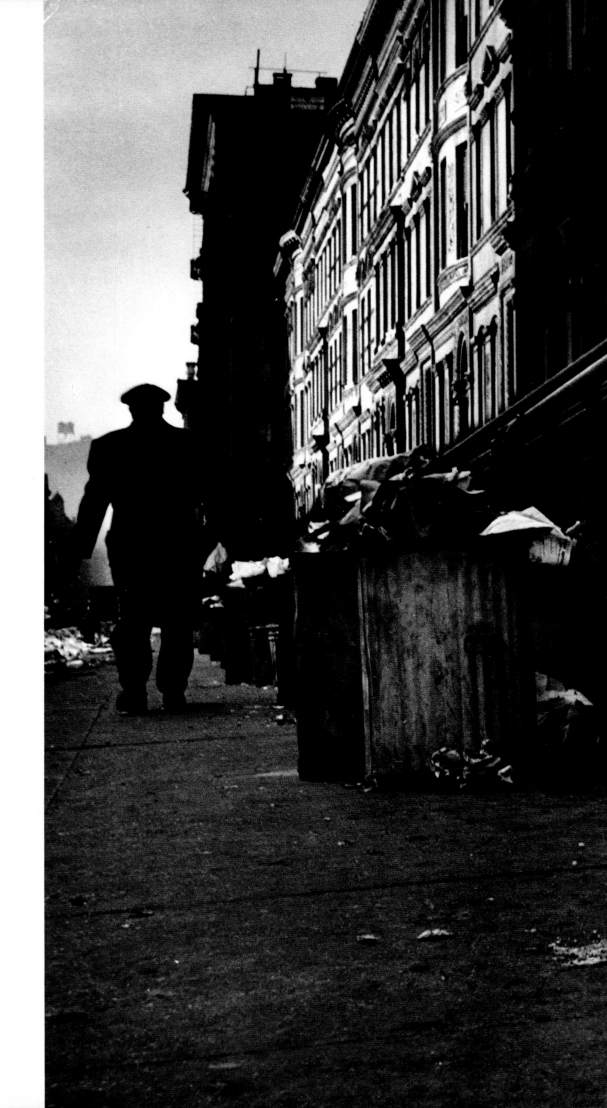

There in my marked-off area of life
I tended each day the garbage gardens,

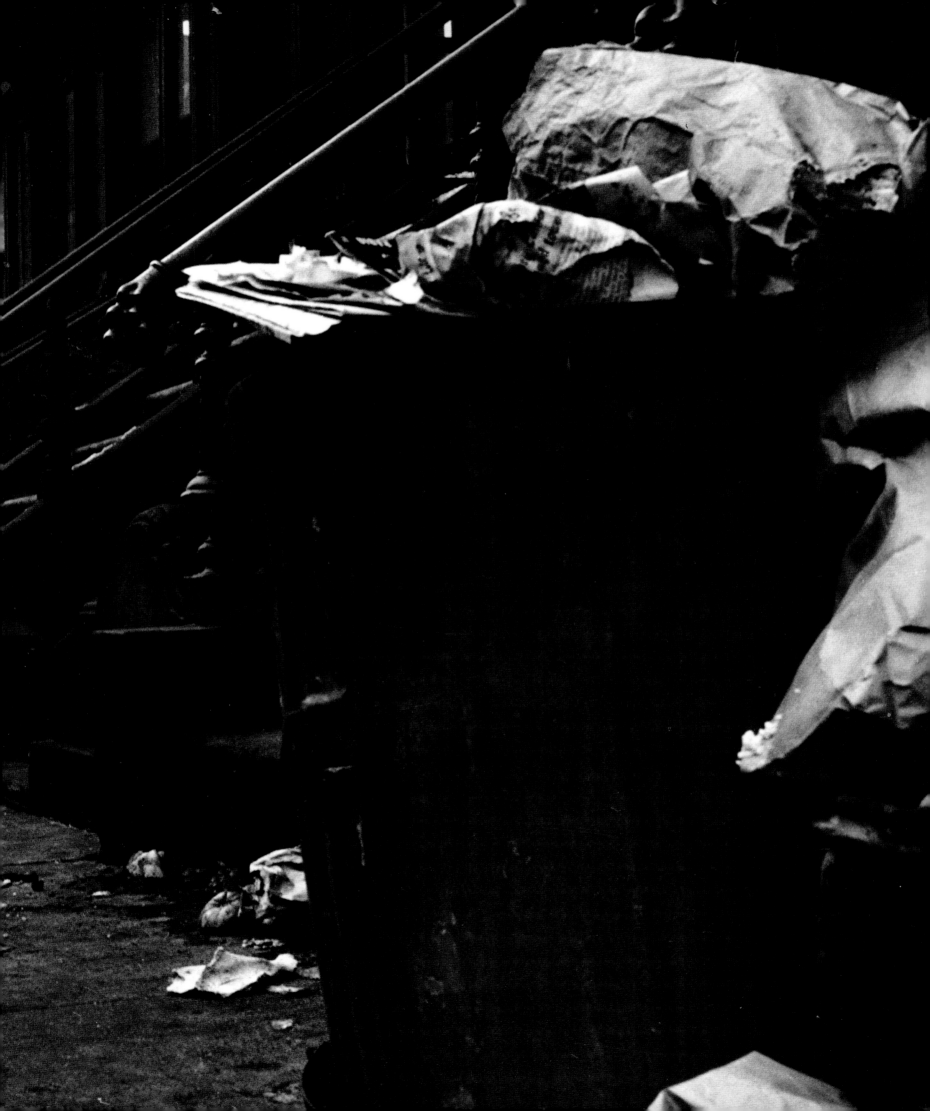

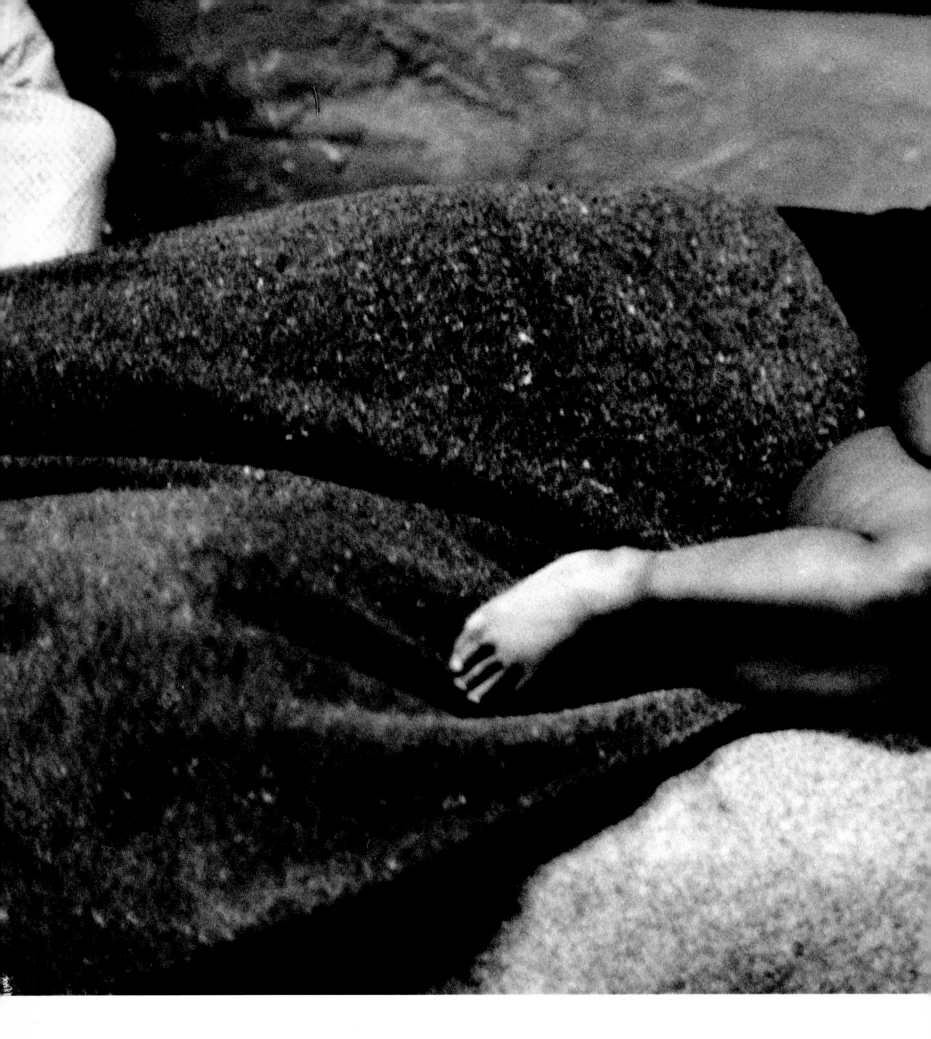

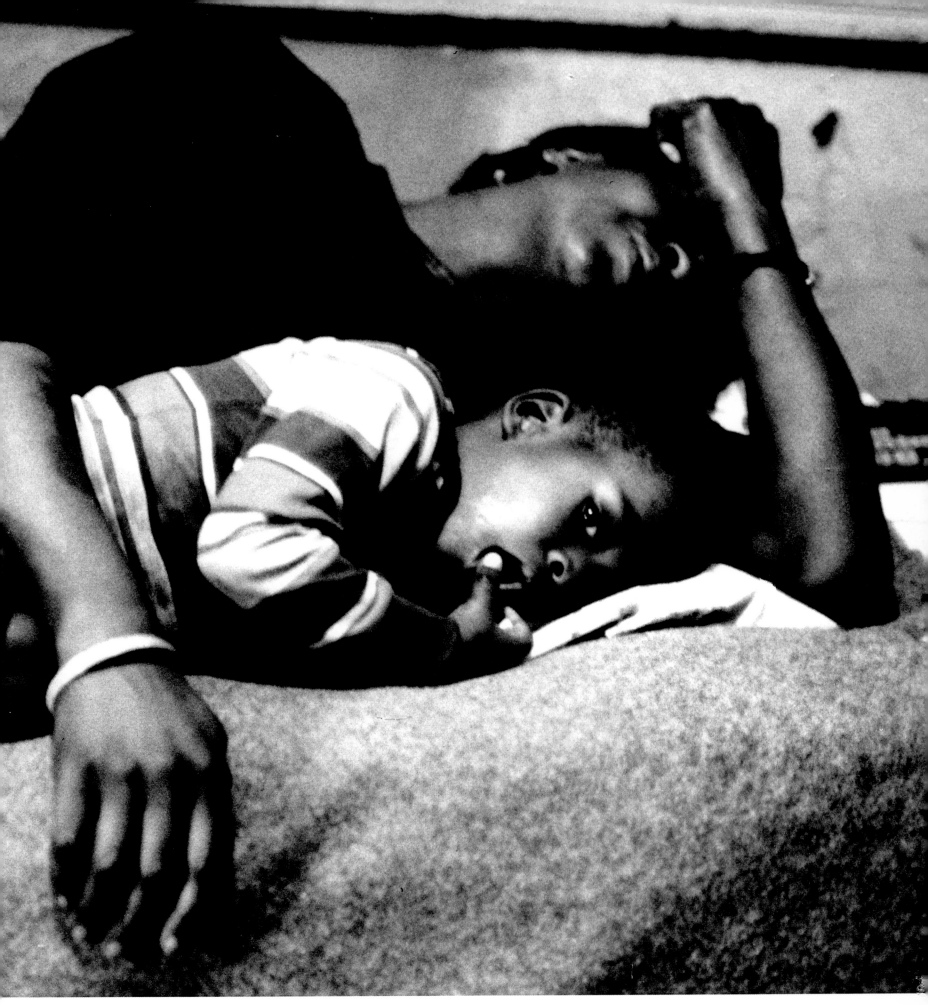

Then climbed to fatherless rooms,
My hopes compressed between mean streets
And rooftops where the death peddler waited.

The needle became my rainbow.
The needle fed my hungry arms
That needed and never stopped needing.

64

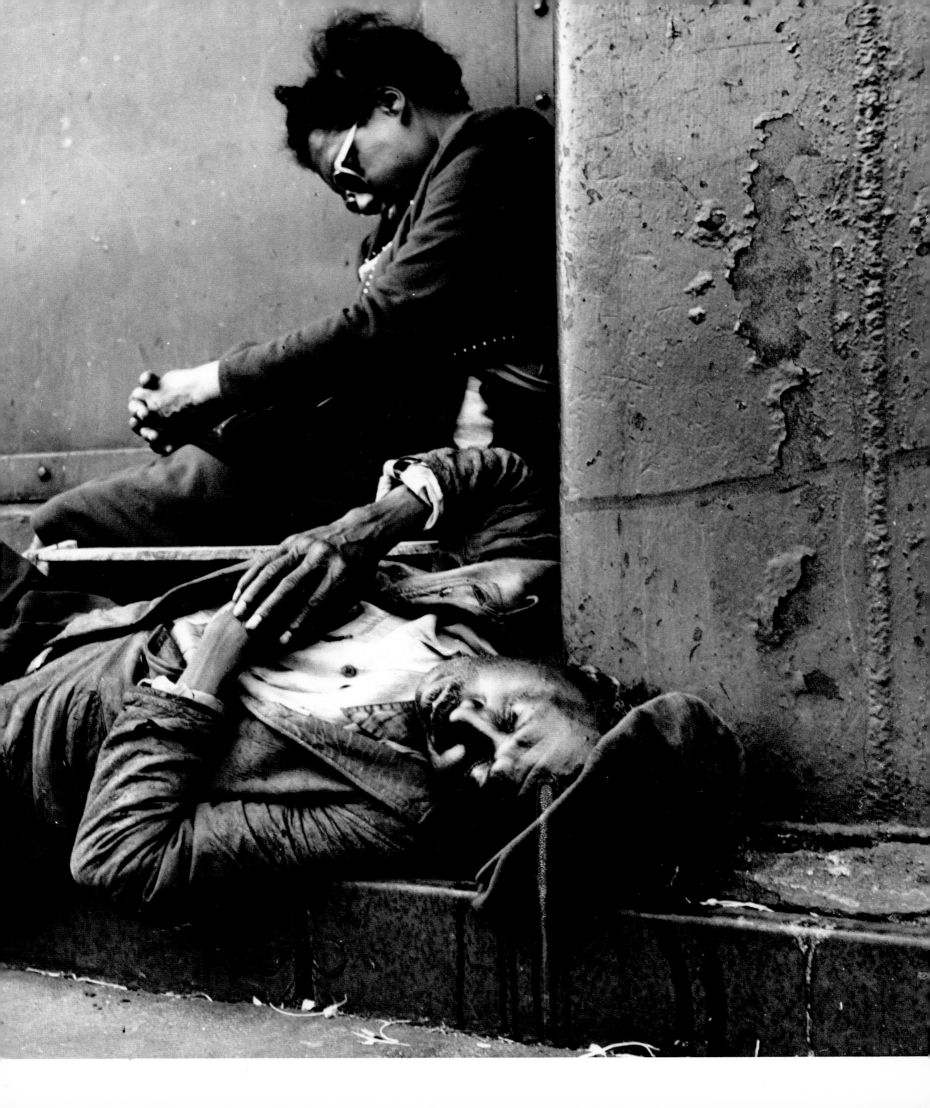

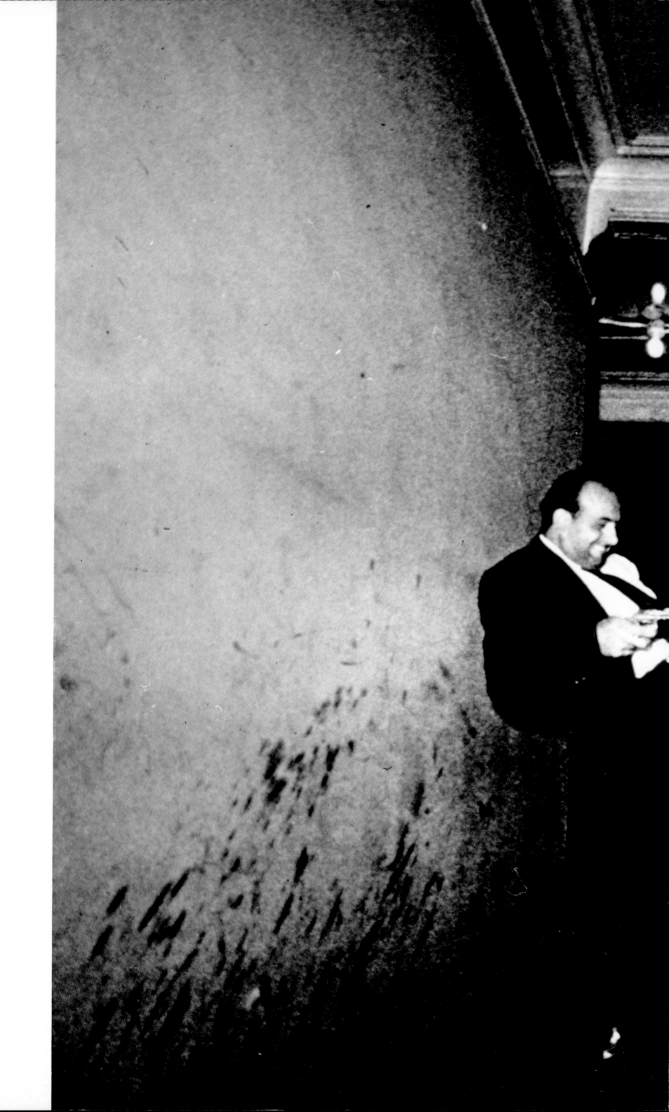

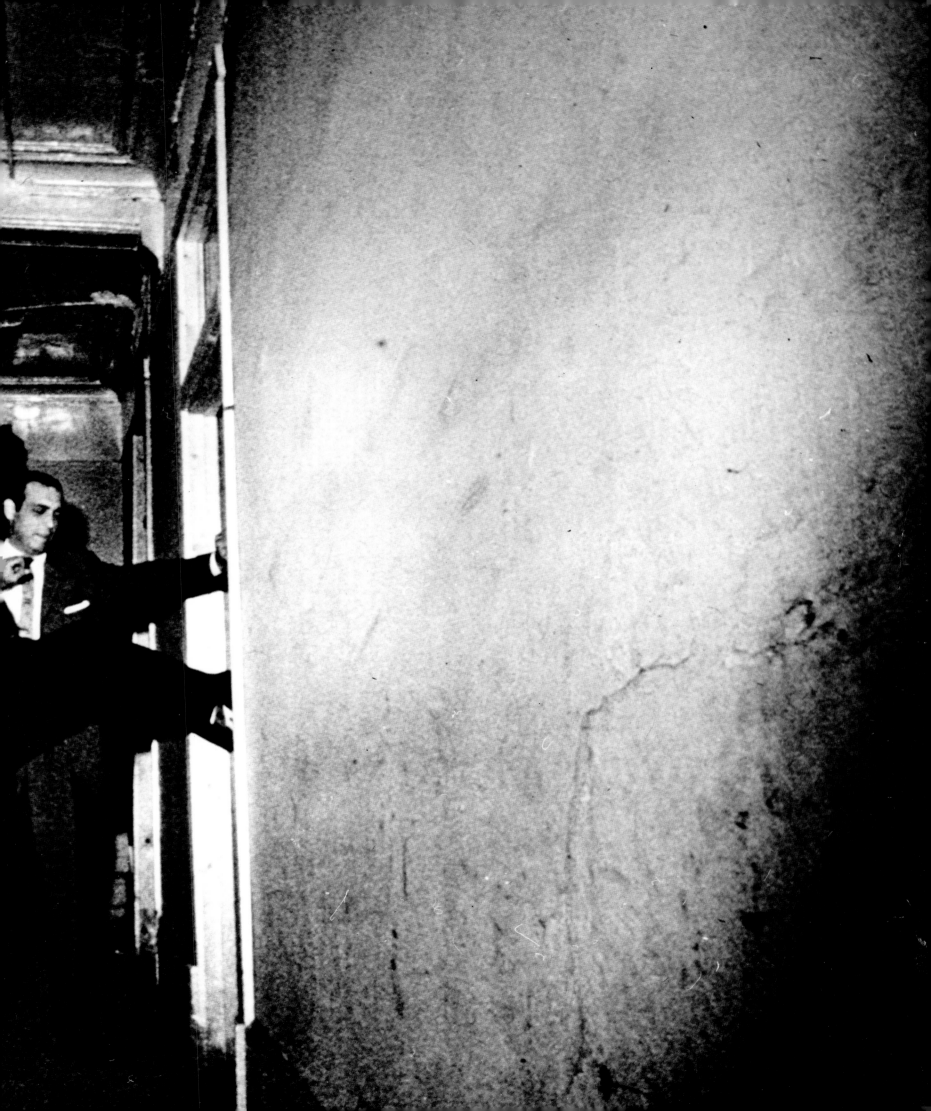

Knife and bullet formed my law
And plunged me into darker darkness. . . .

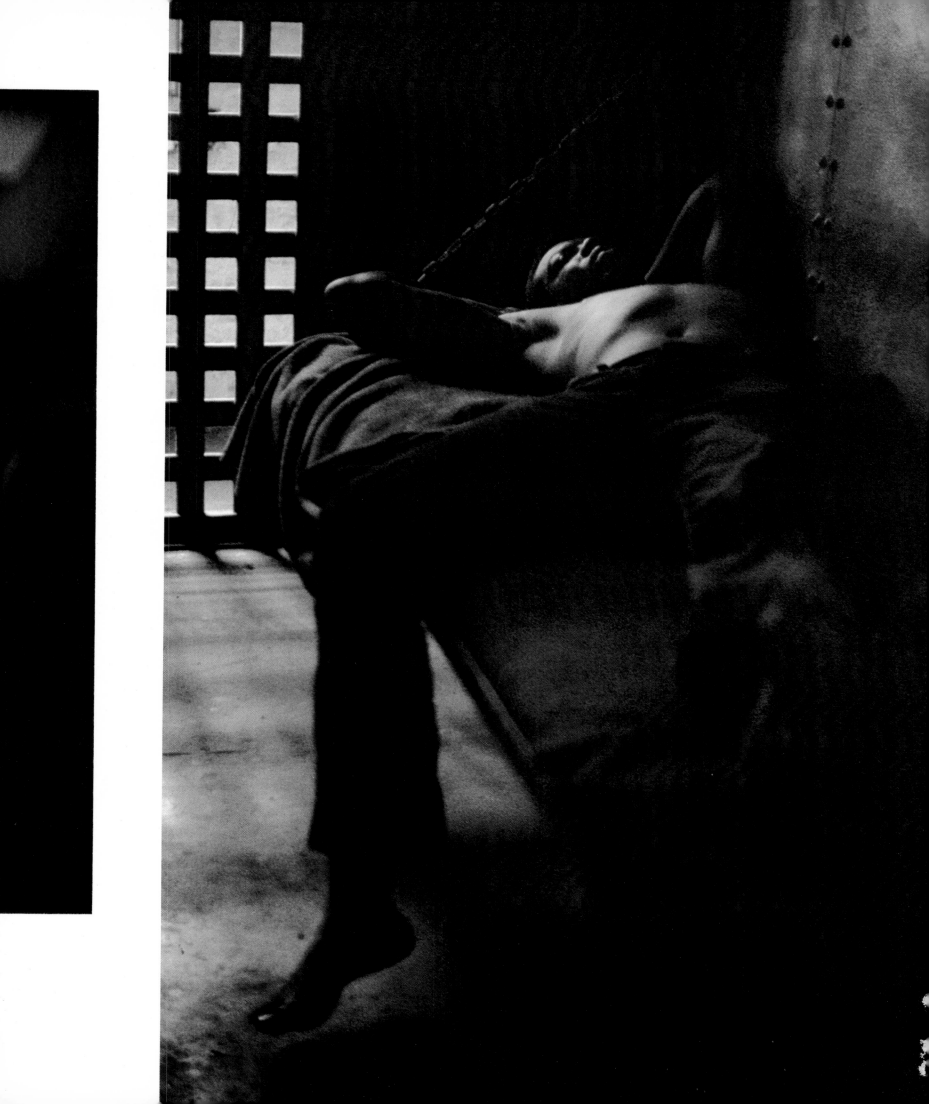

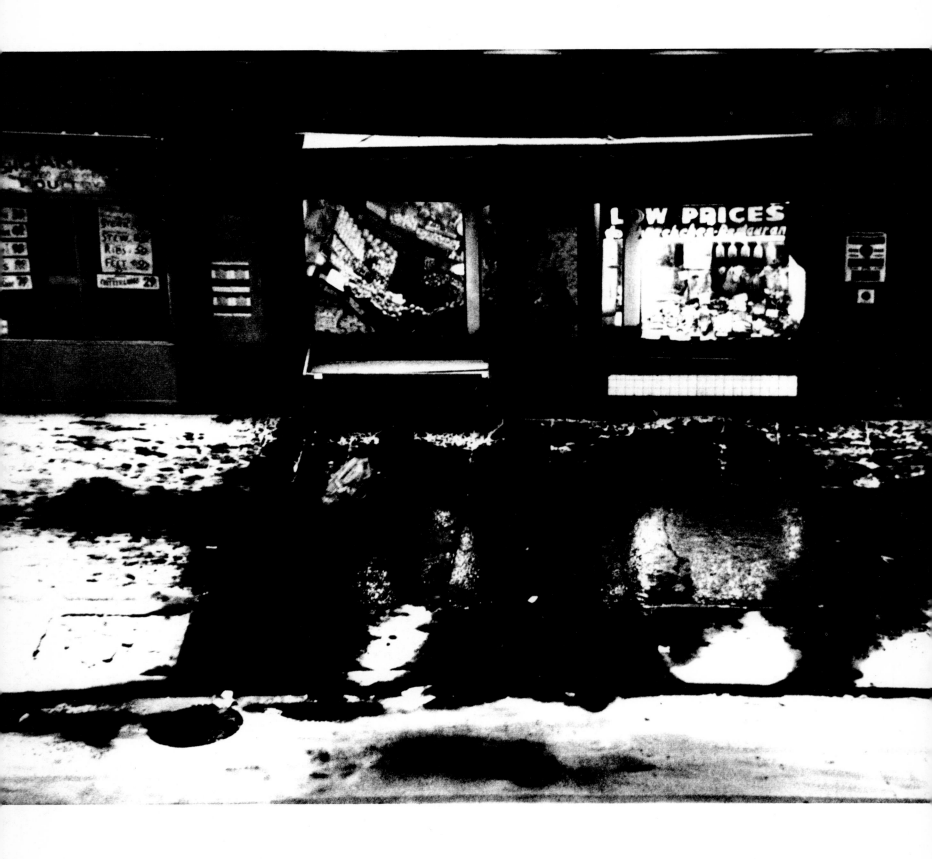

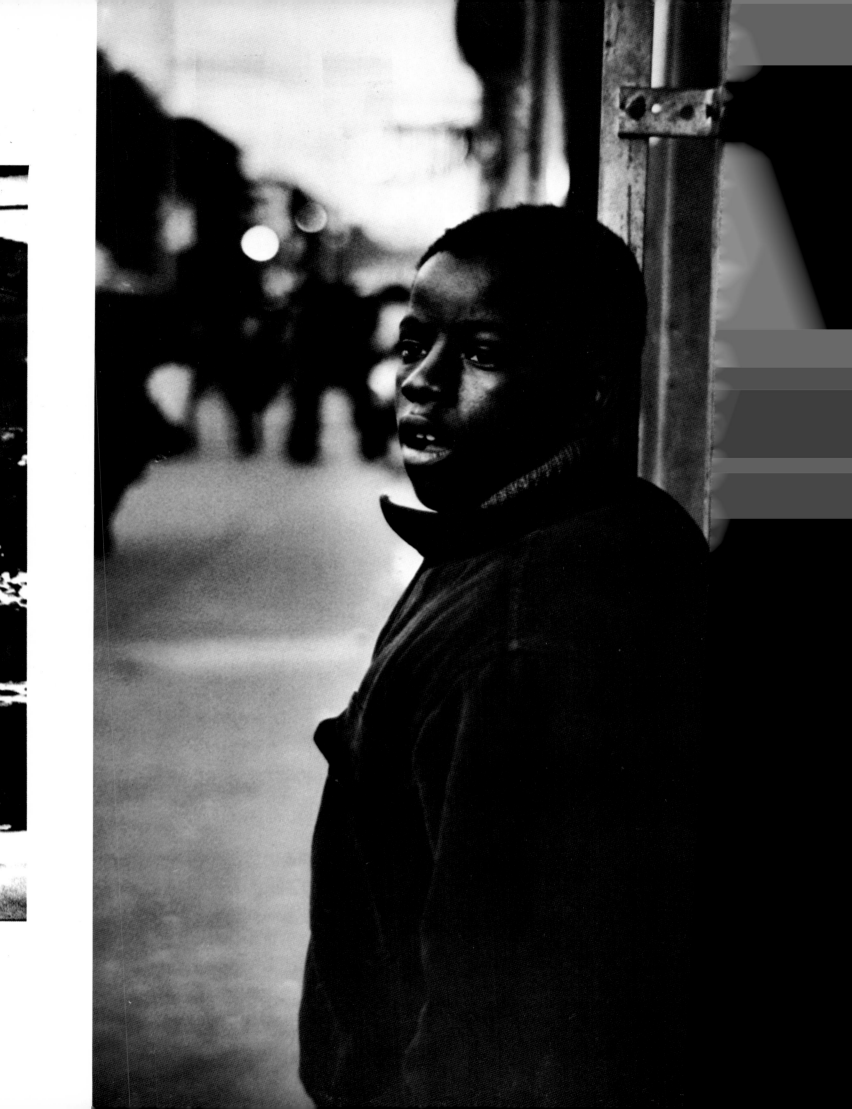

If I were an old man dying now,
I would tell of those who,
 like frightened horses,
Galloped away at dawn and dusk
To escape the poisonous pastures,
Taking with them my sun and moon,

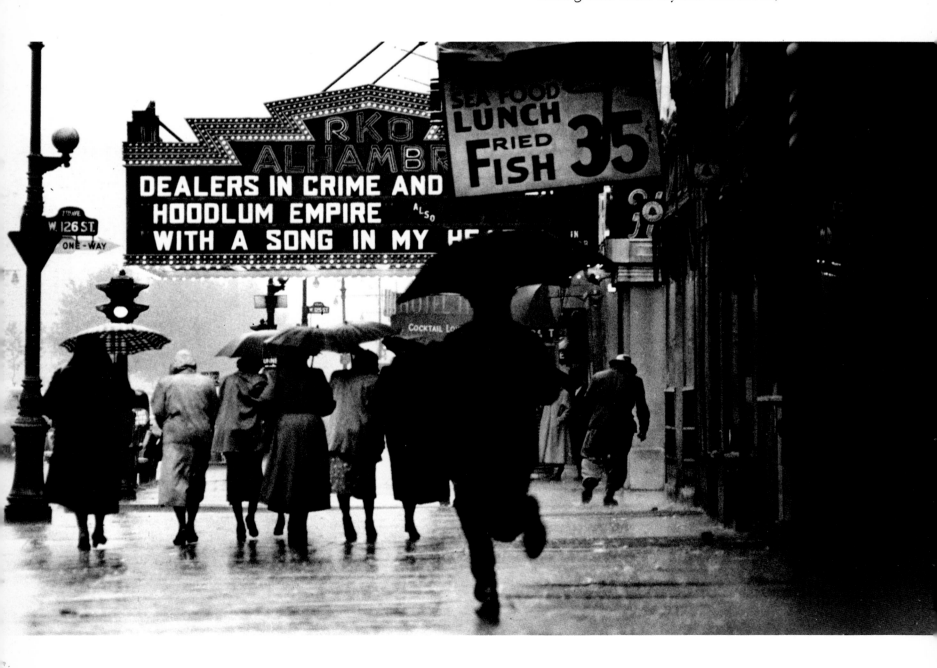

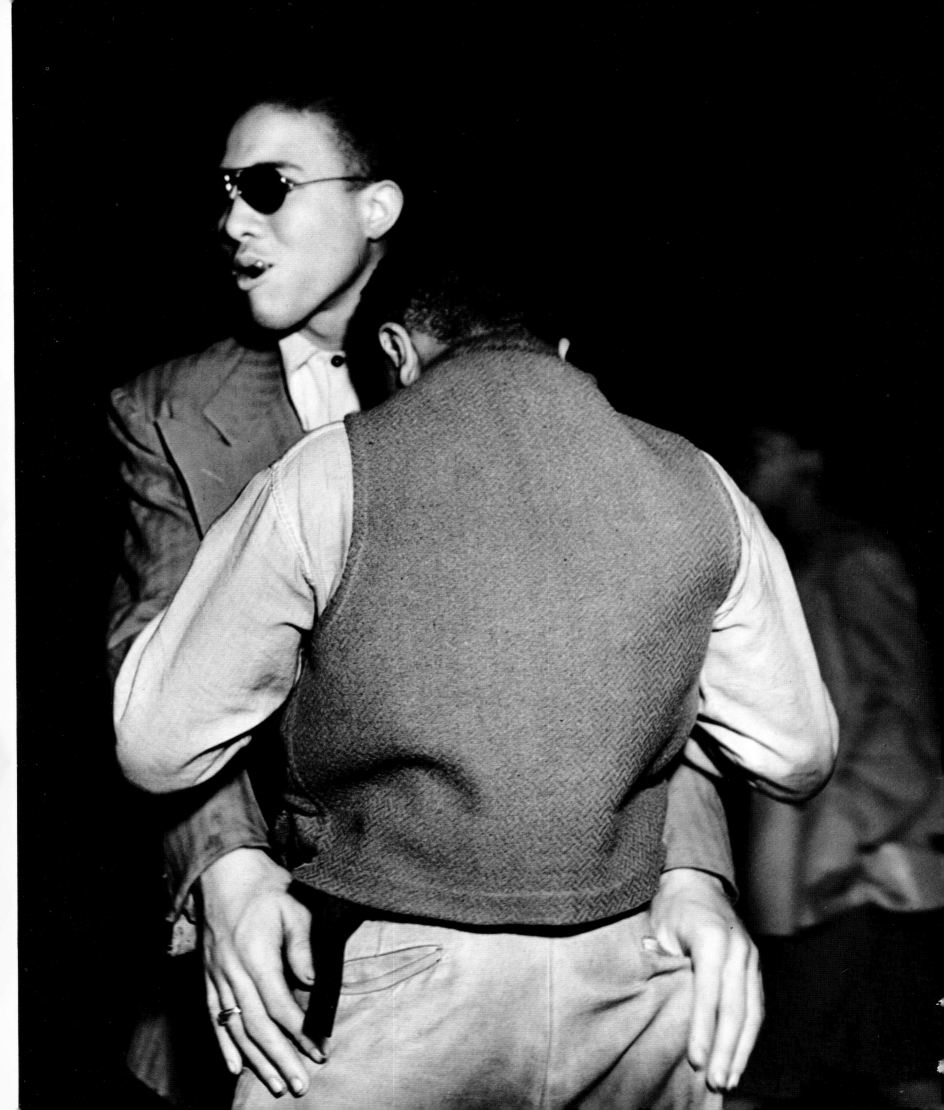

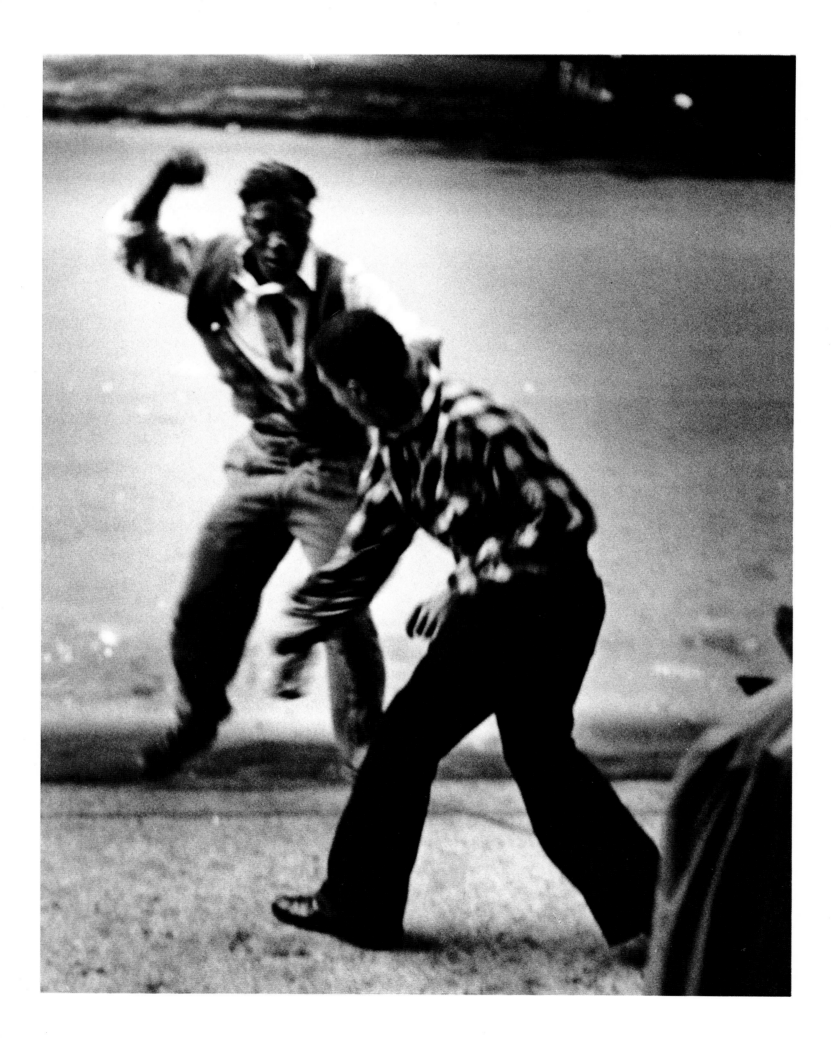

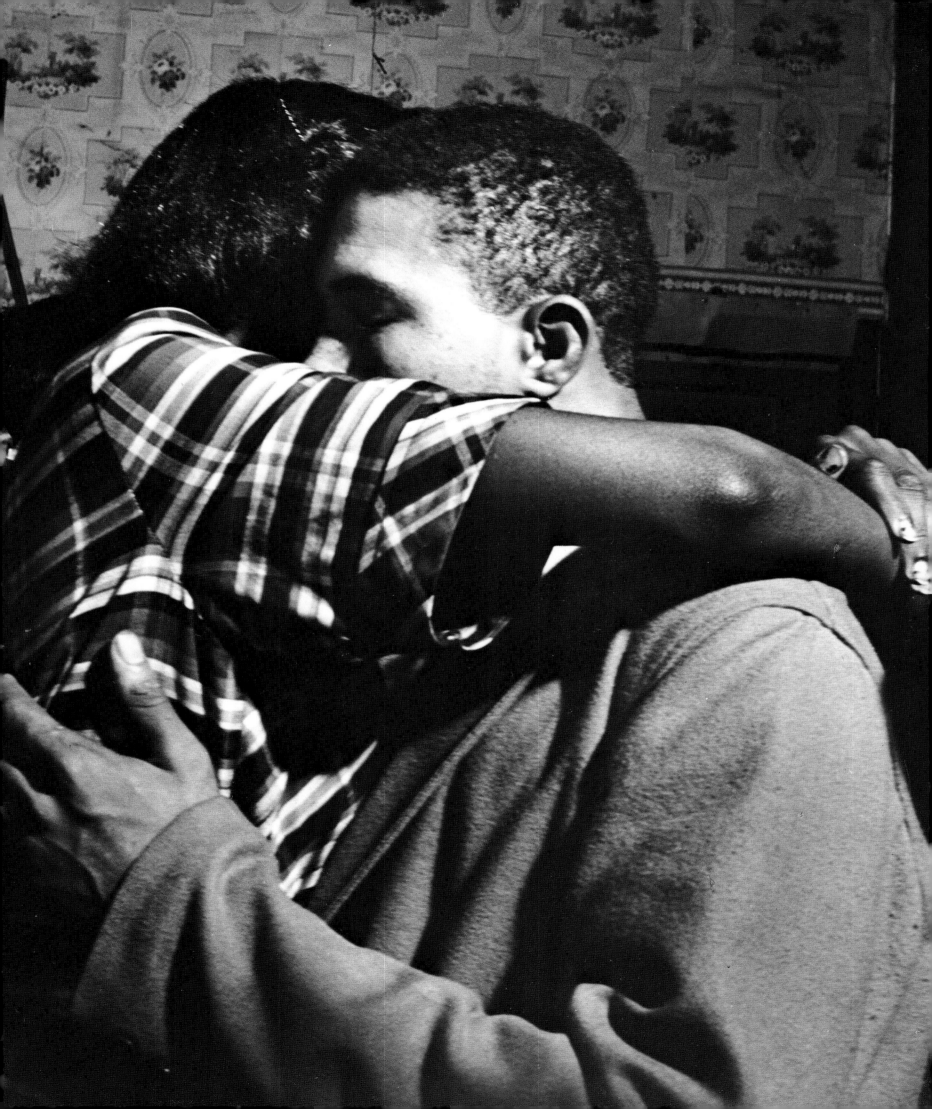

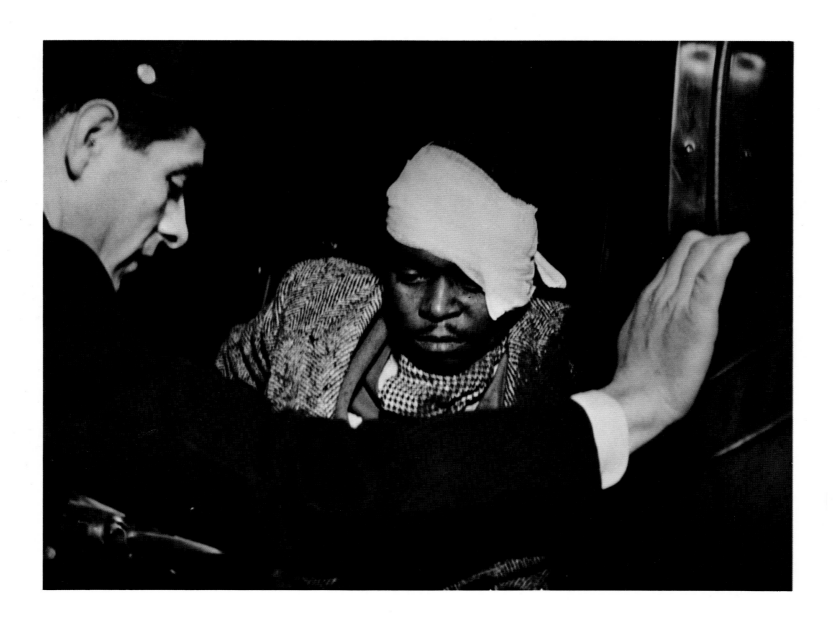

Leaving me to decay inside the blackness.
(Don't knock upon their doors tonight.
They are silent and inaccessible;
They have drawn their shades.)

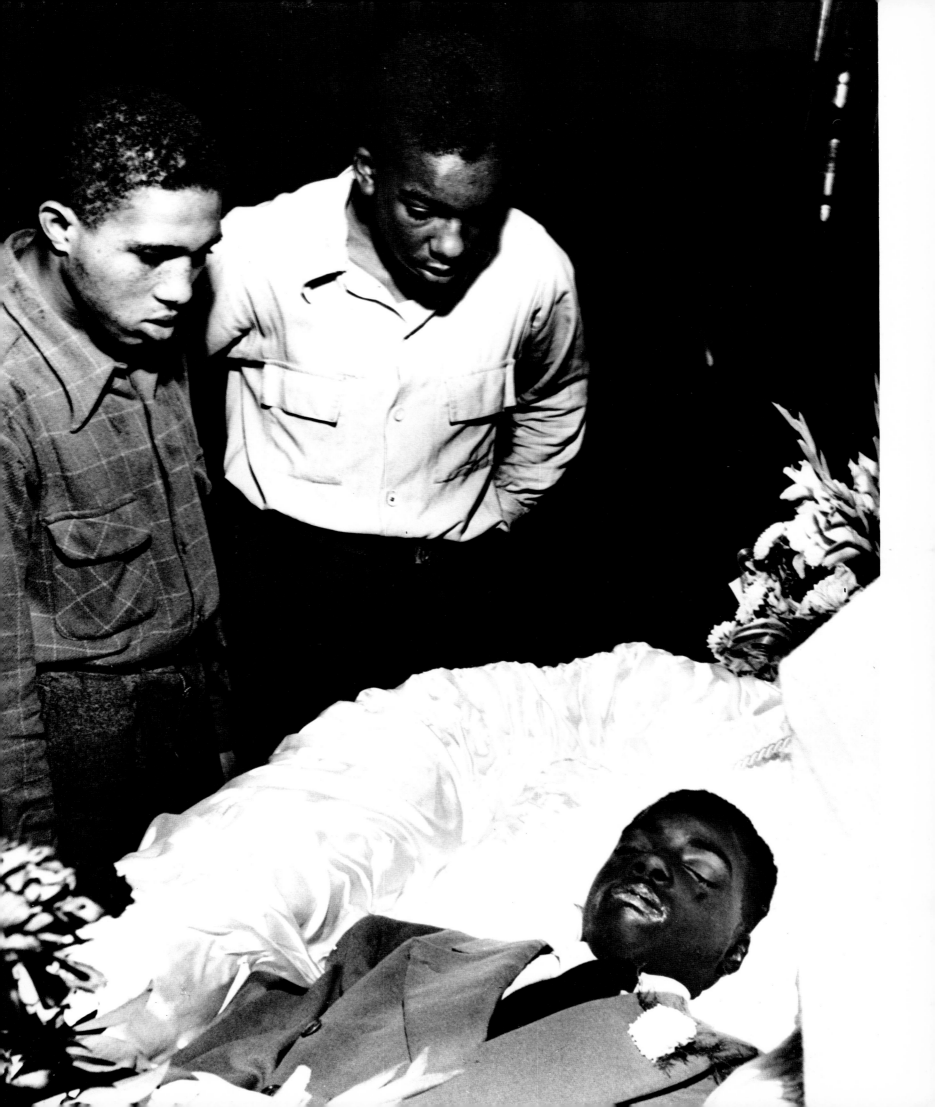

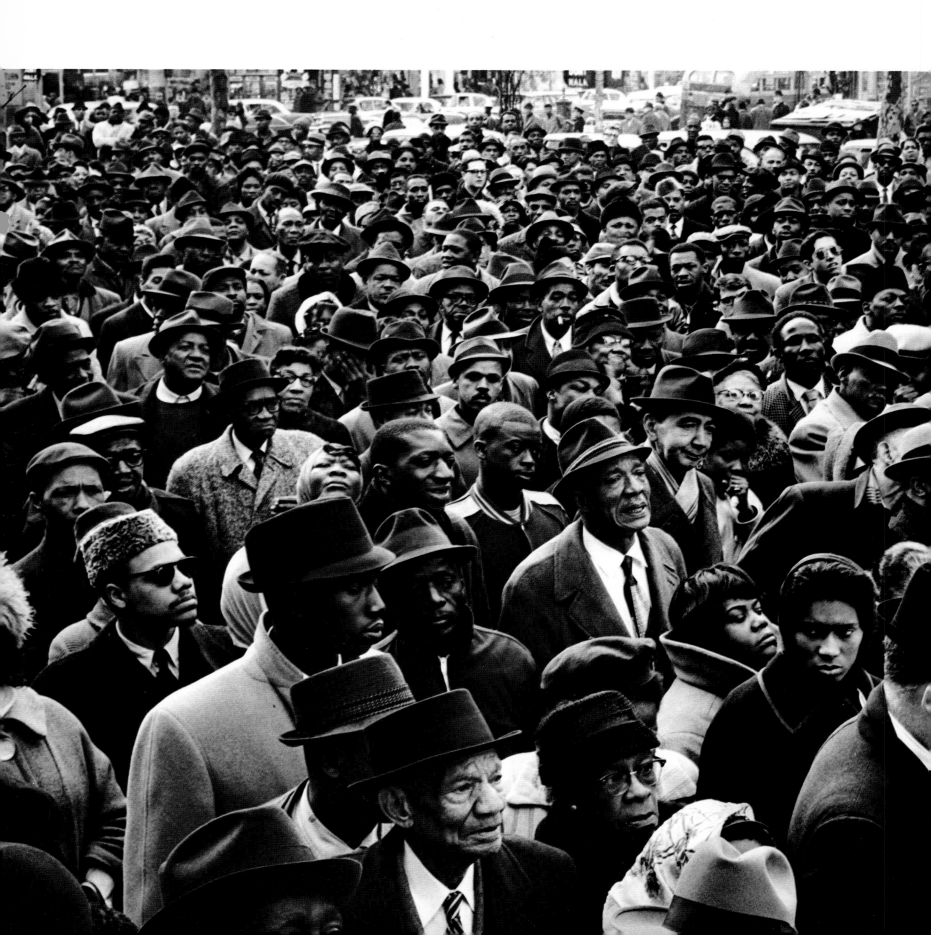

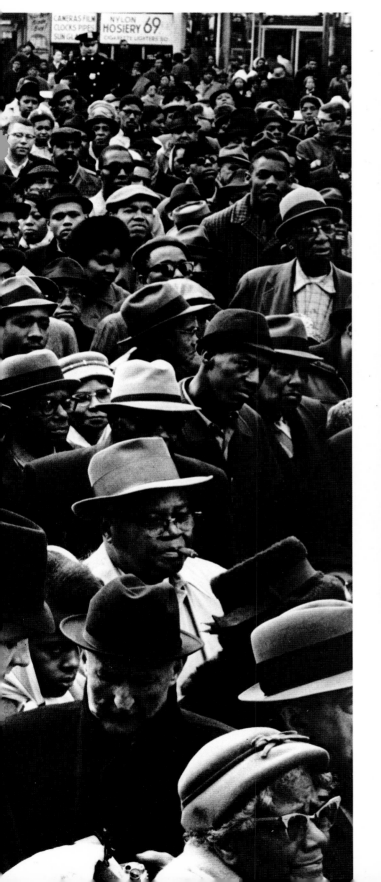

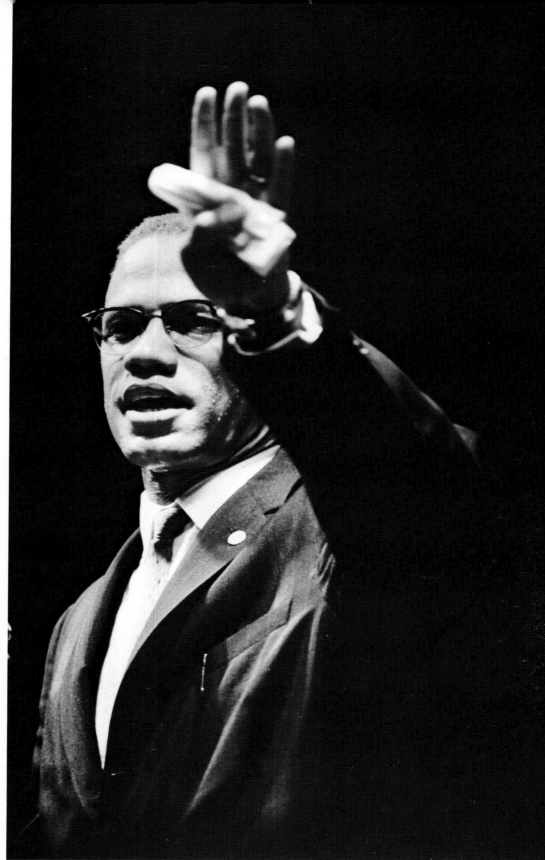

And I would recall the day
My beautiful dream was over,
Murdered and sealed in an oblong box,
Then hauled by mule to a Georgia grave,
And how, before the coffin lowered,
Other voices took up the clamor,
Shouting doctrines alien to my ear.
O Mao! O Marx! O Muhammad!

81

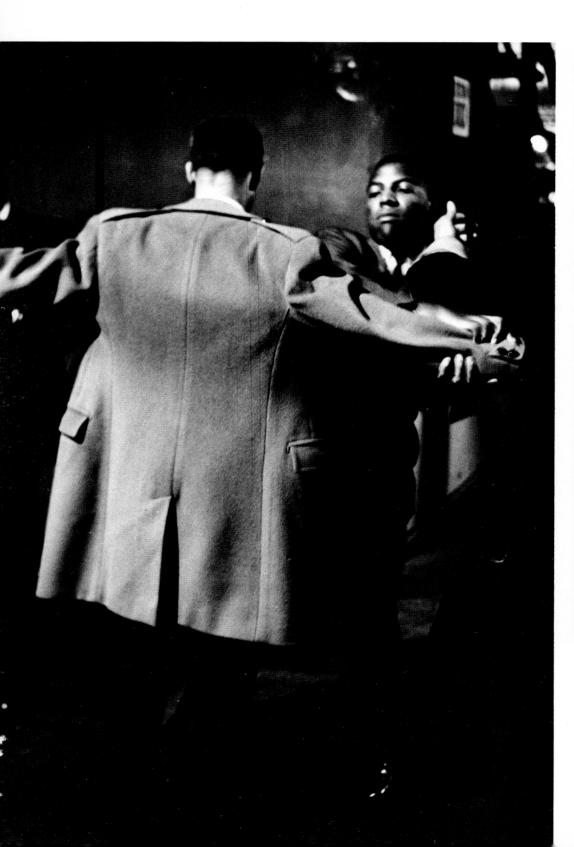

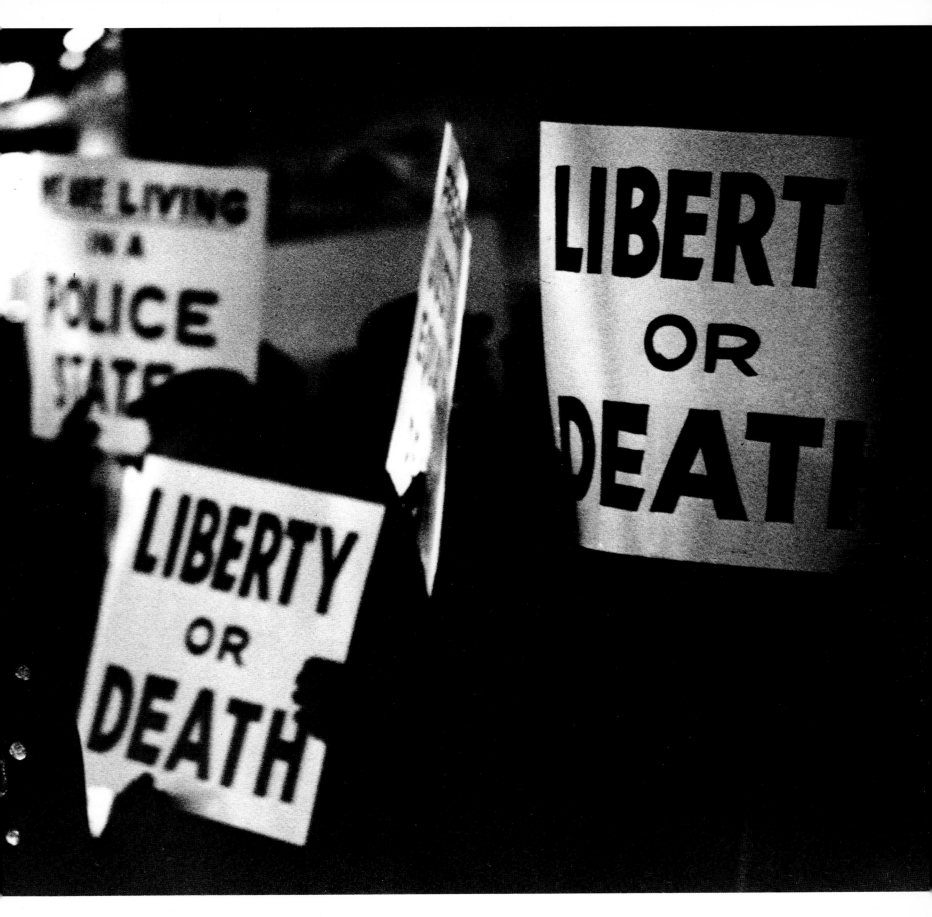

(But I had grown weary of words;
They had become hollow.
I no longer believed my songs;
They had betrayed my promise.
I distrusted banners flying above me;
They were rags dipped in my own blood.

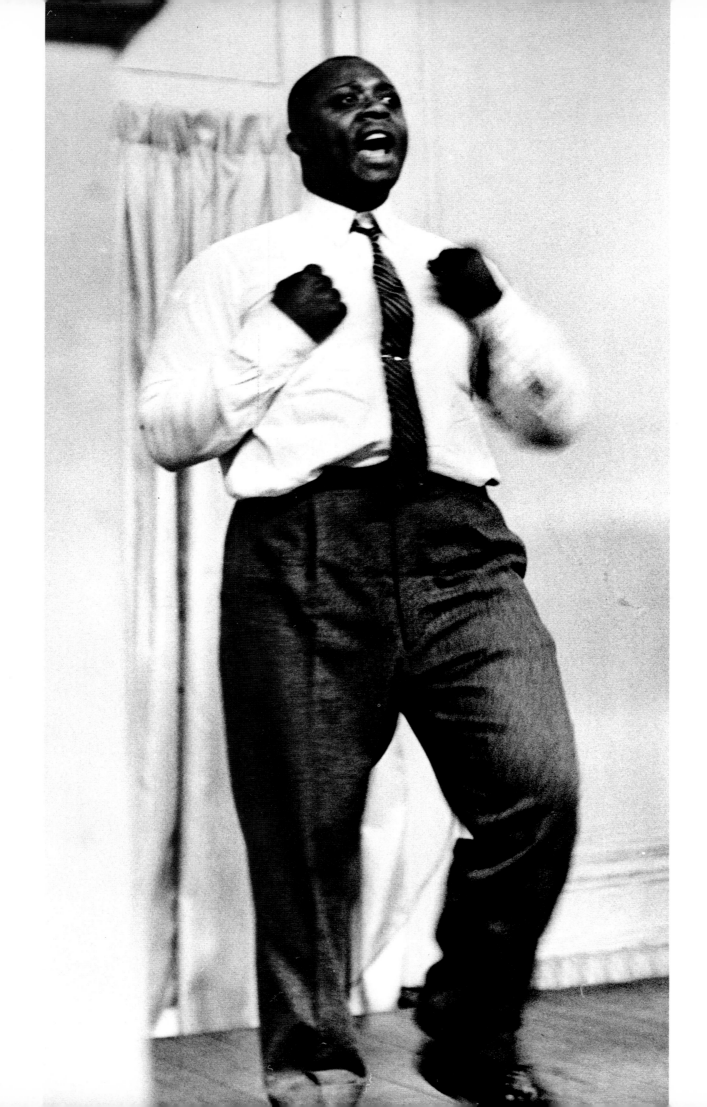

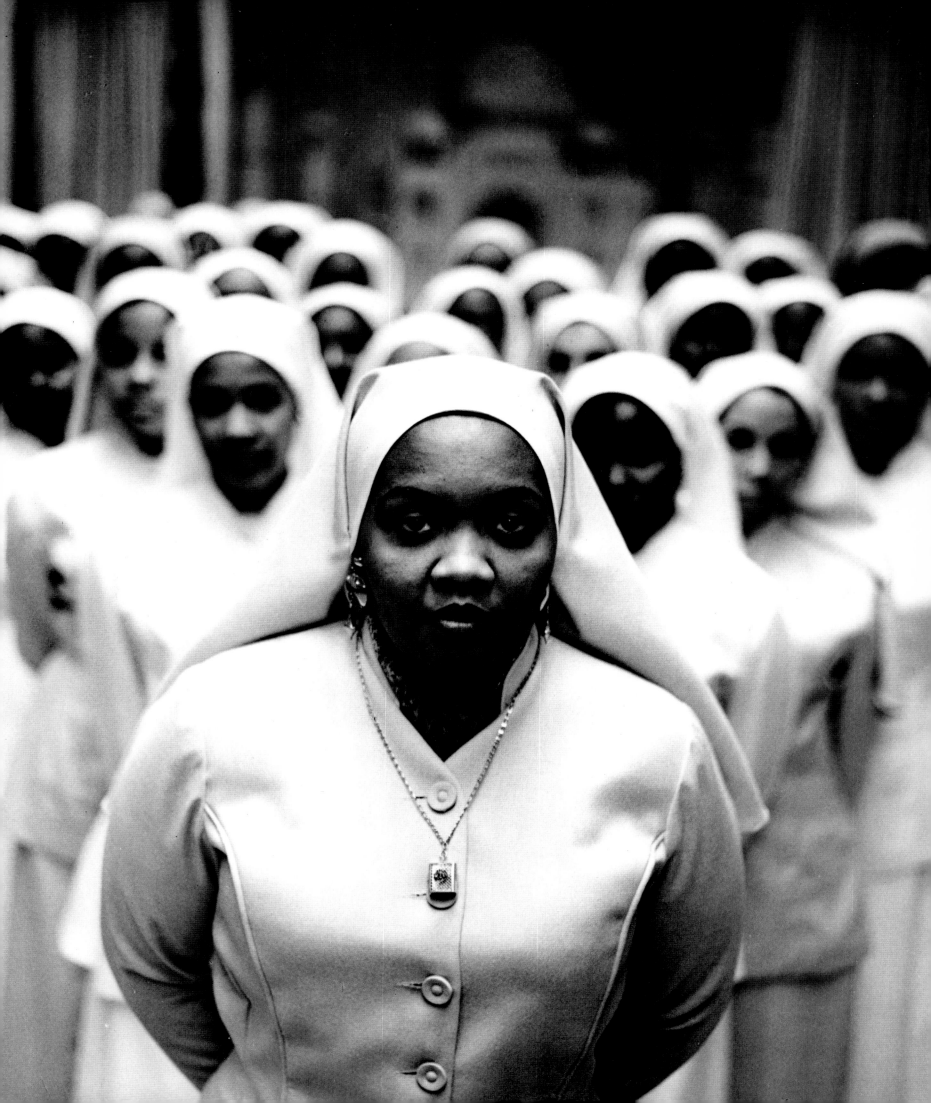

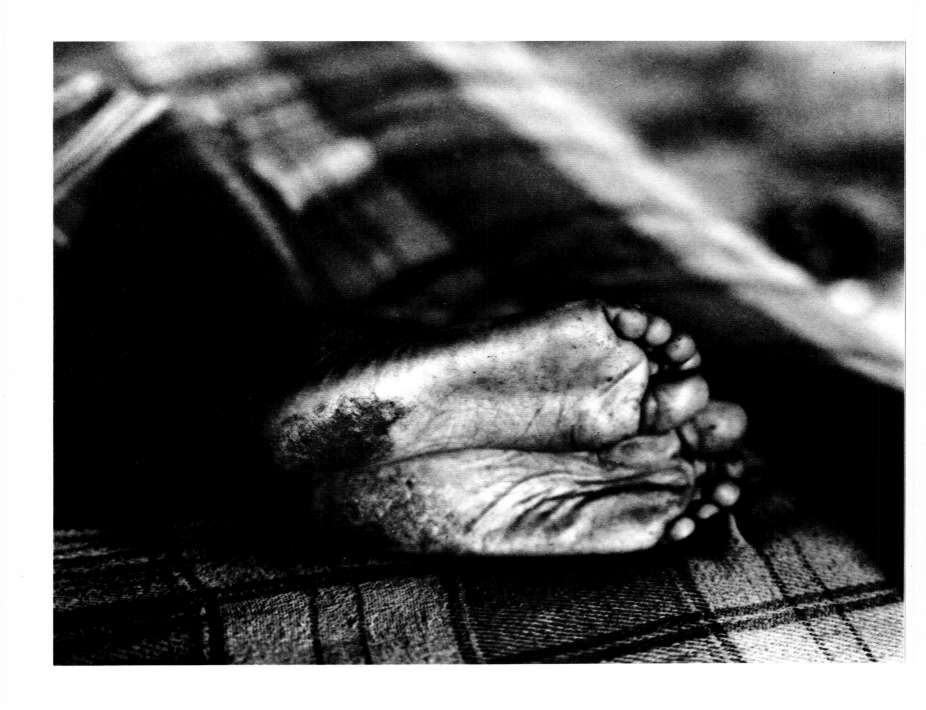

Jesus, the kindler of my hopes, was silent,
And the last of my patience drained away
At the bottom of a stubborn winter.
In the ominous stillness left,
All I could hear was death
Shivering through the noiseless wind.)

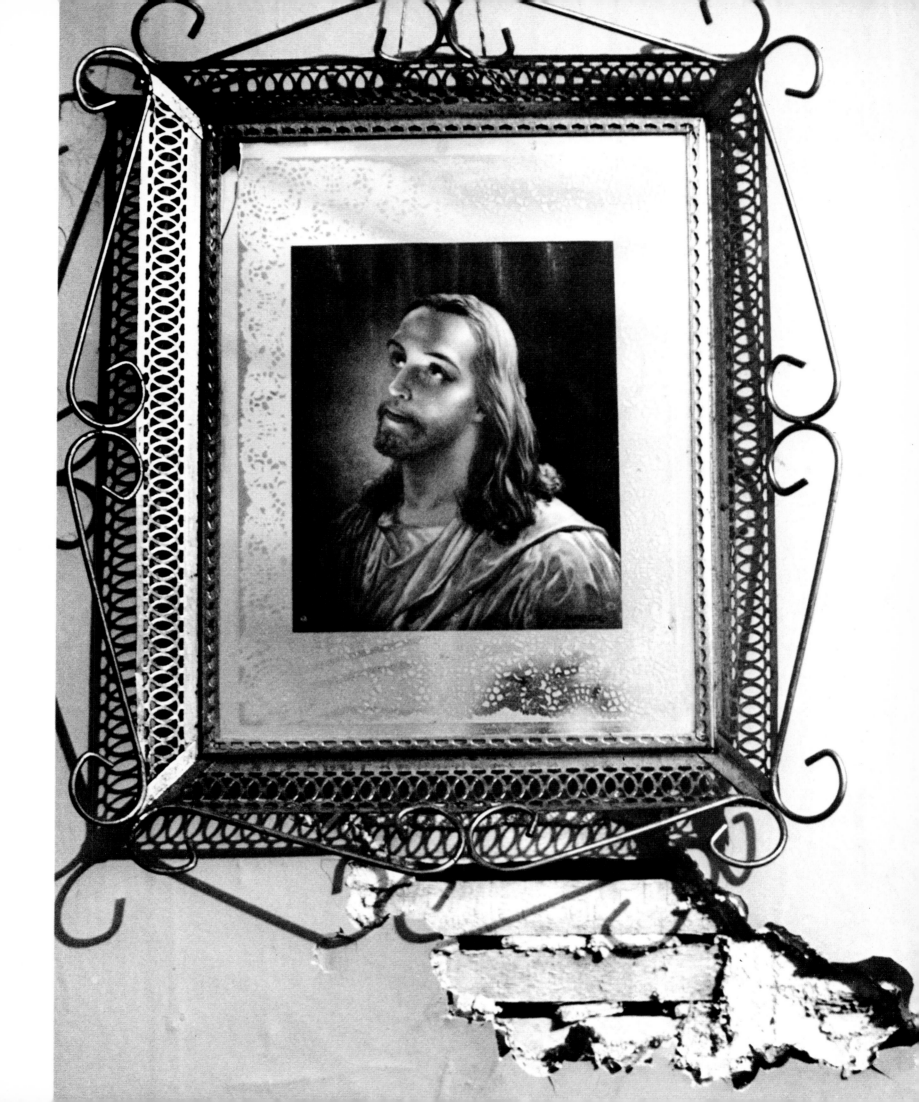

If I were an old man dying now,
I would not speak lightly of those perils
My sons may never have to suffer.
Too much was given in each encounter won
That they in their time escape such things,
Things to be remembered, repeated, and remembered,
Then passed on before the candle flamed out.
Where, at a point that I should stop
In time and space and be no more,
There should begin a brighter flame
 to burn
And mark the place where mine had ended.
Then the last flicker of me
Could endure the approaching darkness.

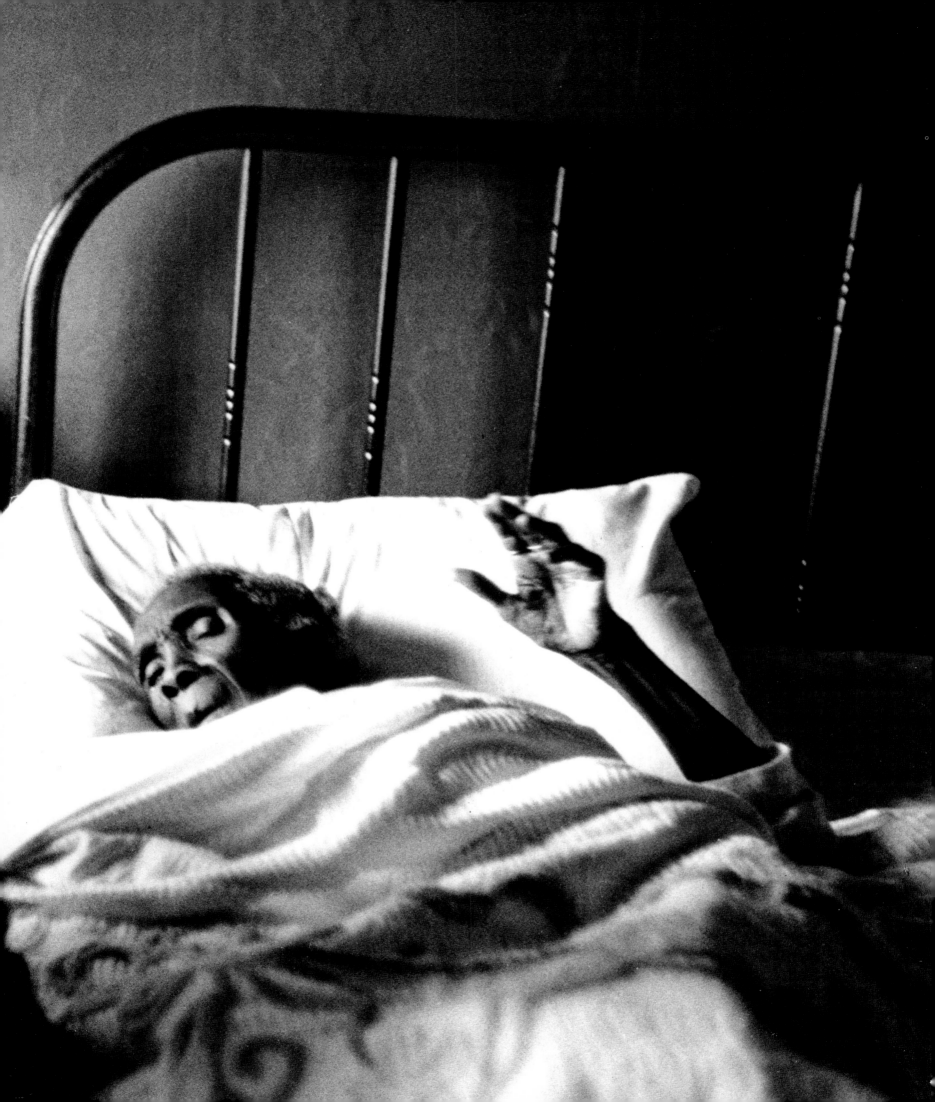

I SPEAK OF A HERO

I speak of a hero
with
Anger in his heart,

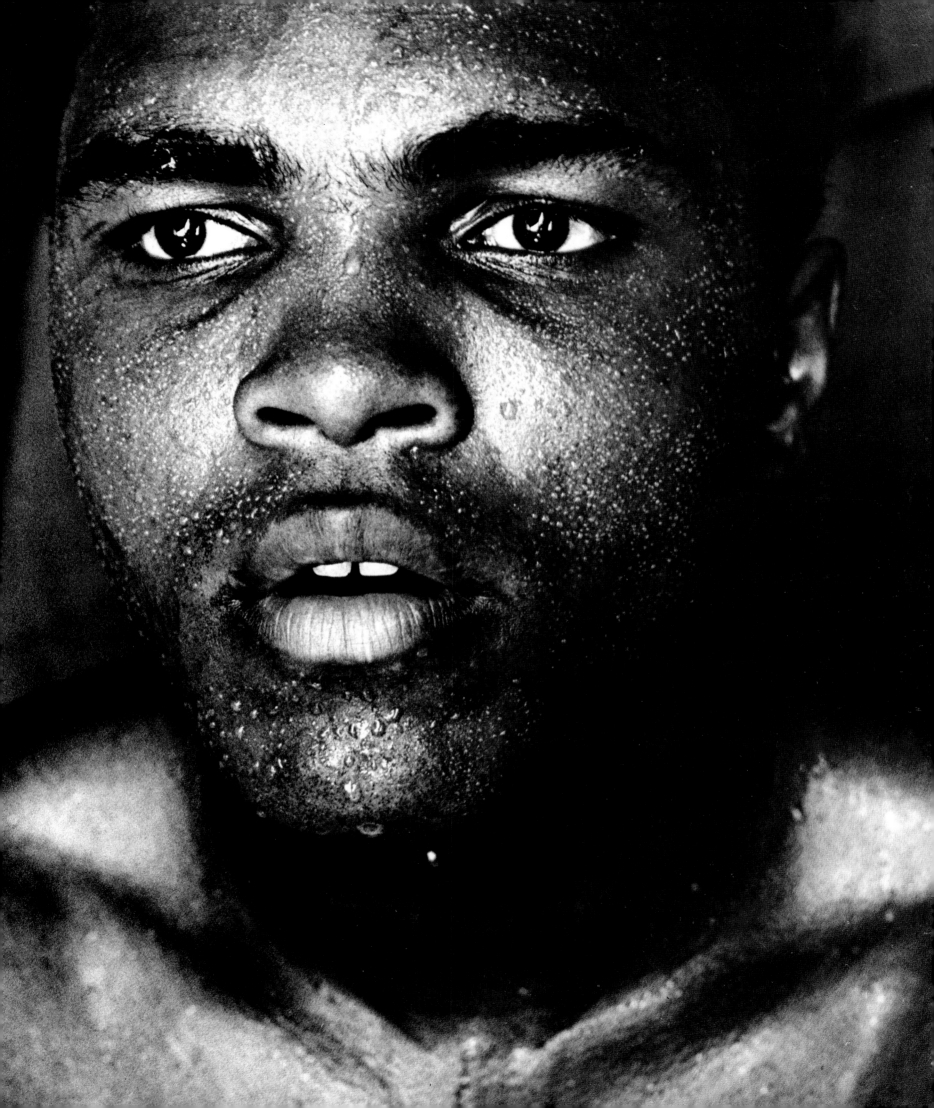

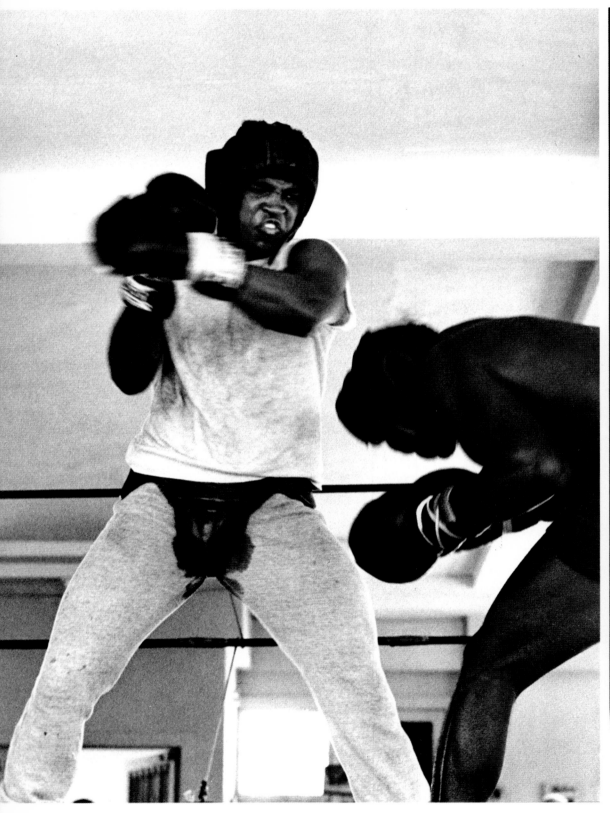

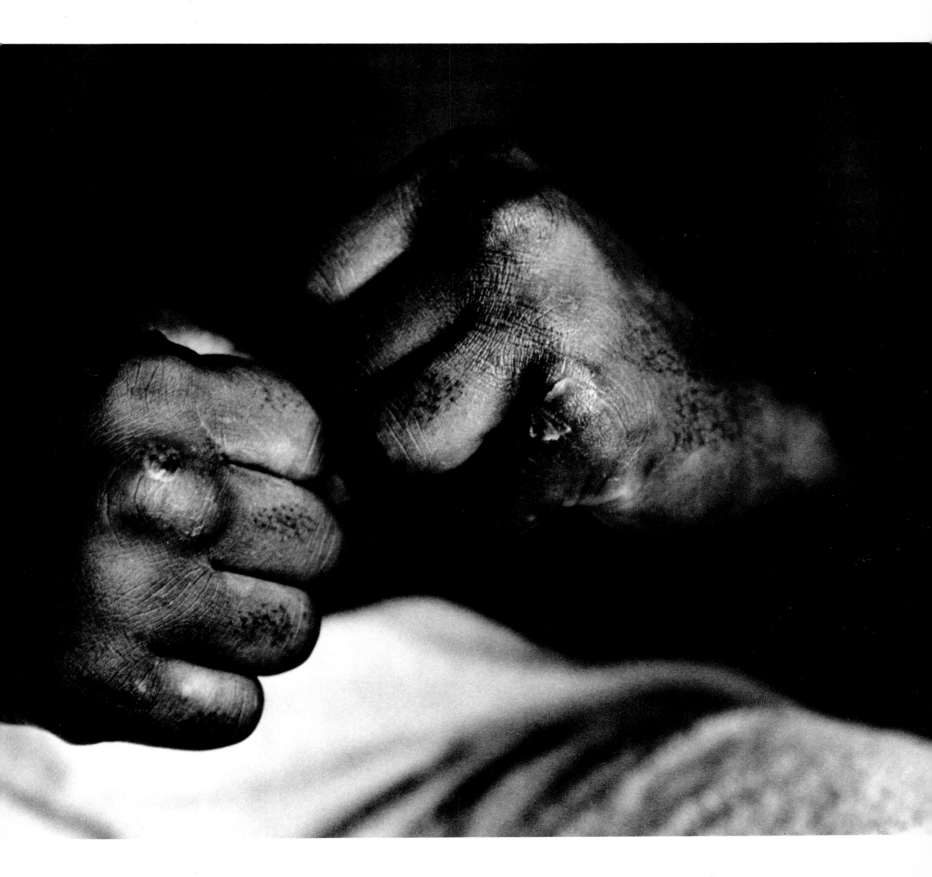

with
Fury in his fist,

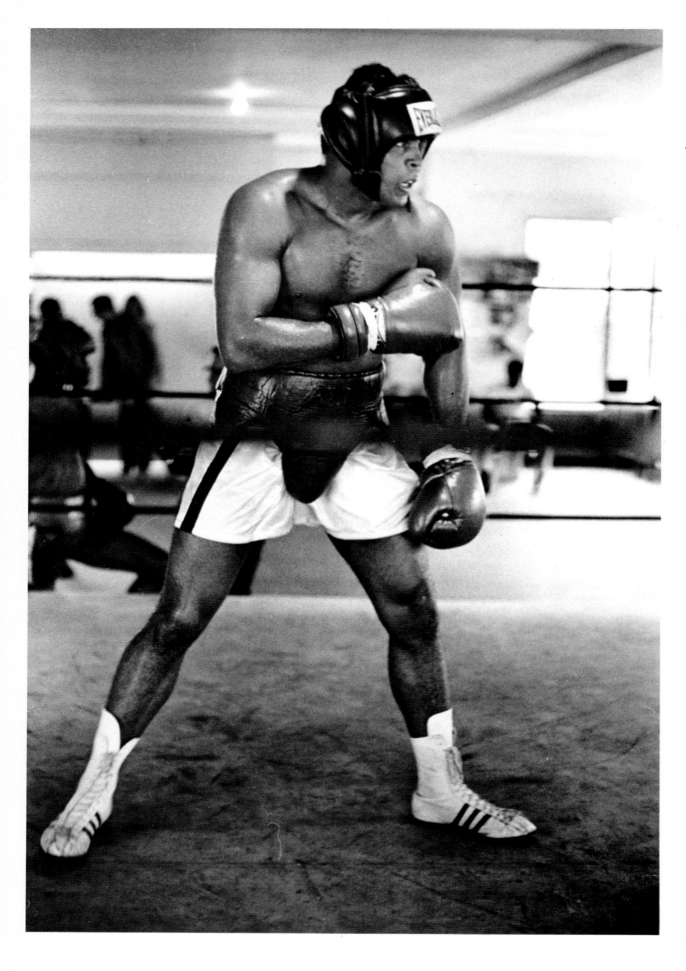

And terror in his sleep.

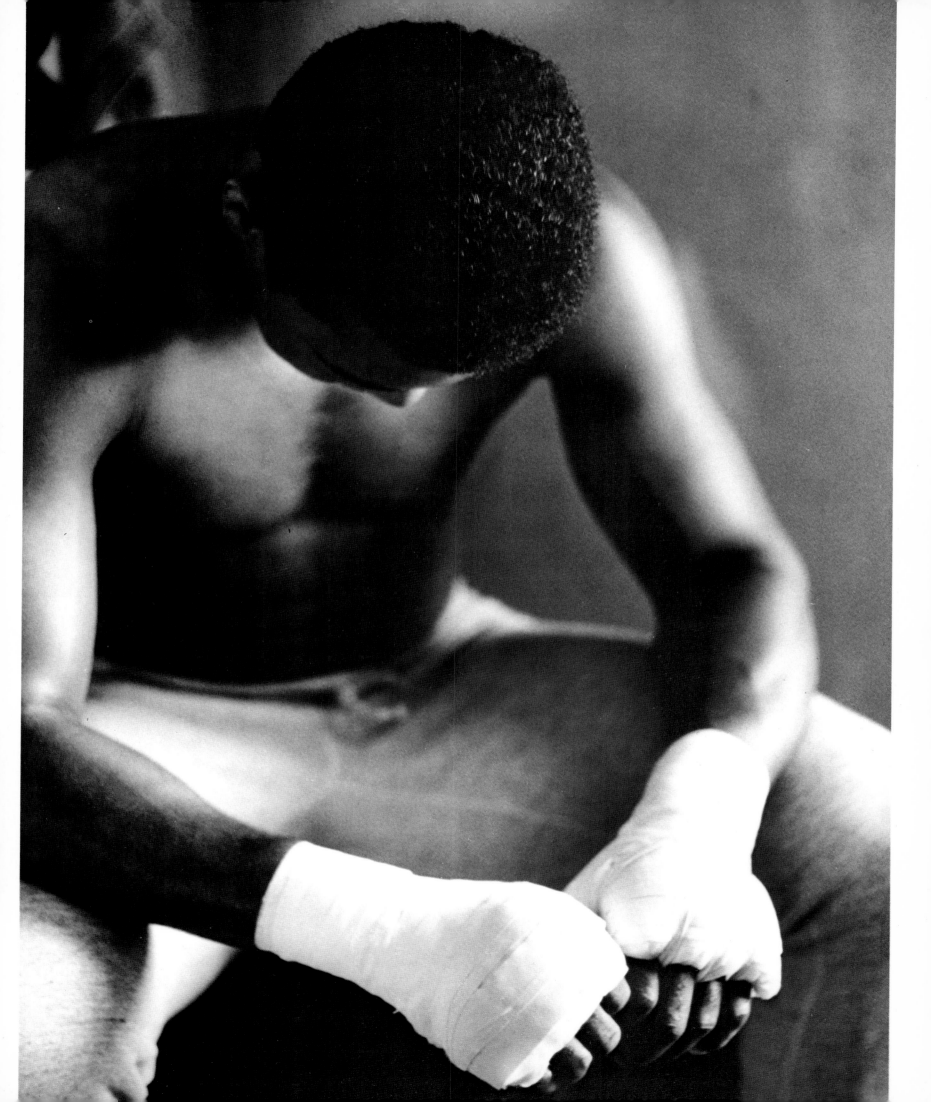

Who Muhammad Ali is
 is what he is
And that is,

 As he would say,
 Exactly the way it is.

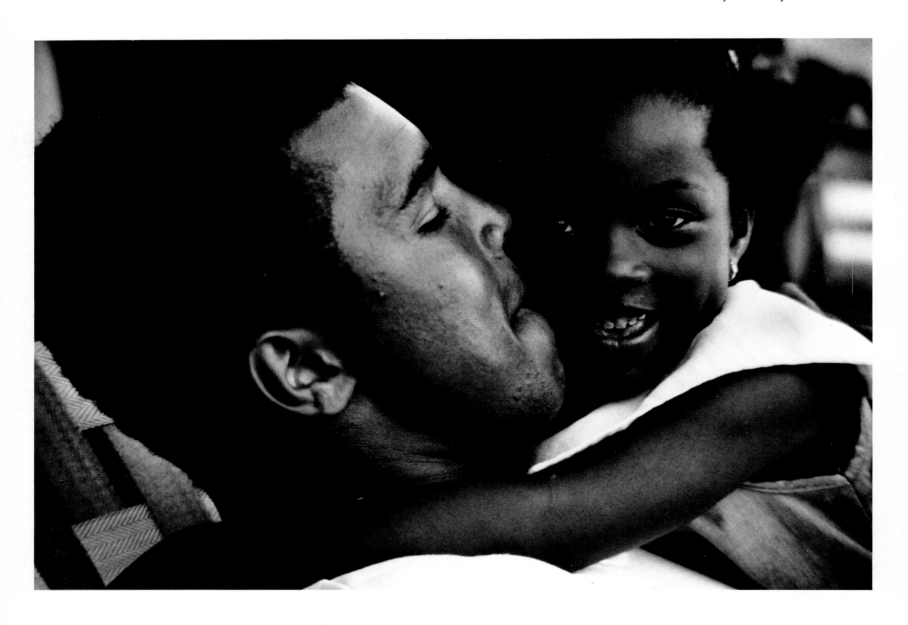

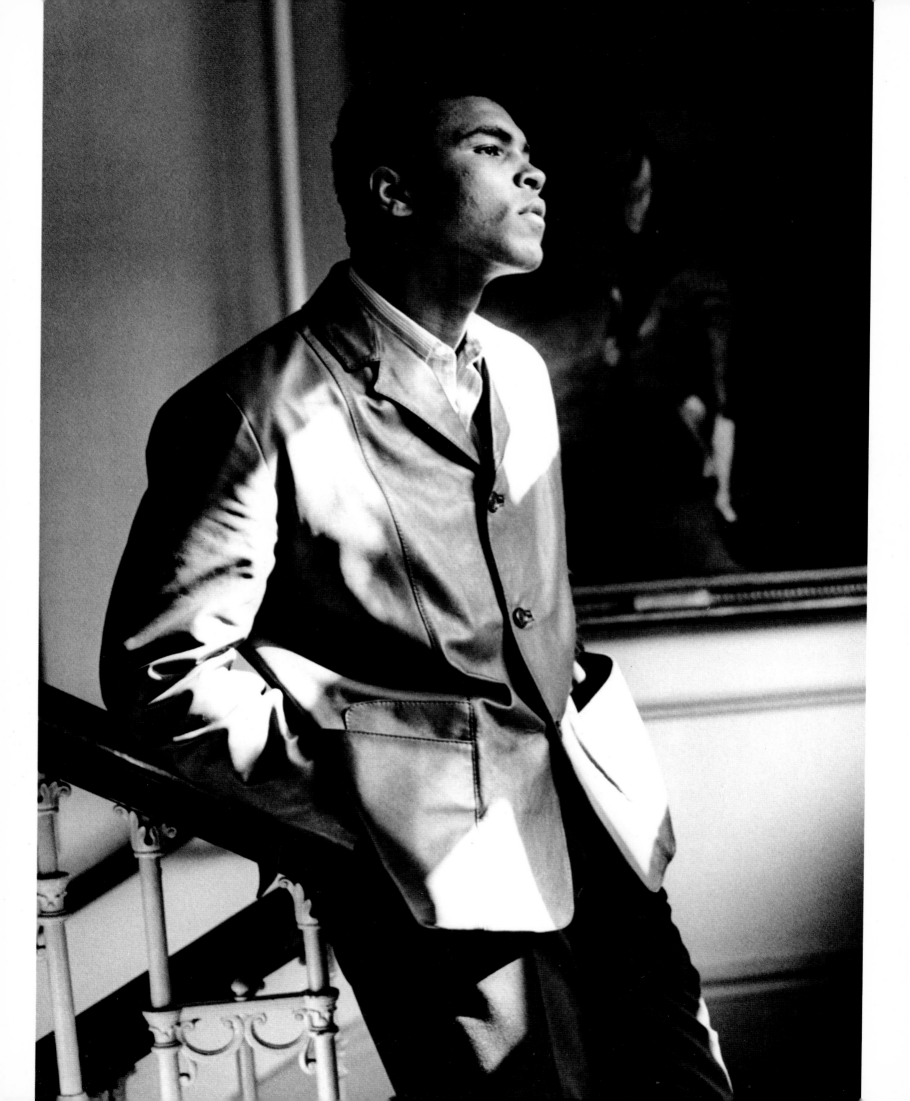

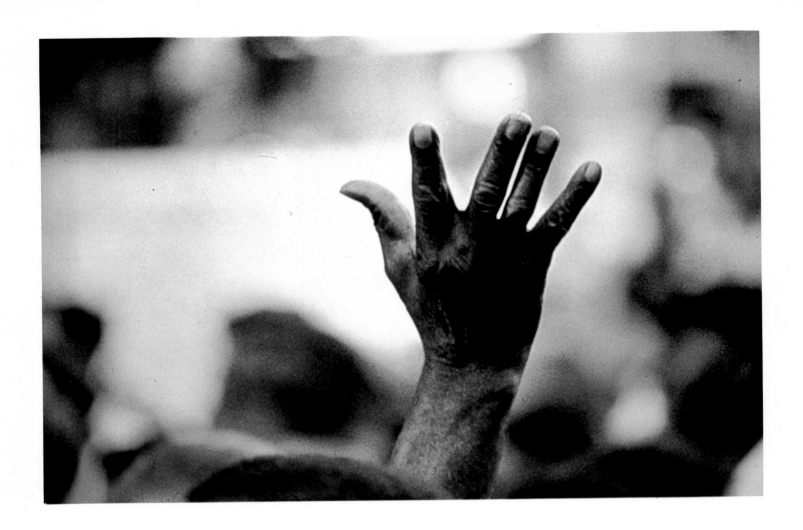

How often have I heard a white man say, "I know the Negro." Nobody knows the black man, not even the black man. Because all our lives we have cloaked our feelings, bided our time, waited for the year, the month, the day, and the hour when we could do, at last, what we are doing just now—looking our white oppressors squarely in the eye and telling them exactly what we think, what we want, and what we intend to get. And all this without fear. The Black Muslims are questionable, but they are unmistakably a part of us.

Our young people tell us boldly: We will not go on suffering while the white man insists on slow surrender through law and time. If some speak to them of new laws and legislation, they answer: If they are sincere, they will raise their voices above those of the racists. And if some tell them times are changing, they answer: We are changing the times. So, my generation yields to them—and in doing so finds pride.

1963

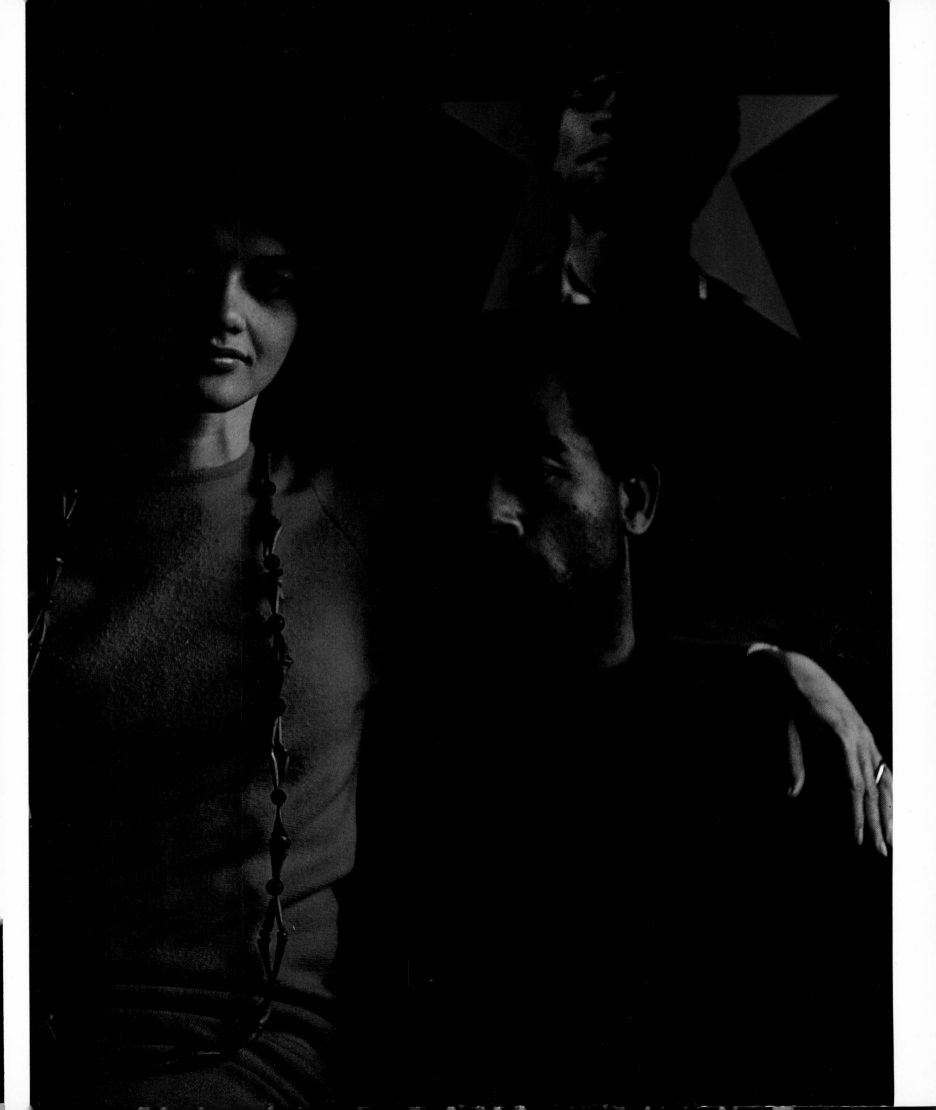

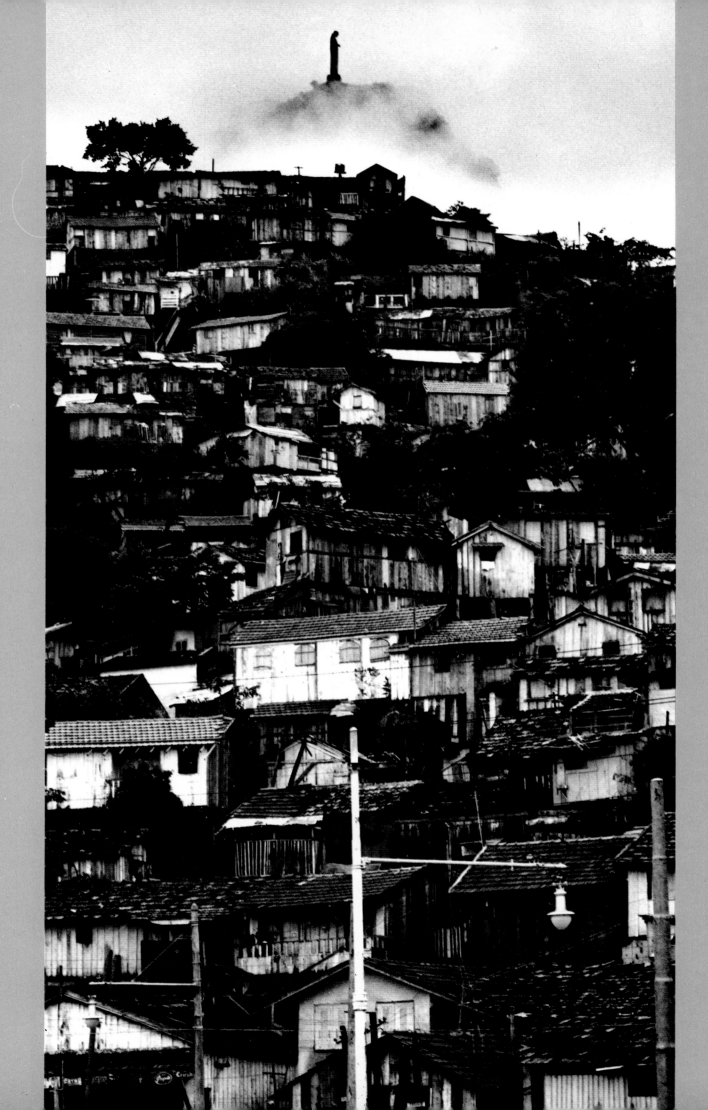

100

QUIETLY THE STRANGER CAME

A stranger, uninvited but expected,
Coming from a distance
That only a mind could travel,
Sat silent outside the door,
Patiently feeling the pulse
Of this stilt-leg house,
This minute scab
On a mountain's festered side.

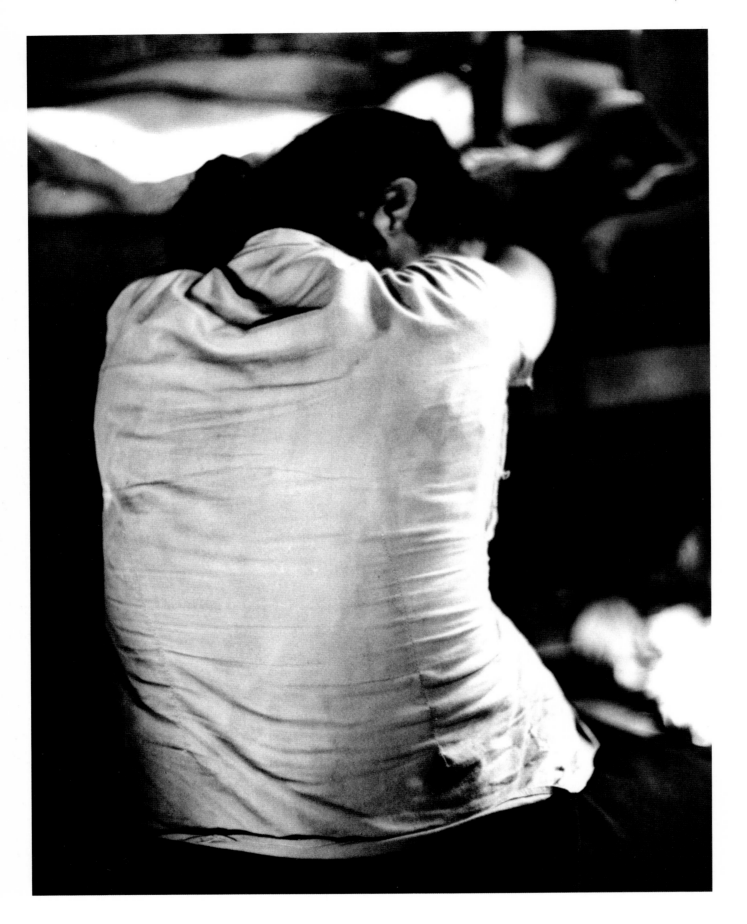

Inside, crumpled in his fevered bed,
A boy lay, silent too, thinking,
Trying not to remember much,

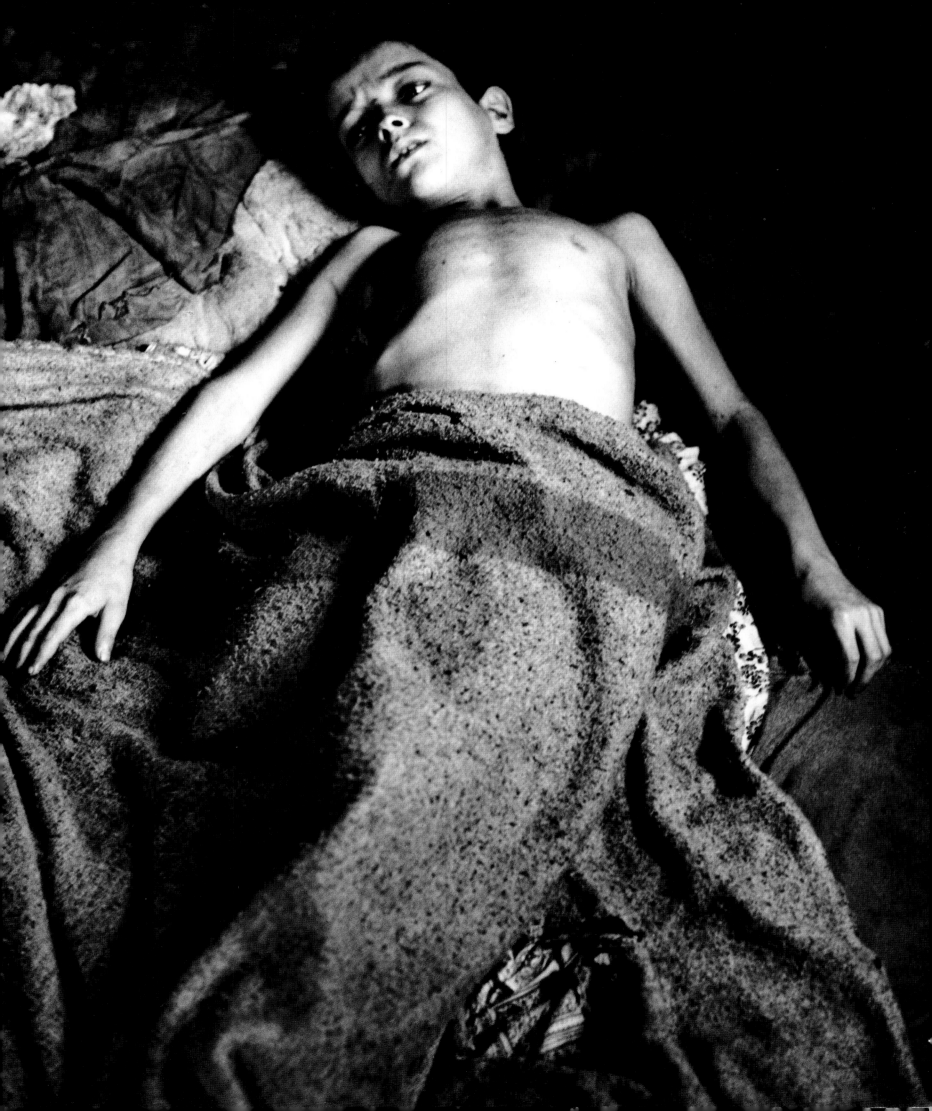

Knowing there wasn't much to remember,
 only that
His knees stood just above the weeds,
 only that
His shadow still slanted short
Beyond the hot glow of late suns that

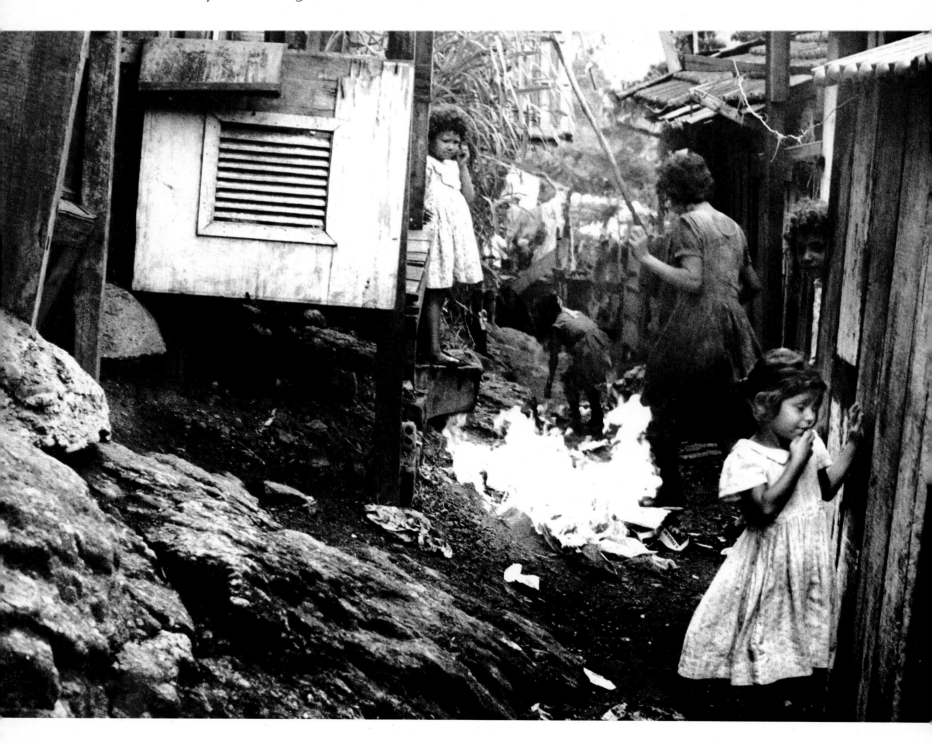

Cut red across steaming paths
(Dung paths of man and dog alike)
Where only beasts should have to climb.
Why then, asked this boy of so few moments,
Should this stranger have come so soon
To sit uninvited at his door?

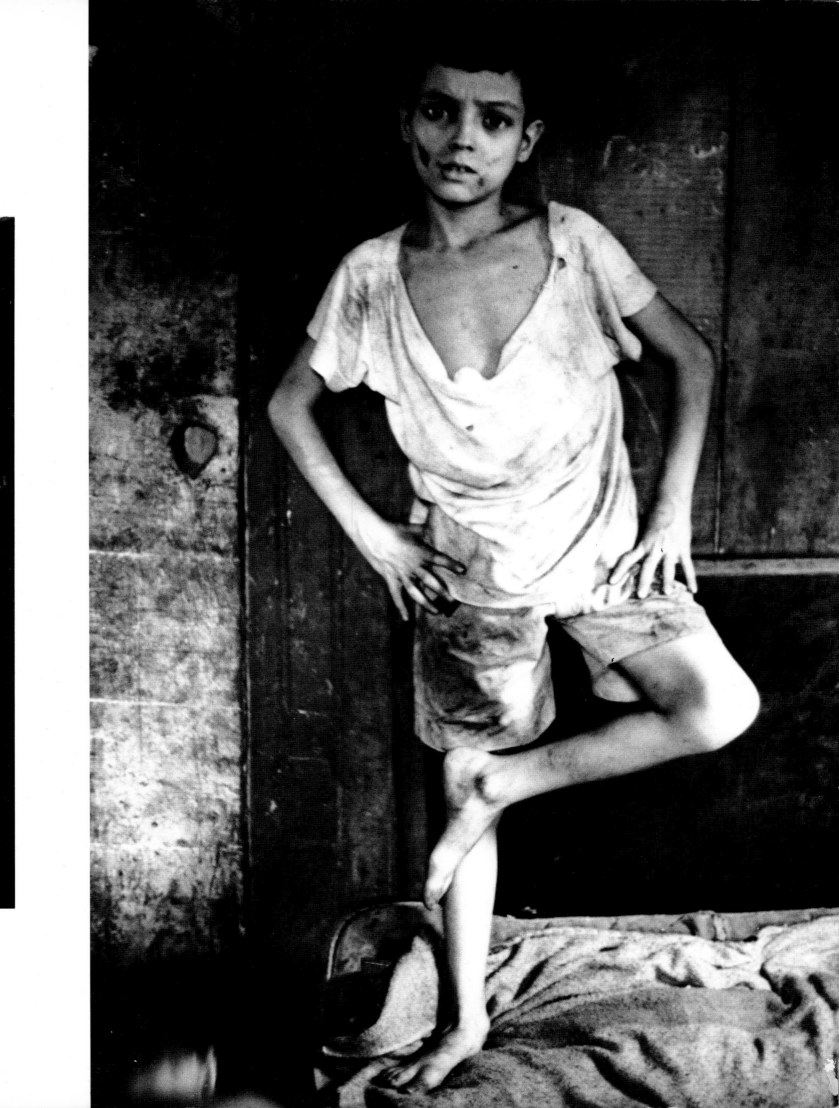

 and
With all his wisdom gathered in,
No answer could he find.
God's heart perhaps was busy
With some more uncommon grief
Far beyond the black-diamond sea.

Night fell.
The stranger, still unspeaking, waited,
His pallid fingers drumming lightly
Against the fog-wet door
While the boy stirred to voices
Burning within his delirious night,

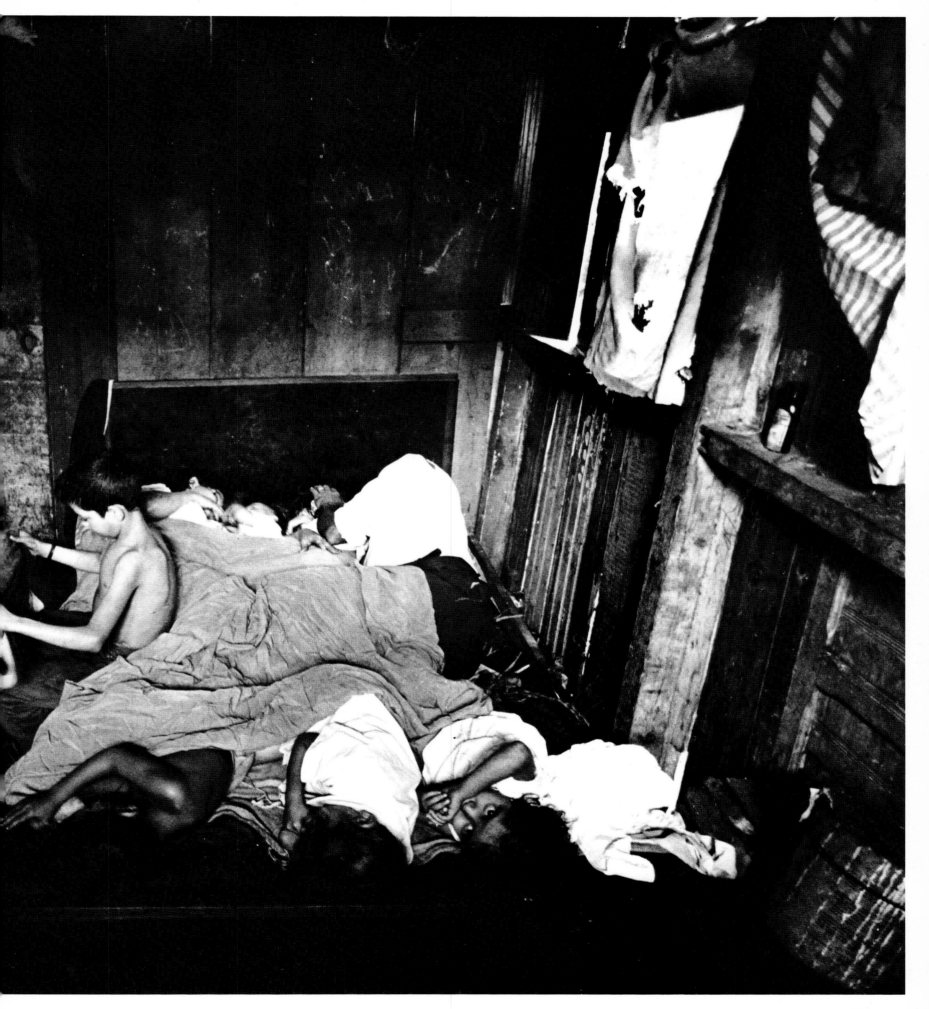

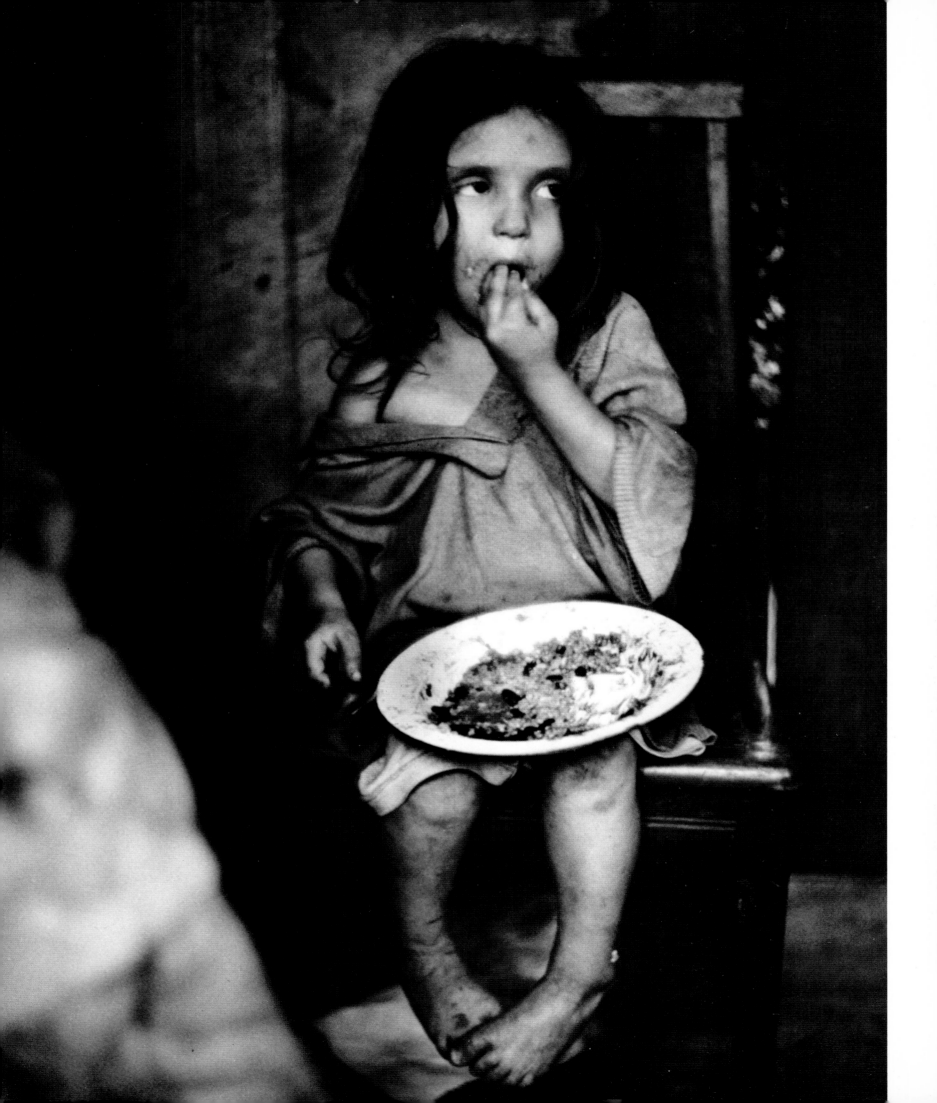

A sister's voice,
 naked,
Trembling with fear and hunger,

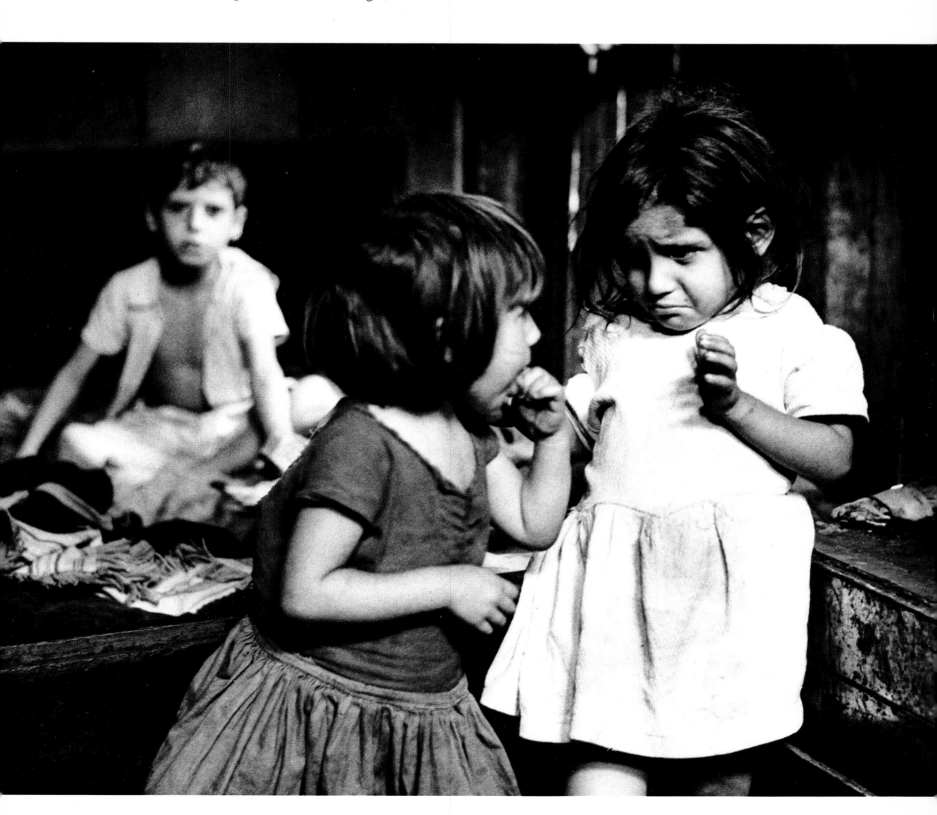

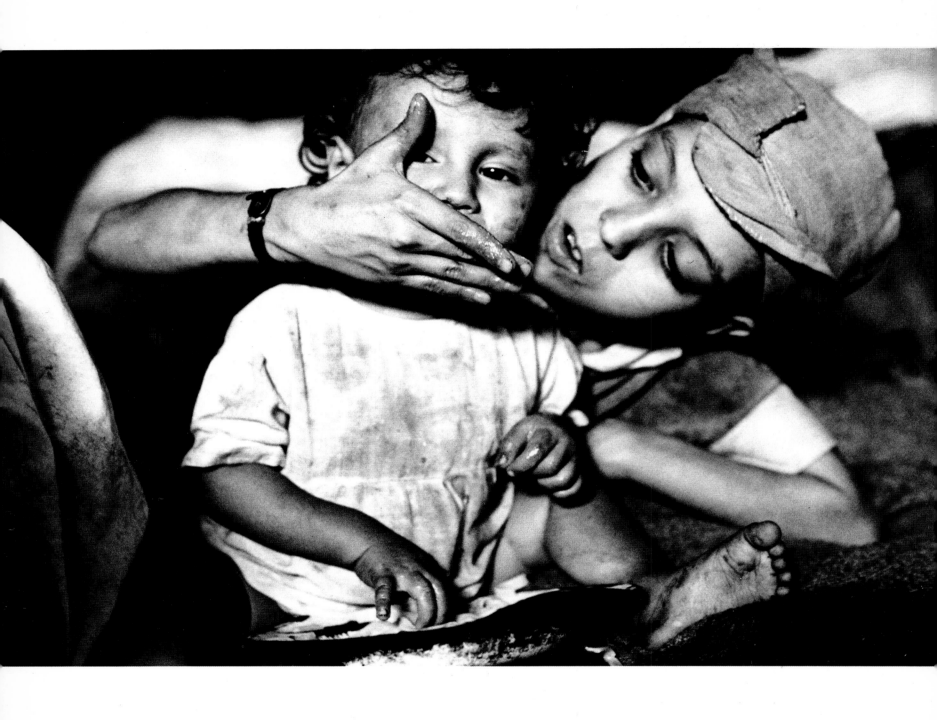

A brother's voice,
Aflame with pain and surrender.

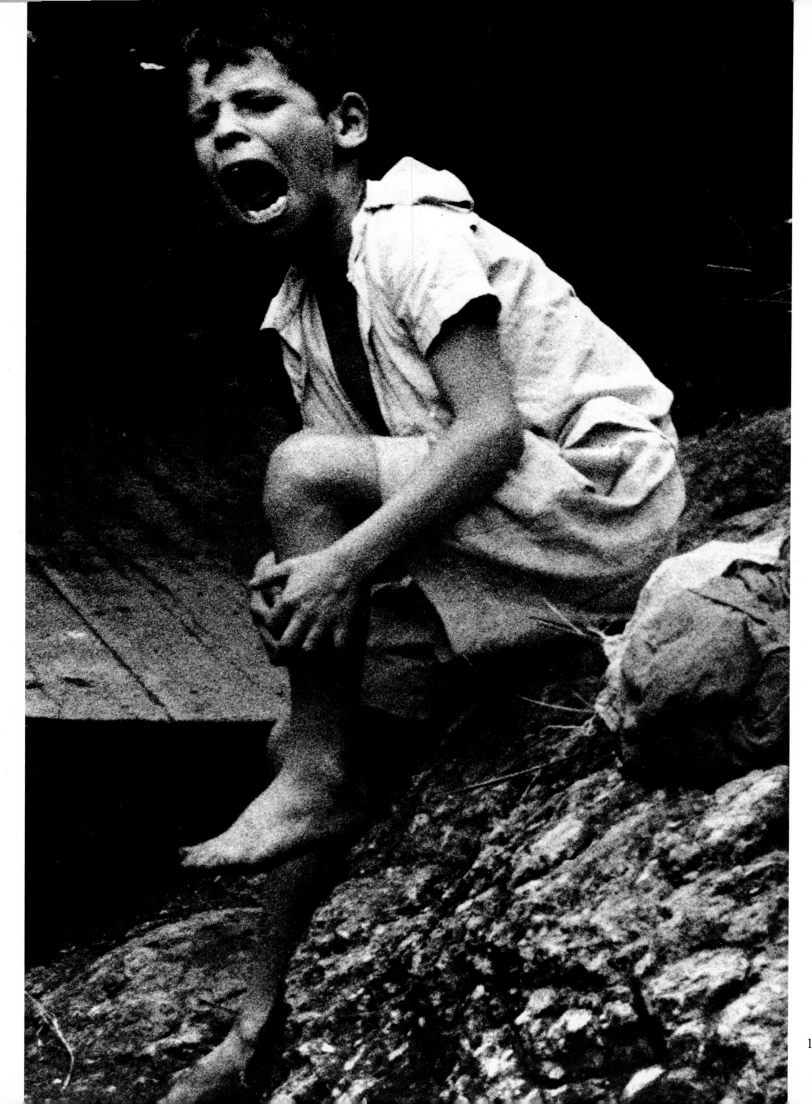

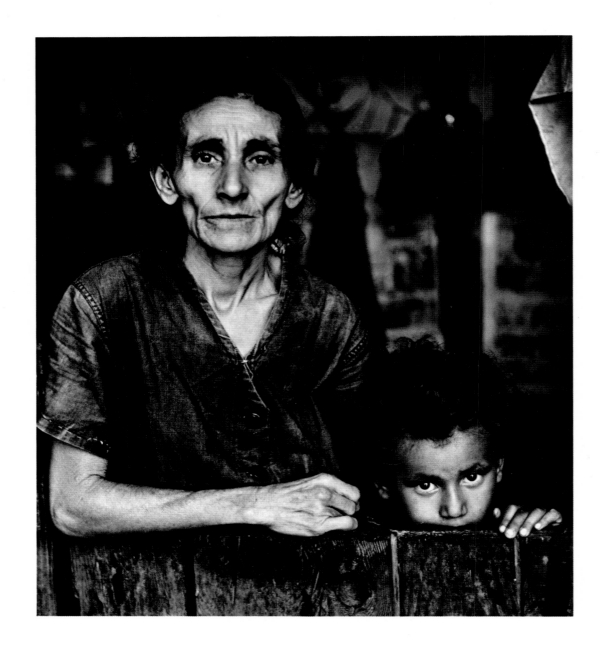

Voices from his mother's womb,
Choking in the noonday steam,
Scalding the terraced garbage slopes,
 voices
Drowning slowly, slowly melting down,
Sliding down, slowly winding down
The long passage toward the blackest
 opening,
Where all voices finally stop and
All tomorrows are silent.

As quietly as the stranger came,
Just as quietly he departed.
Not to travel far this time,
Just a short way up the path
To stop outside another door,
Where inside, other voices grew.
There he would patiently sit
To wait out another night.

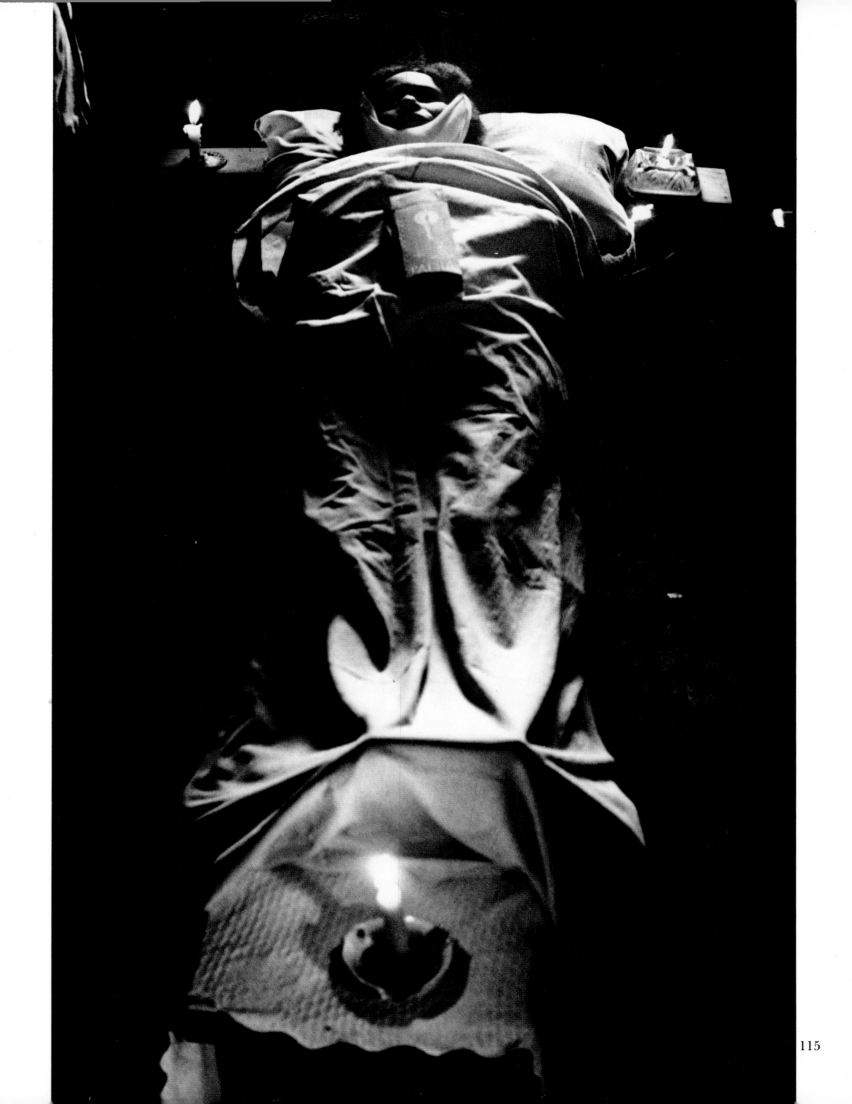

ODD MOMENTS

In this place
Where all clocks have frozen,
These images without heartbeat
Stare at me with their authority,
Piercing me with their presence.

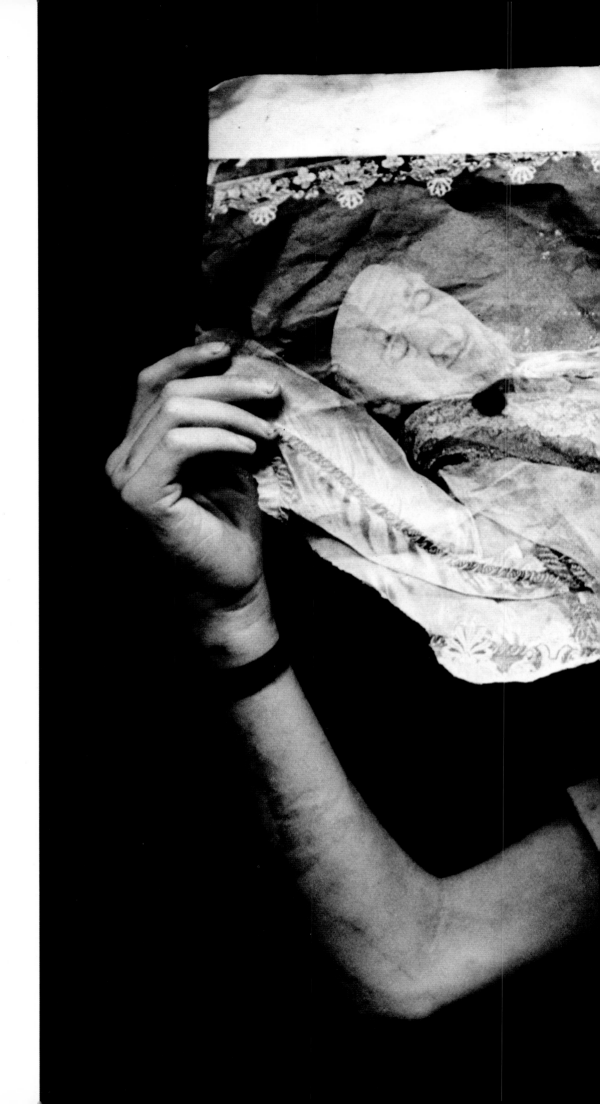

Here, a boy thinks outside himself,
His mind slipping at the edges,
Creeping toward a shawl of darkness.

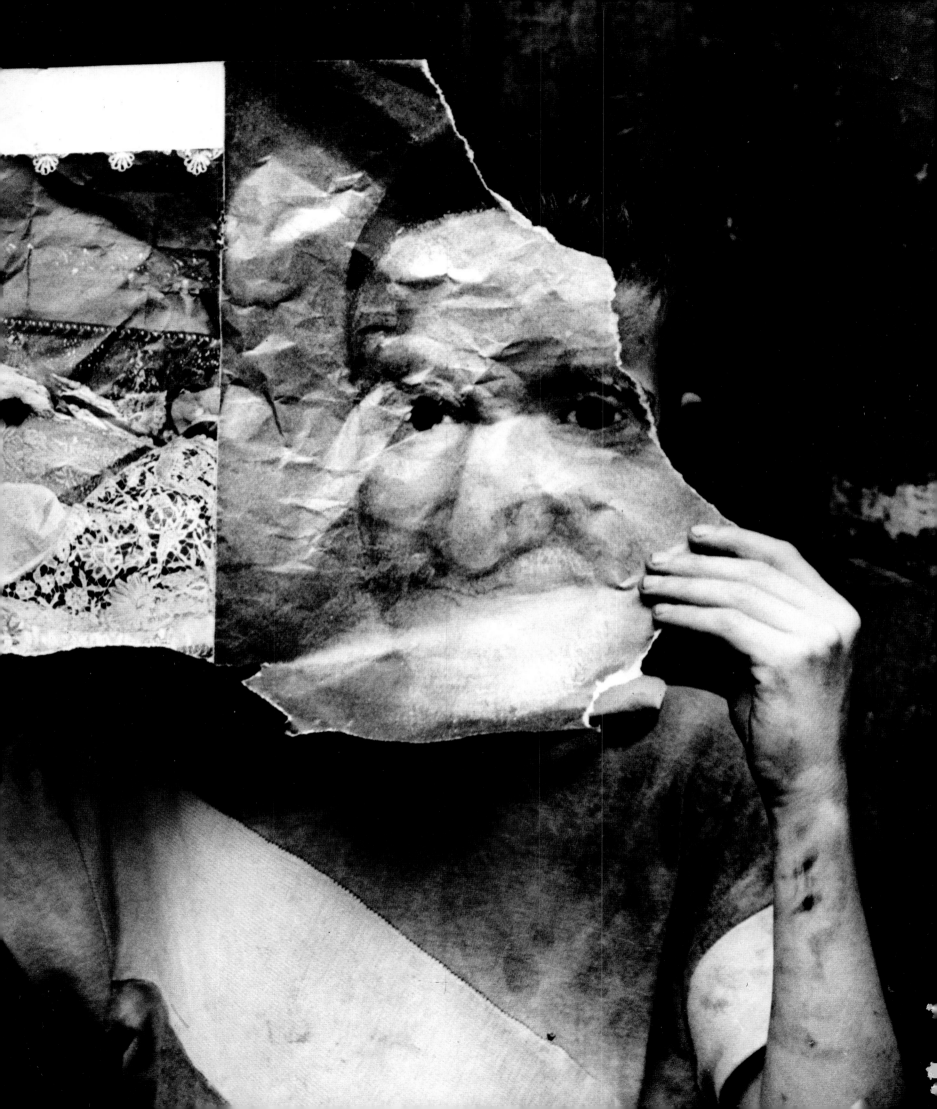

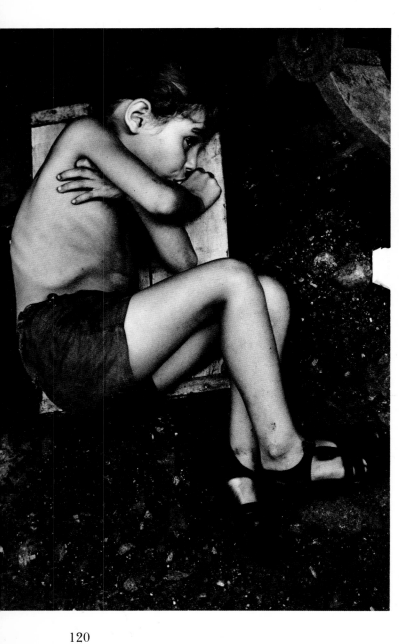

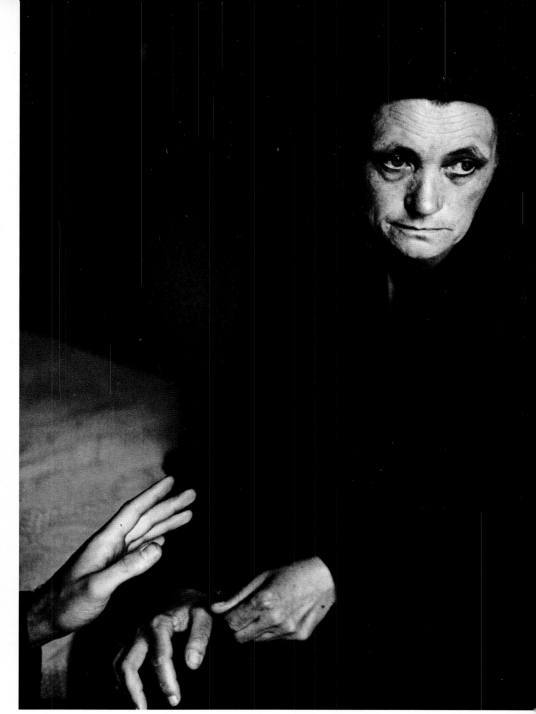

There, a girl whom time has worn
Lies anguished on a withered hill,
Pregnant with a summerful of secrets—
Both, children of the forgetting day.

In these odd moments
Love gathered like butterflies
On soft-beating wings;
Puzzling moments,
Understood by only those who lived them,

A heartbeat away from some aging mistress
Voicing her somber wintersong.

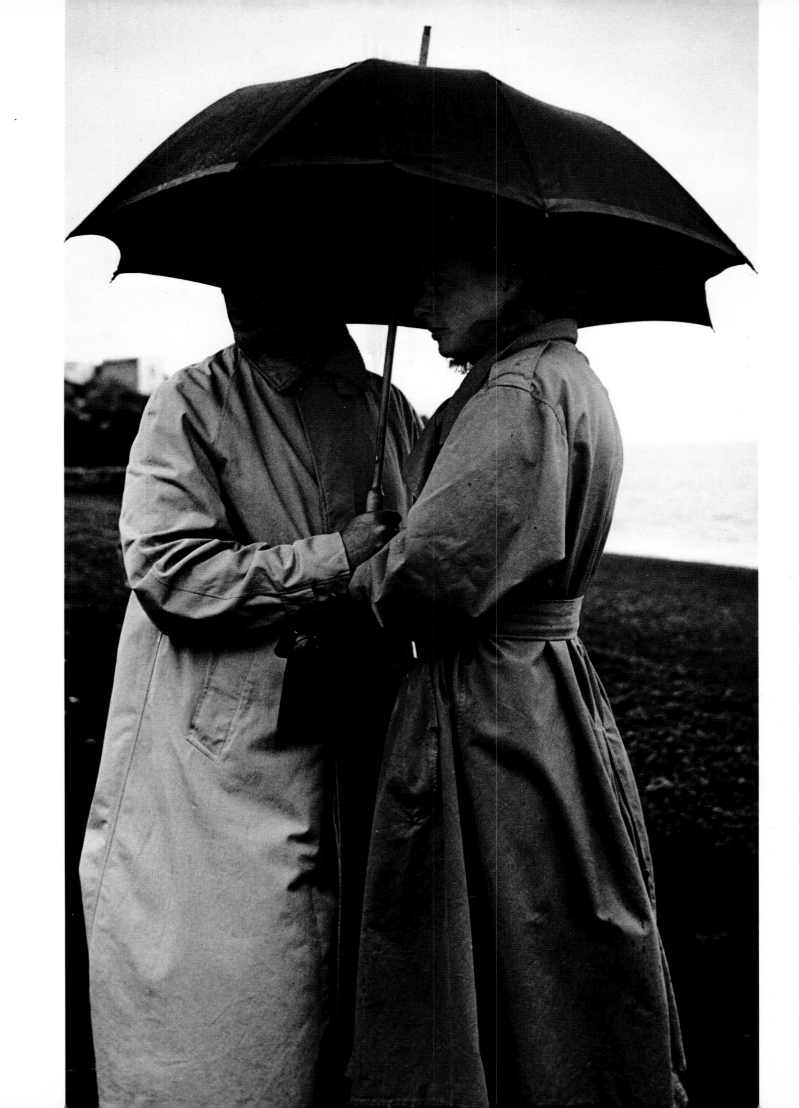

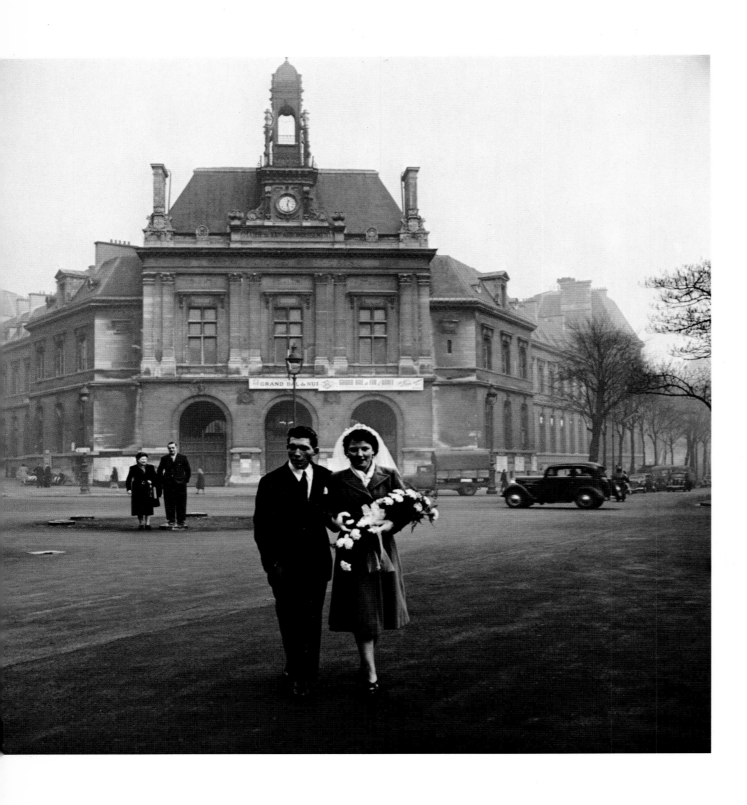

Good moments, fragile as lilies
In their unsoundable meanings.

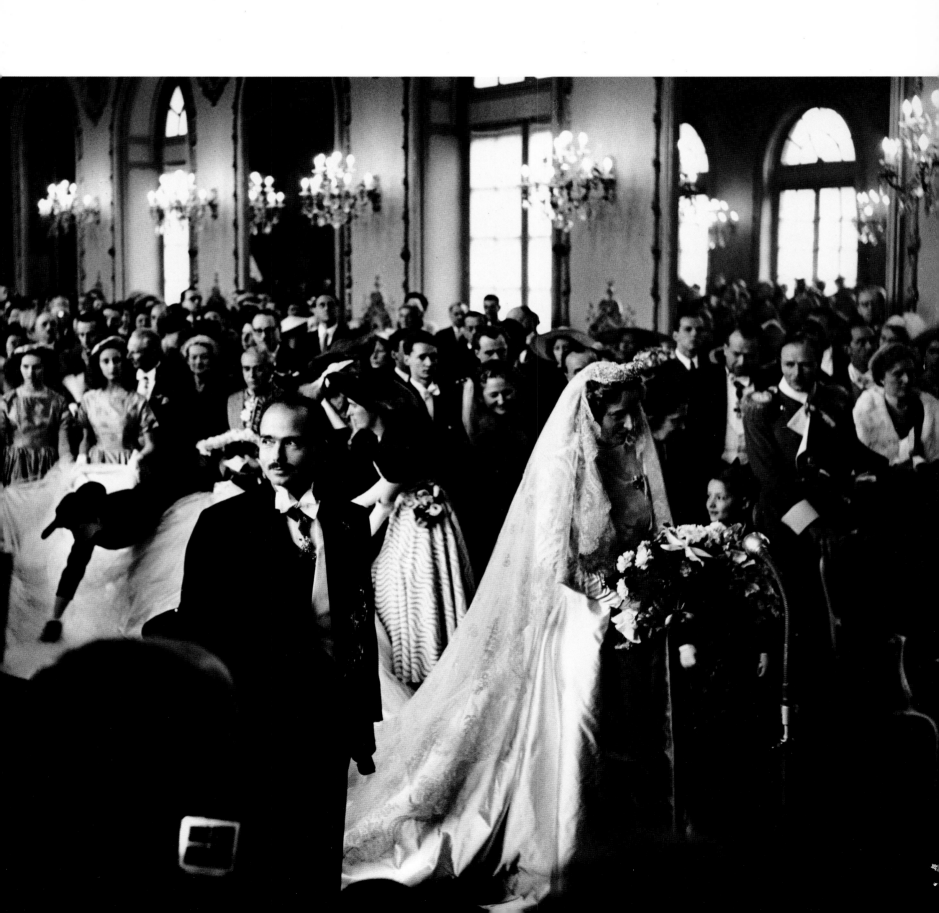

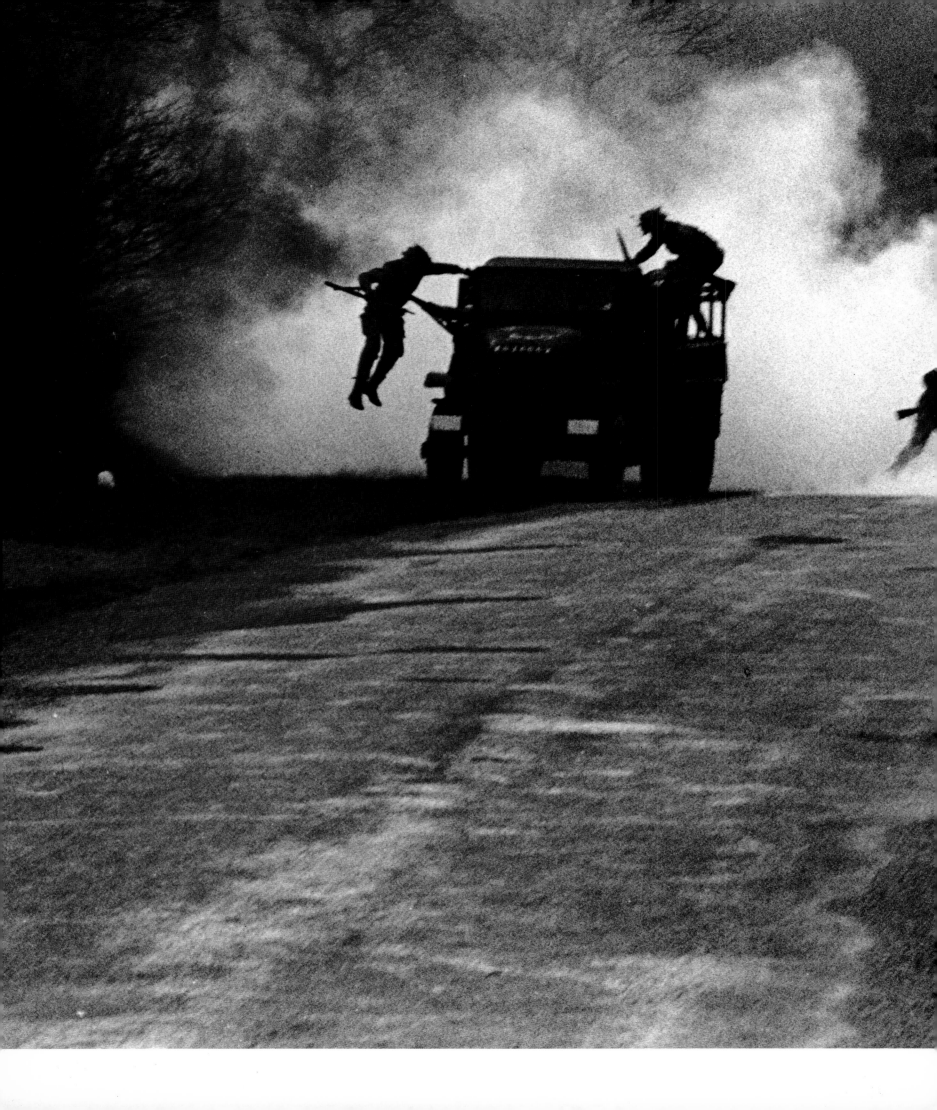

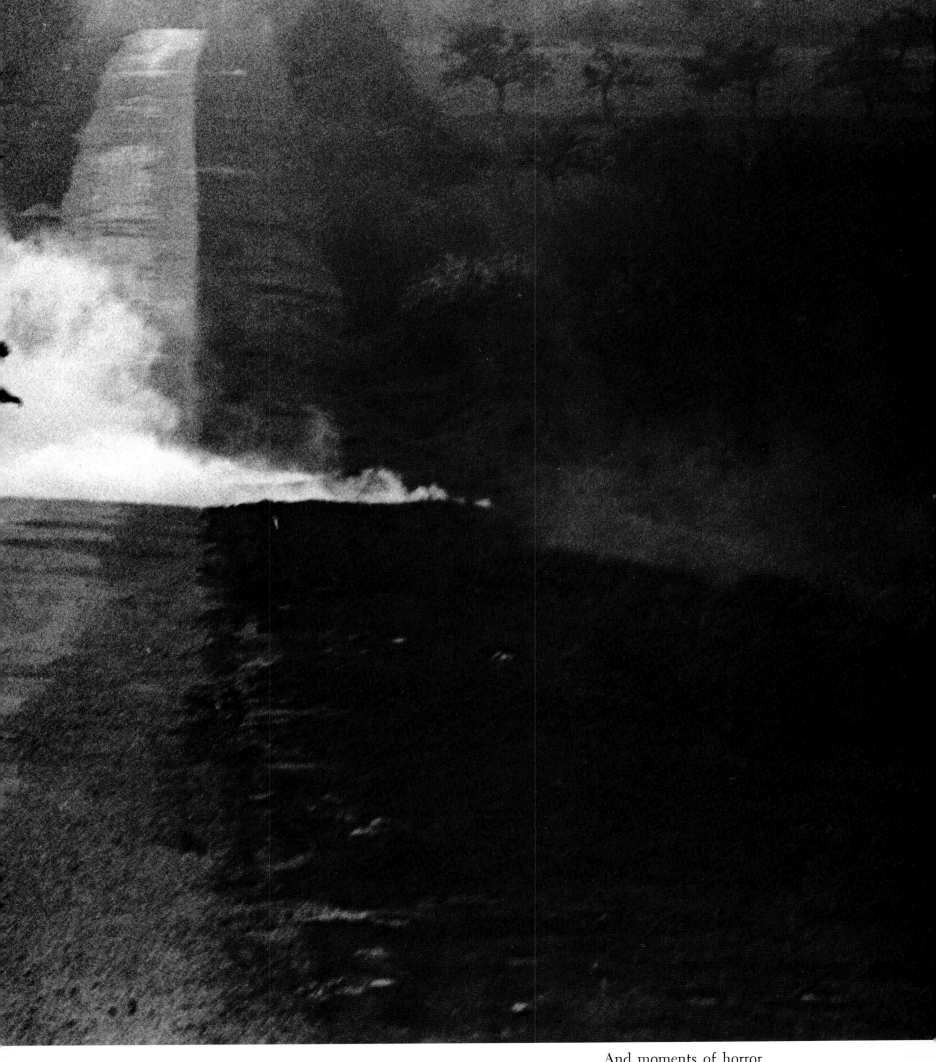

And moments of horror.

And here, these instances of common folk
With faces that speak of nothing special
About their terrible past that is not past—

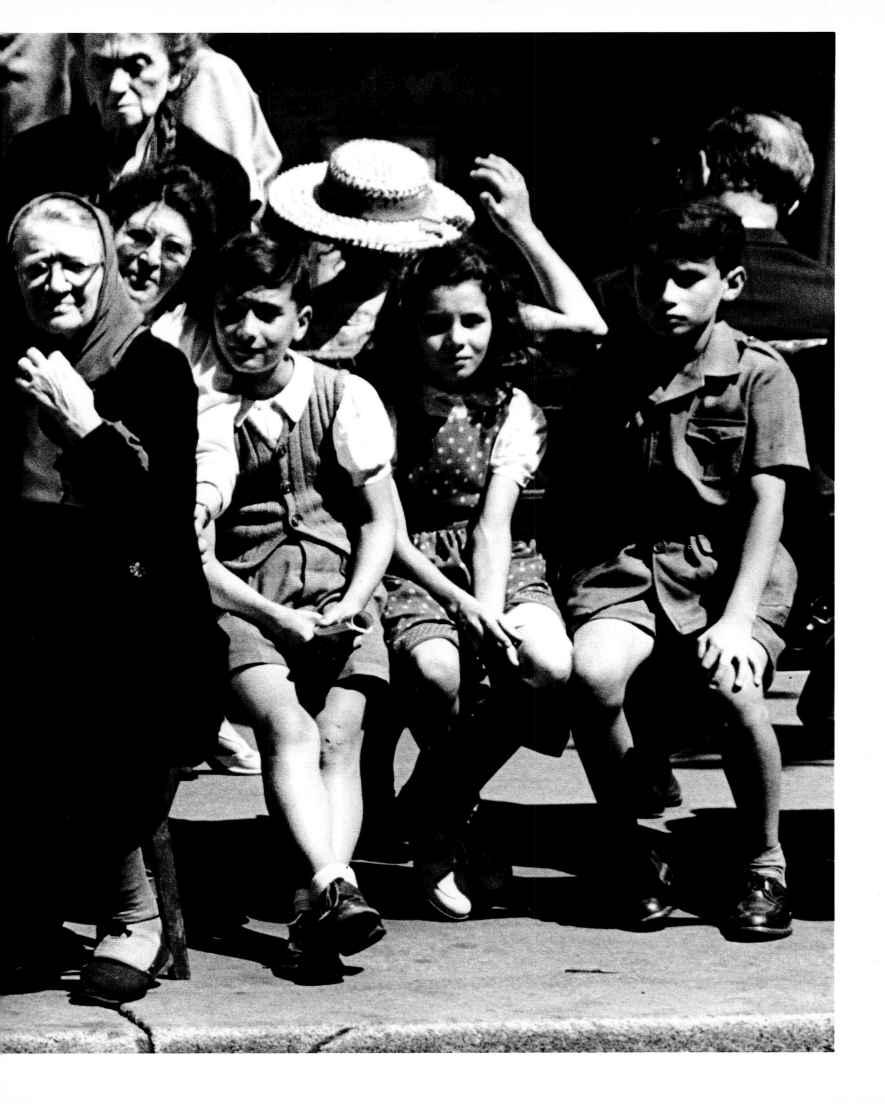

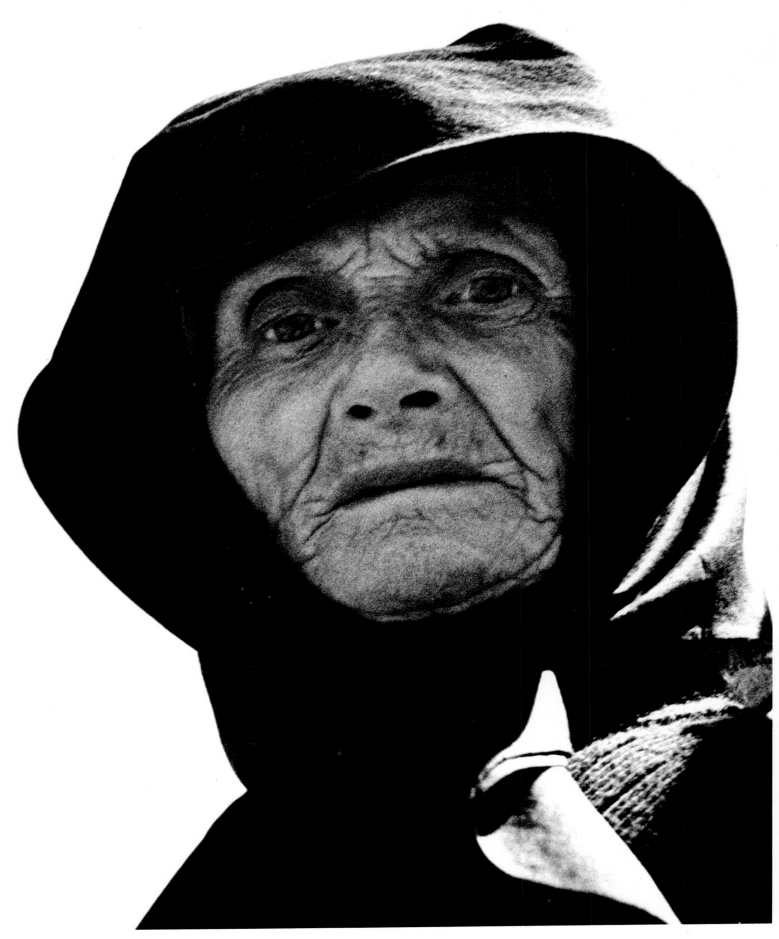

Of those moments without proper names
Where terror is told in the wrinkled faces

And patched coats of old men
Smothering slowly
Inside the events of grander men.

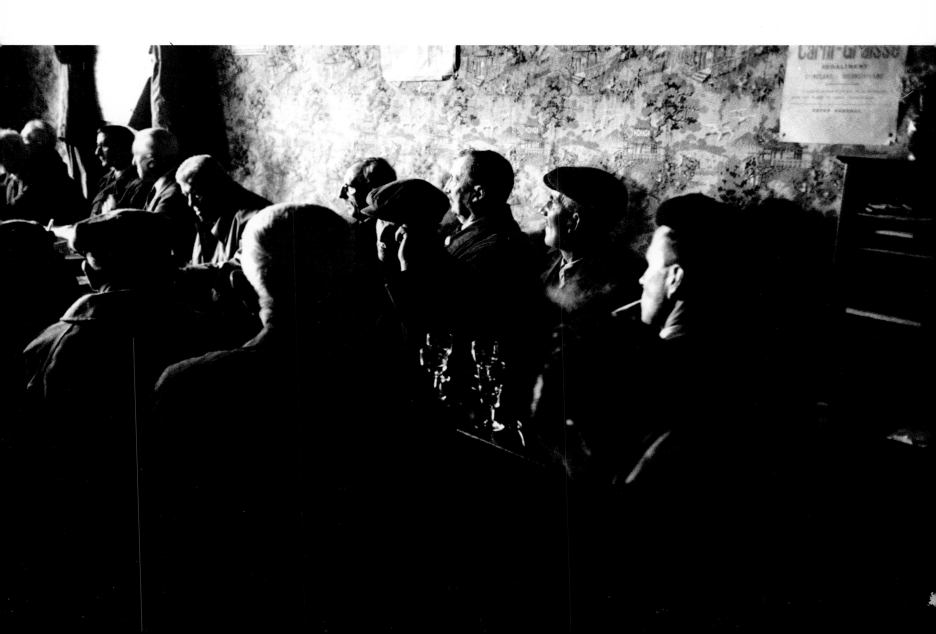

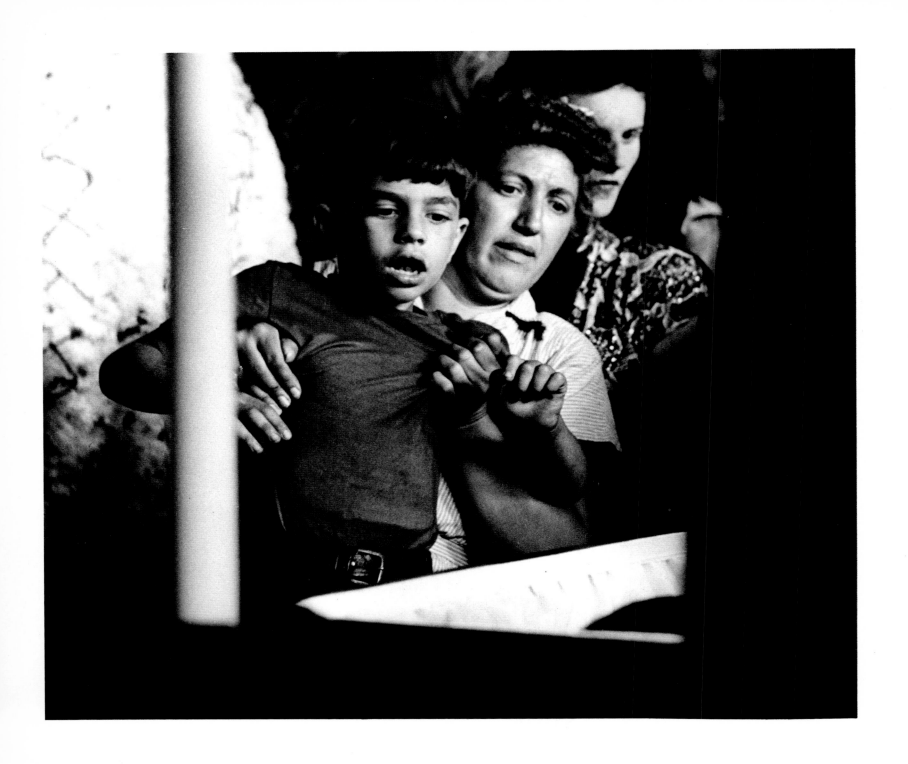

In this place
I spin a young widow's years,
Stopping where her world has stopped,
Tending flowers at his mourning stone
On which her farewell reads:
 A MON EPOUX
There I last saw her in black,
Glaring unforgivingly at me
From a landscape of crosses.

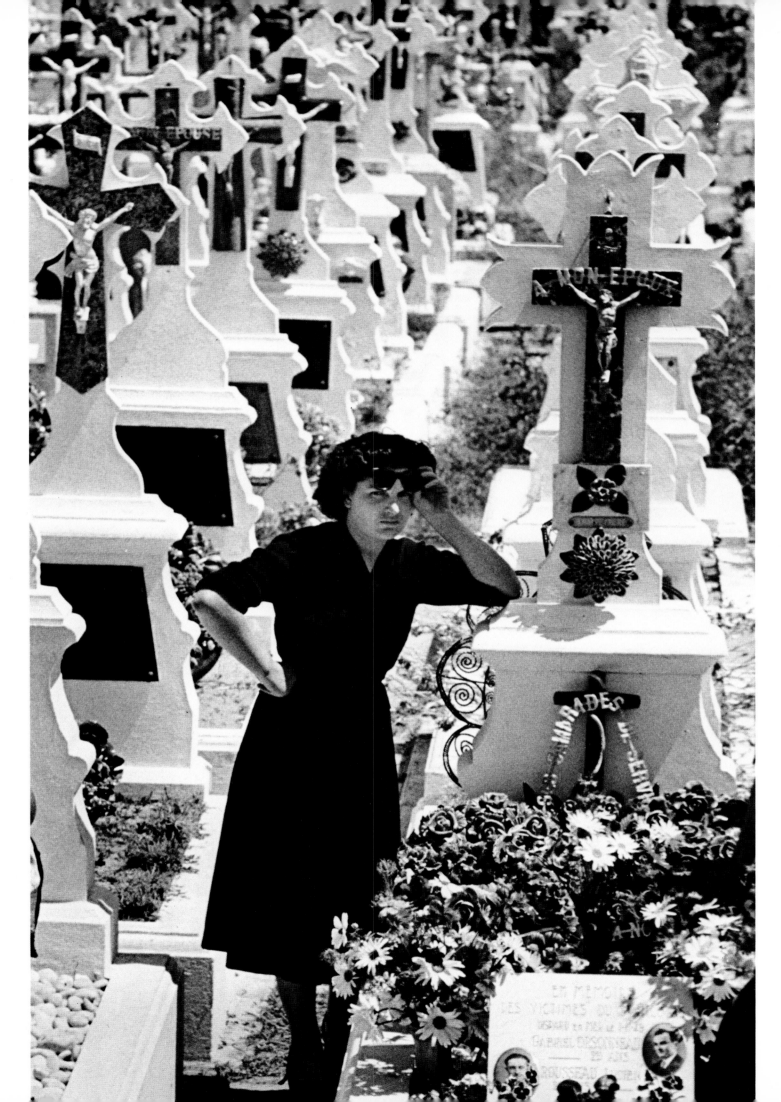

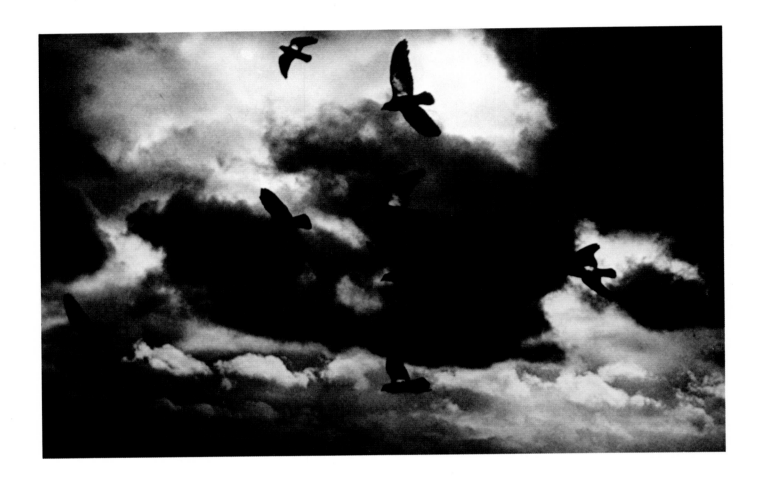

Now the pendulums swing again.
The wind sings over the lowlands,
And morning birds pack the eaves,
Twittering away the silence.
What will the children do?
They will wish to be alone.
Where will they go?
There will be ample space
In the places of old men gone to sleep
Beneath mounds of dry leaves.

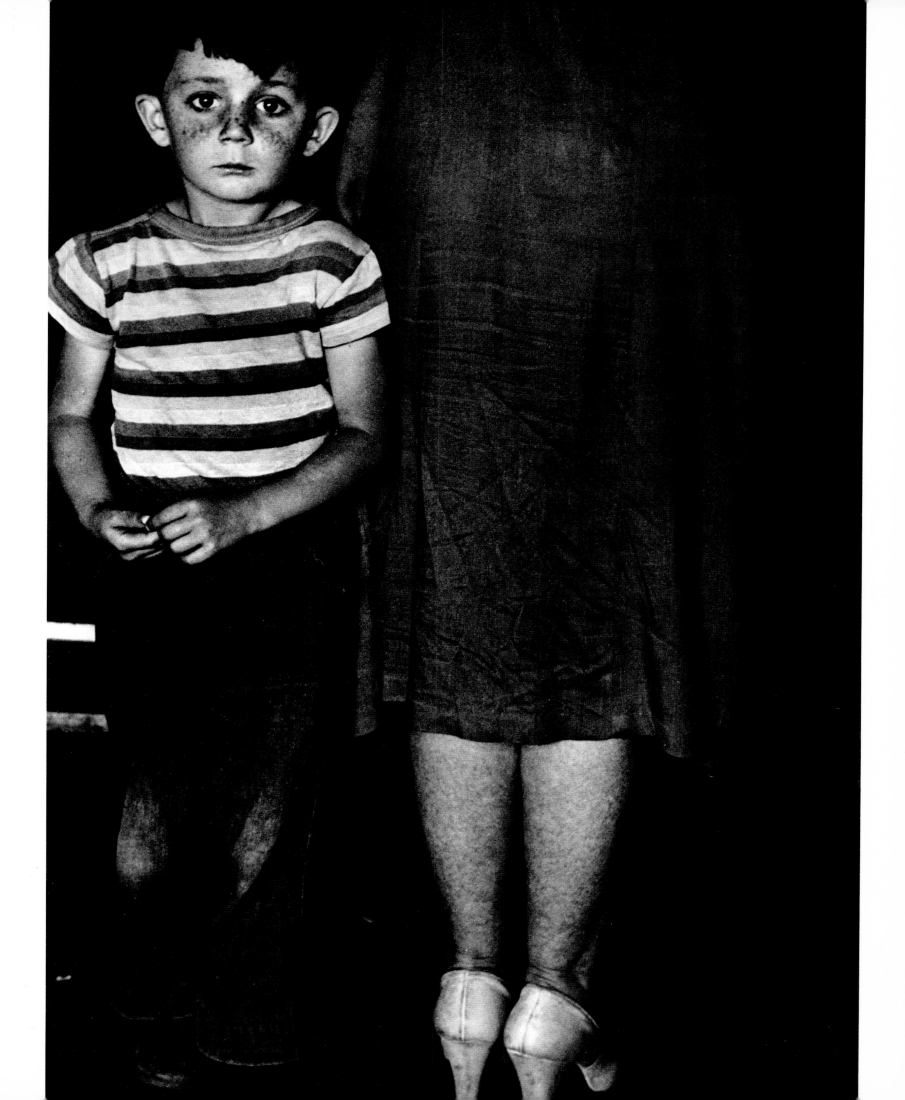

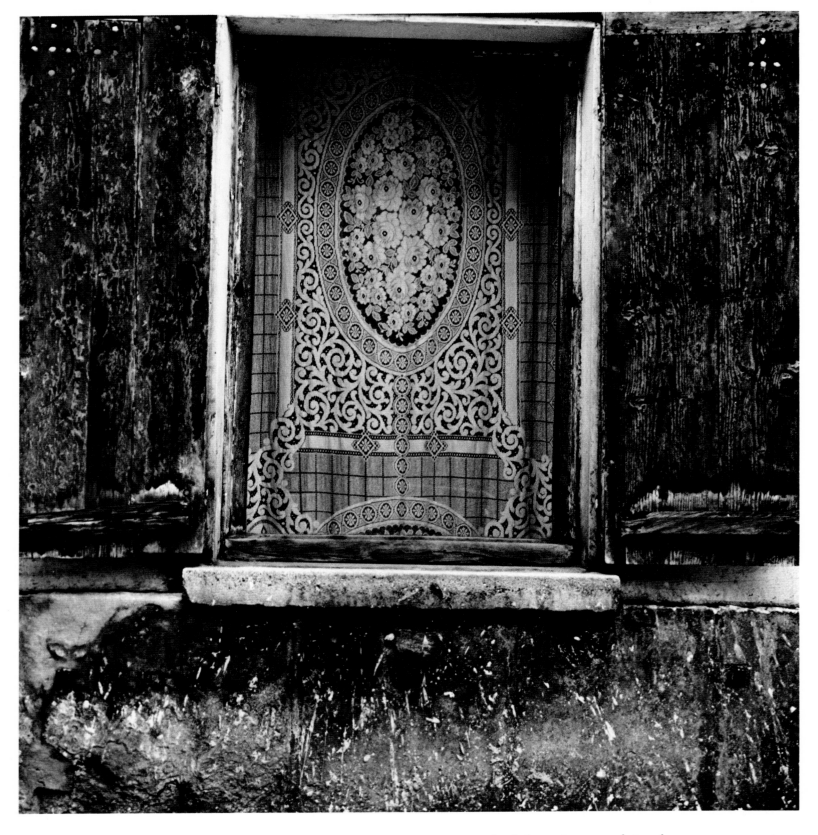

And there is room—lots of room
In the heartbroken houses of young warriors
Lying faceless in distant mudfields
Where a violent moment froze them
And left them lying there
Under the black sky music.

The clocks are in motion—
Time is once more under way.

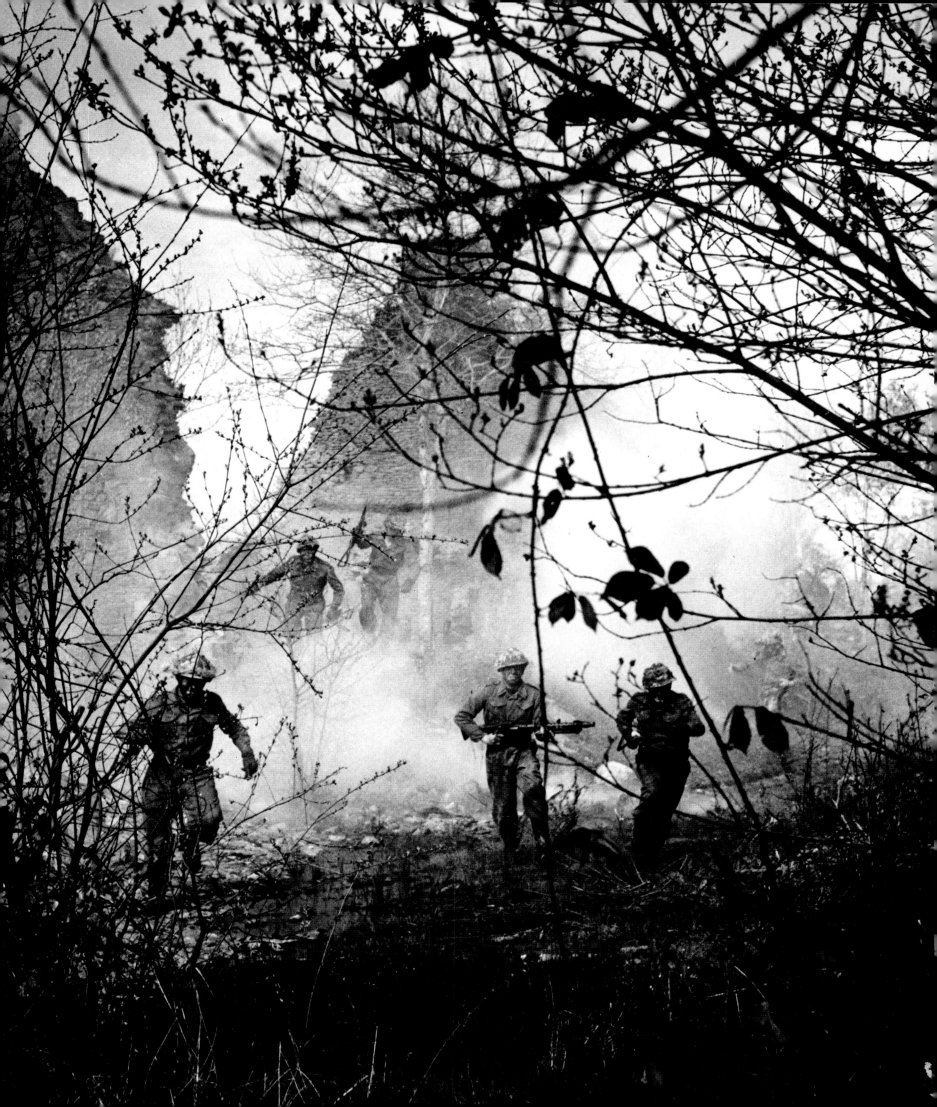

BEAUTY IS WHAT BEAUTY IS

What,
I asked a wise man once,
Is beauty?
The sun was sinking;
He pointed westward,
 saying,
It is useless without valleys to fill.
Eastward
The moon was rising;
He pointed toward it,
 saying,
It is worthless without meadows to touch.

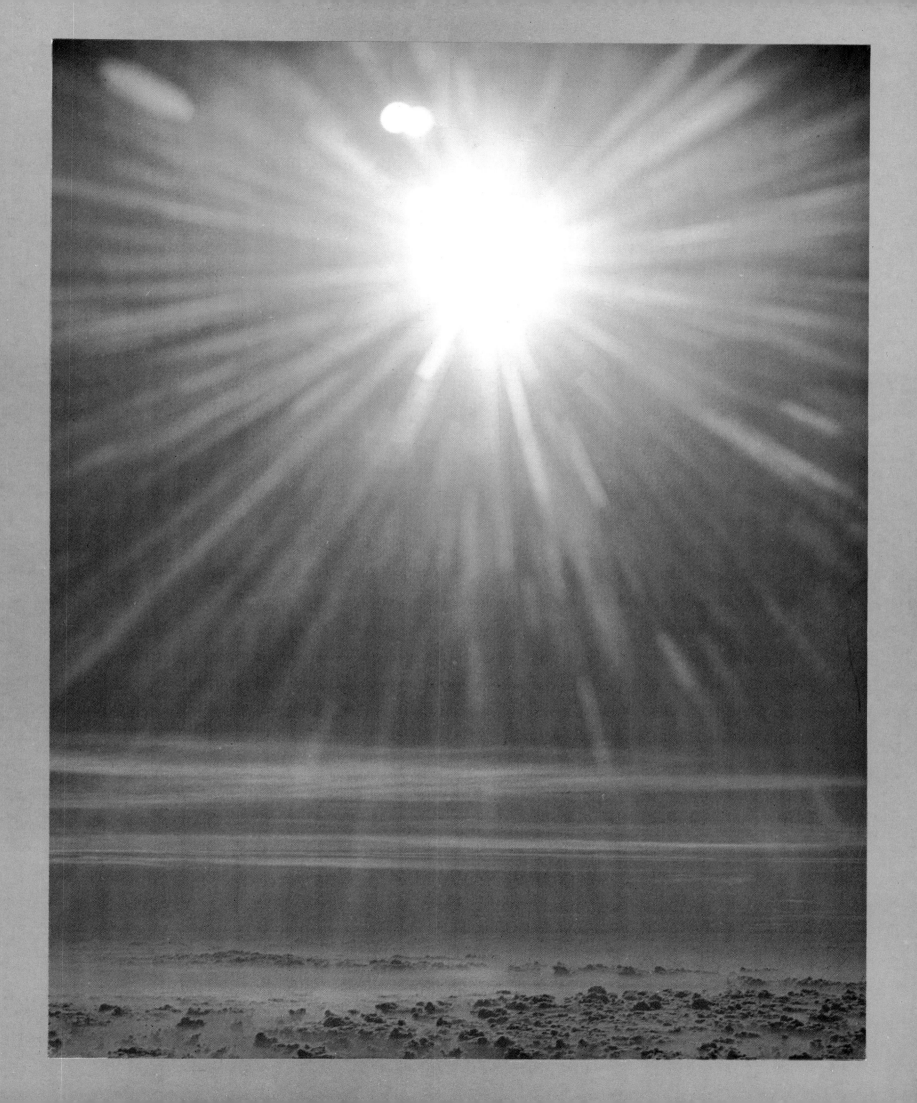

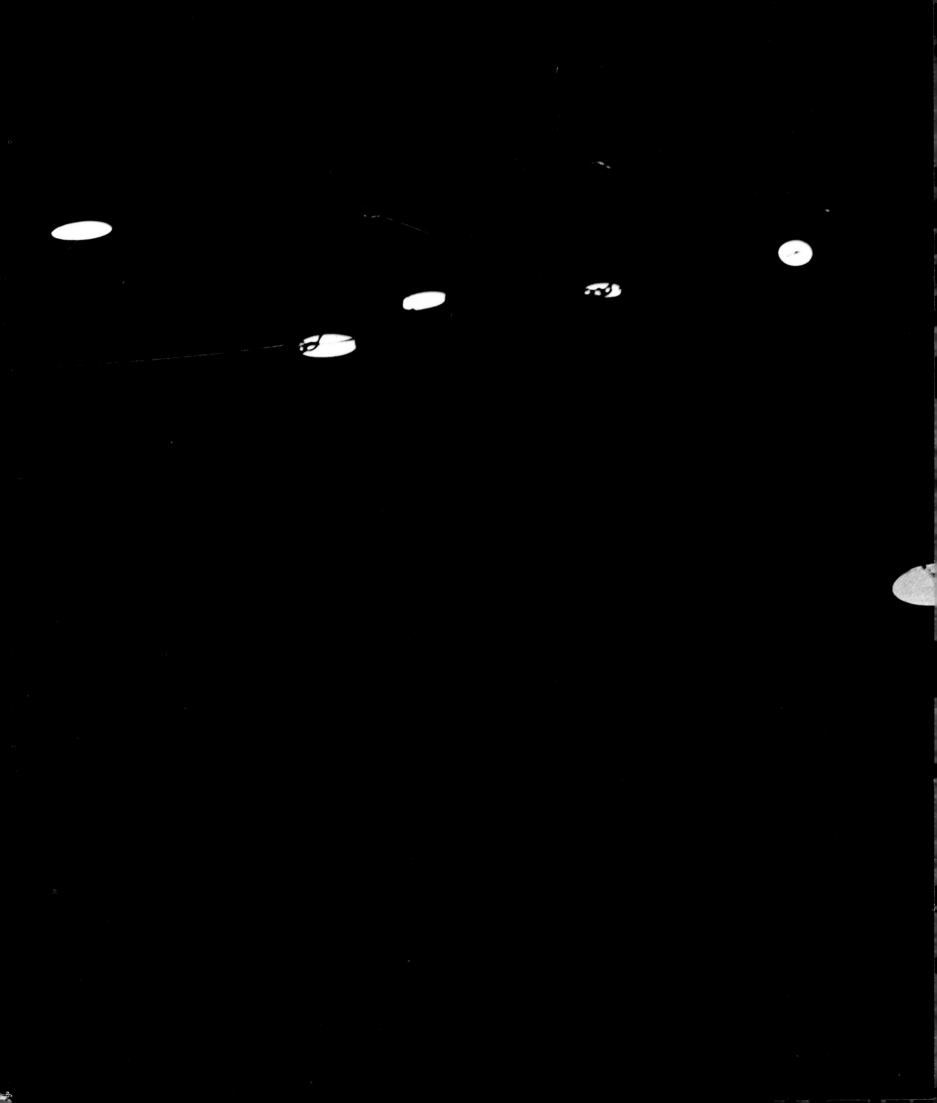

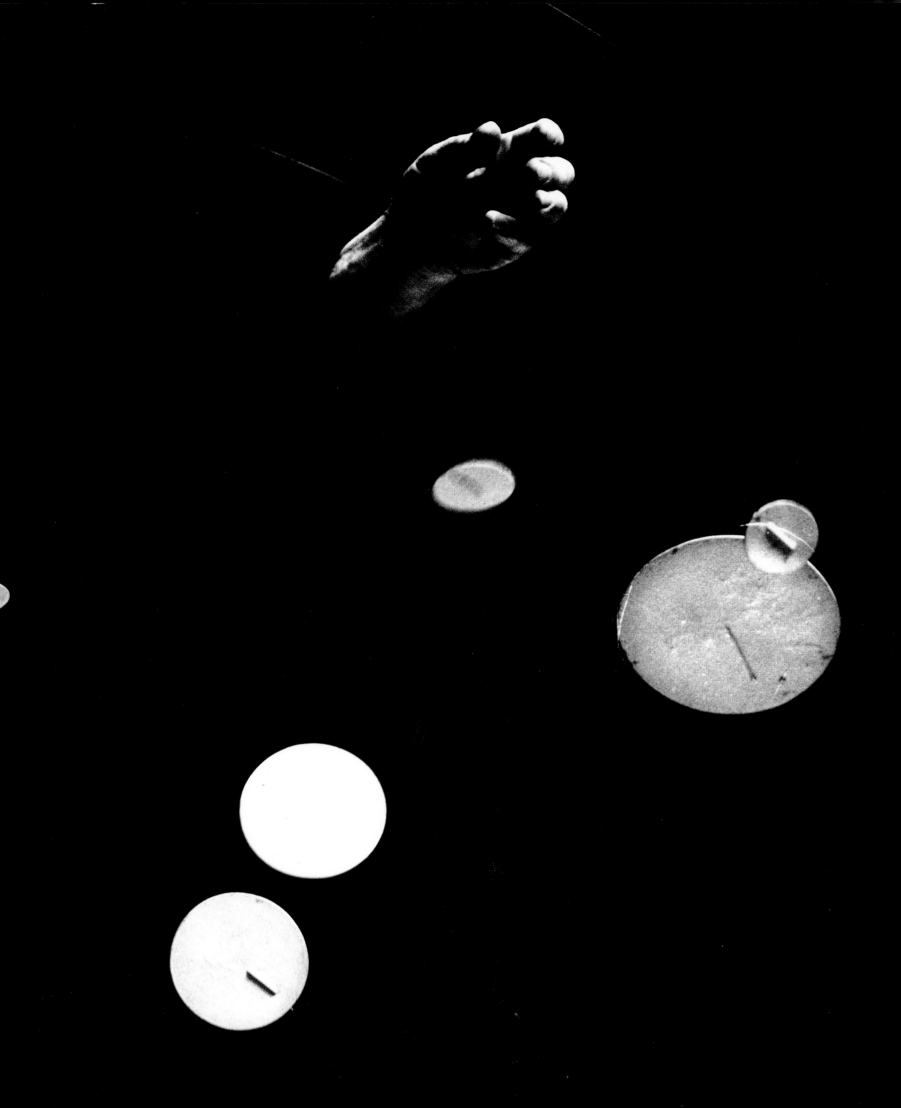

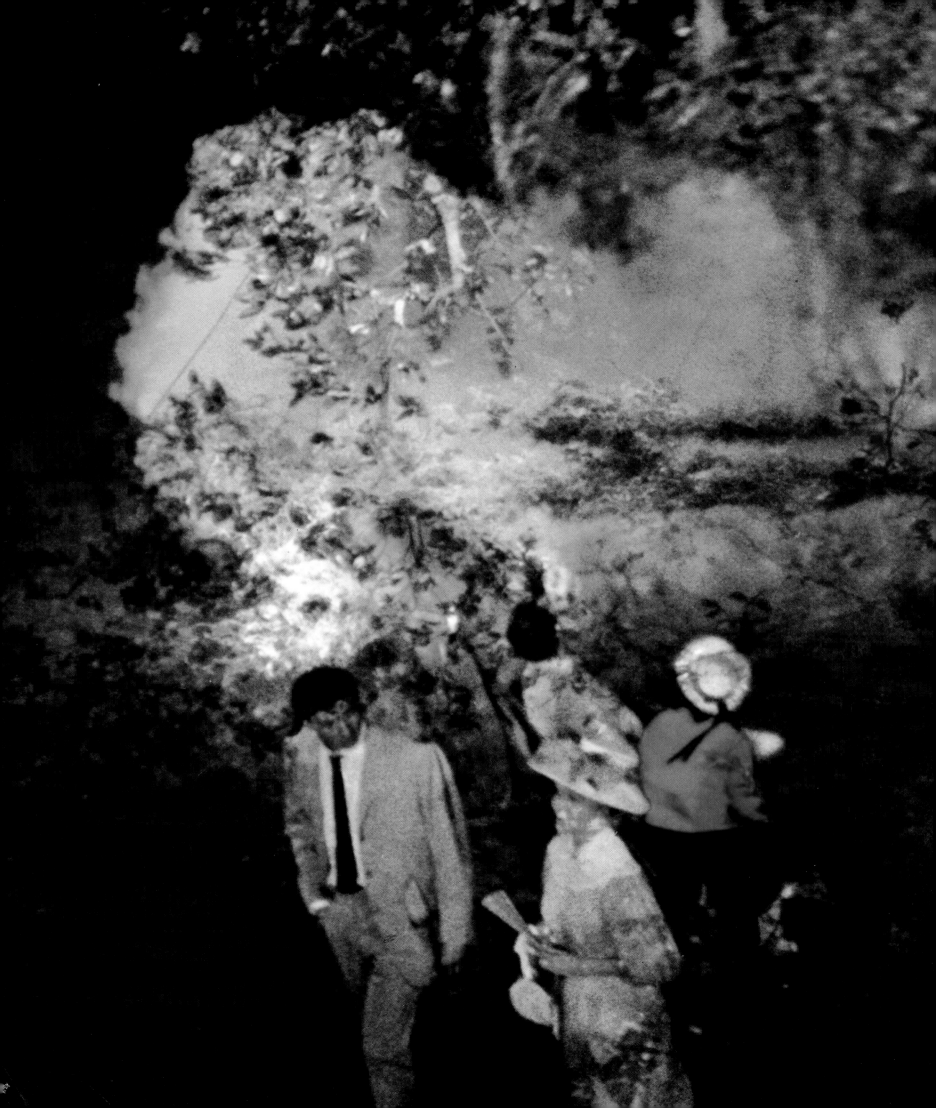

Beauty is what
Beauty is,
Wherever it is.
This was his answer.

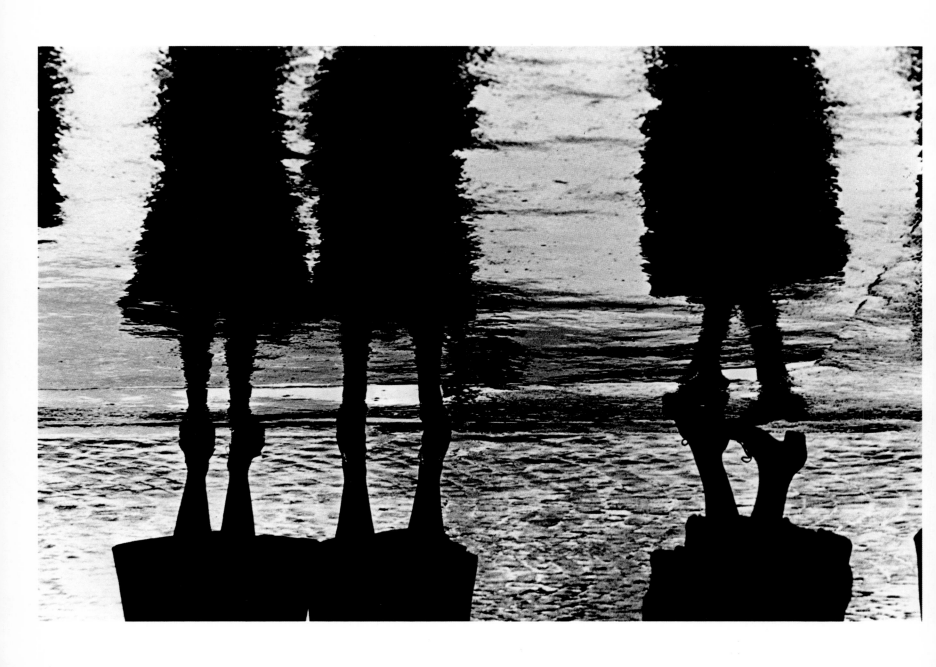

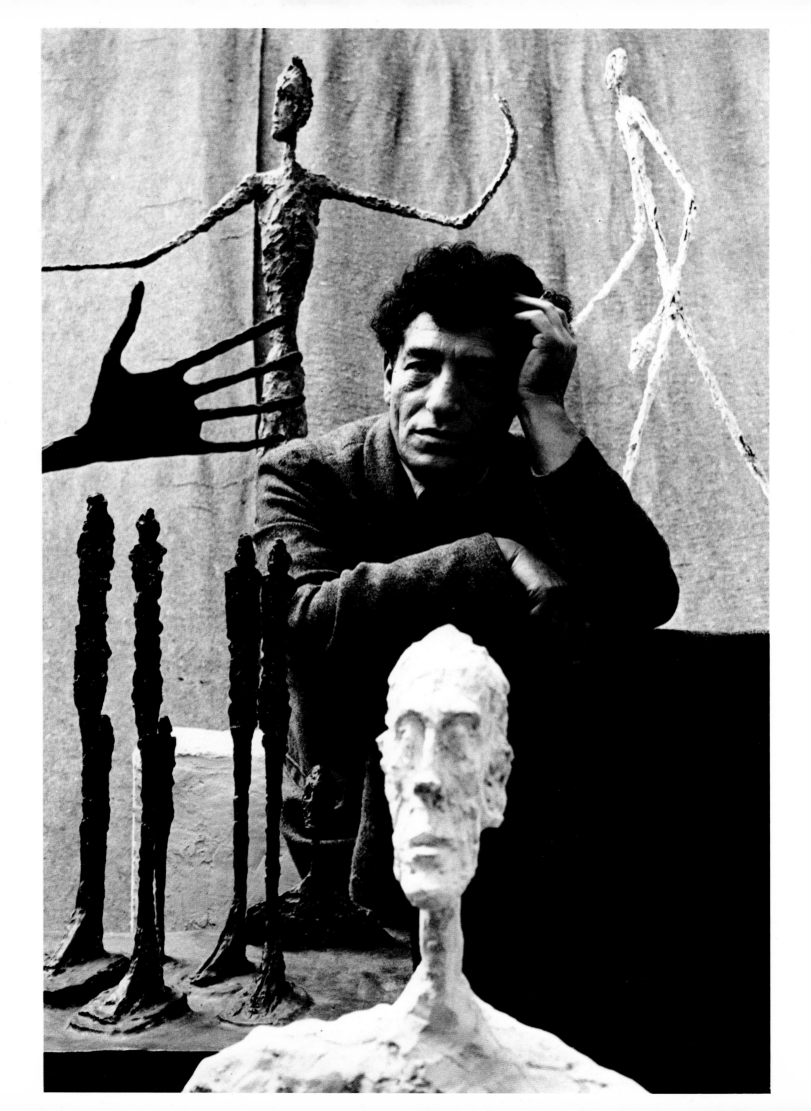

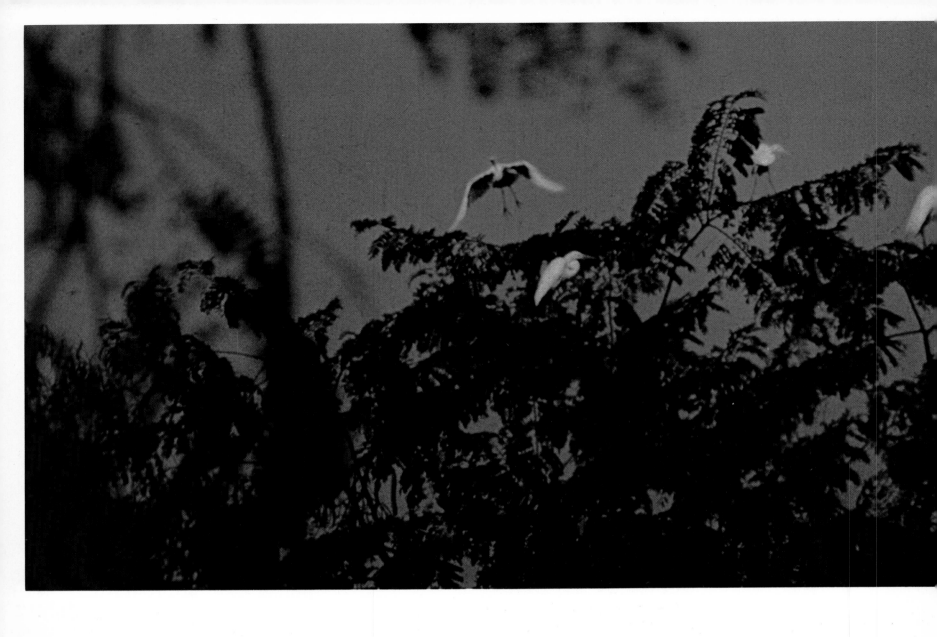

I think back to Africa,
Far out beyond the swamp trees,
 remembering
This beast, black velvet black,
His eyes searching every leaf,
His tail curled against the jungle damp.
 And
Beauty was this leopard, roaming
The cool green dark.

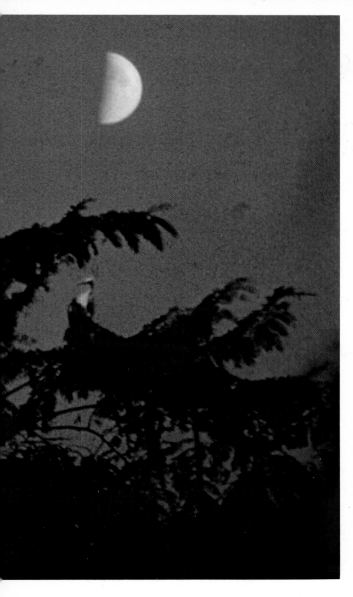

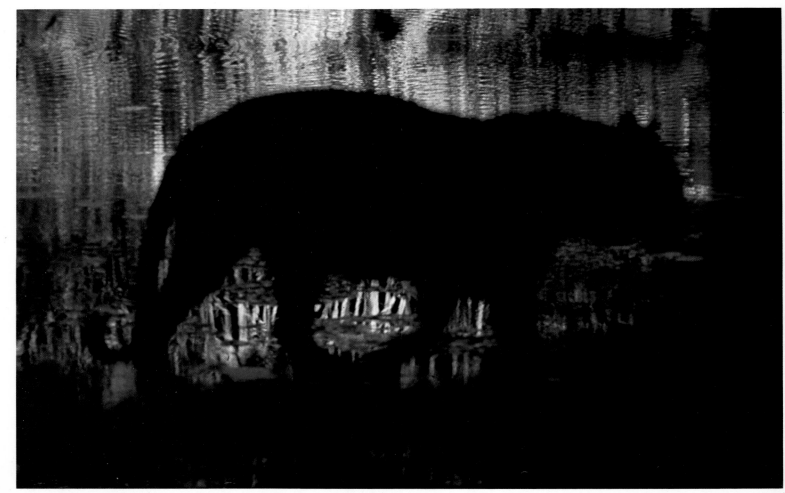

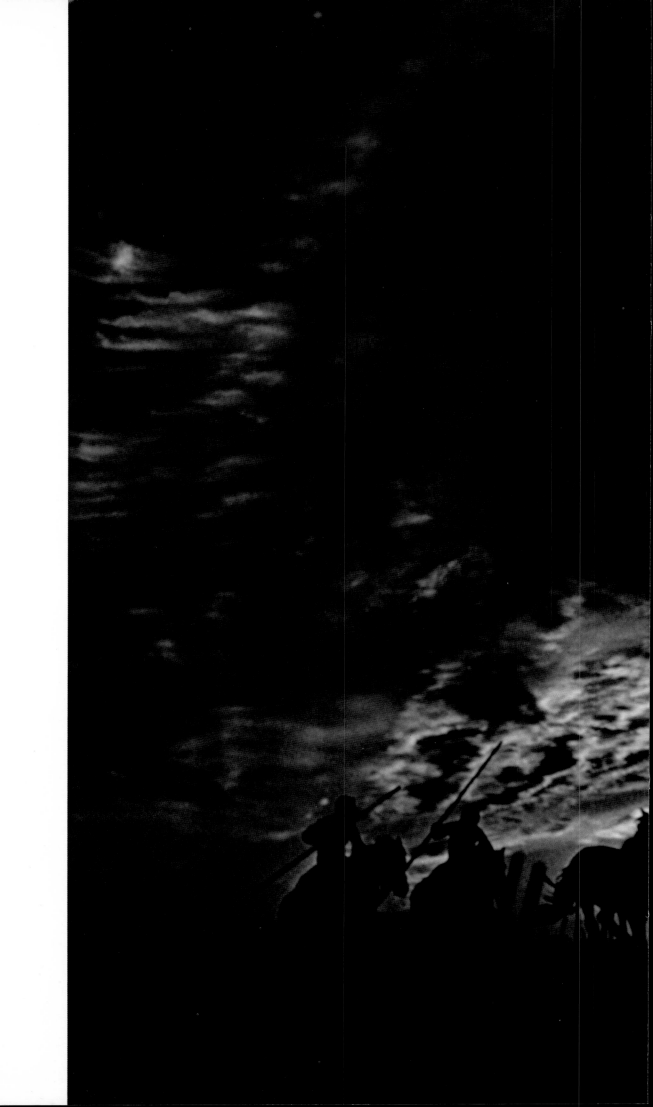

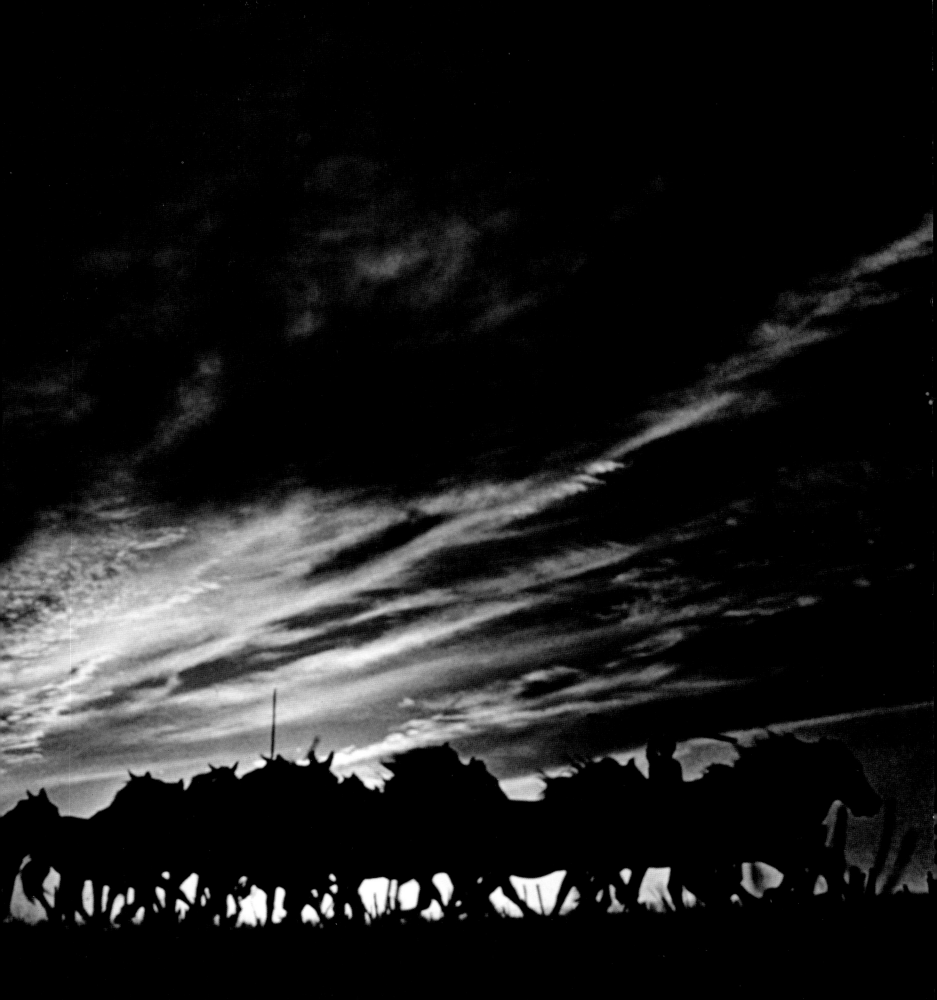

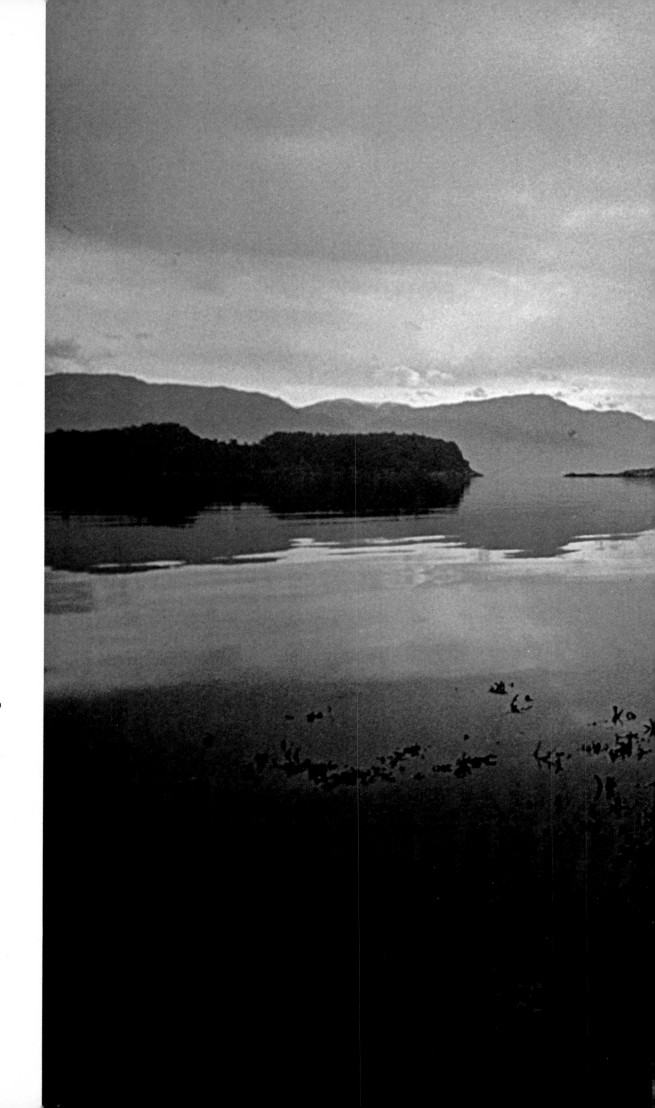

My memory curves to Capistrano
Where swallows dip, then shriek
Out over the wrinkled sea.
And to a rose-stained light

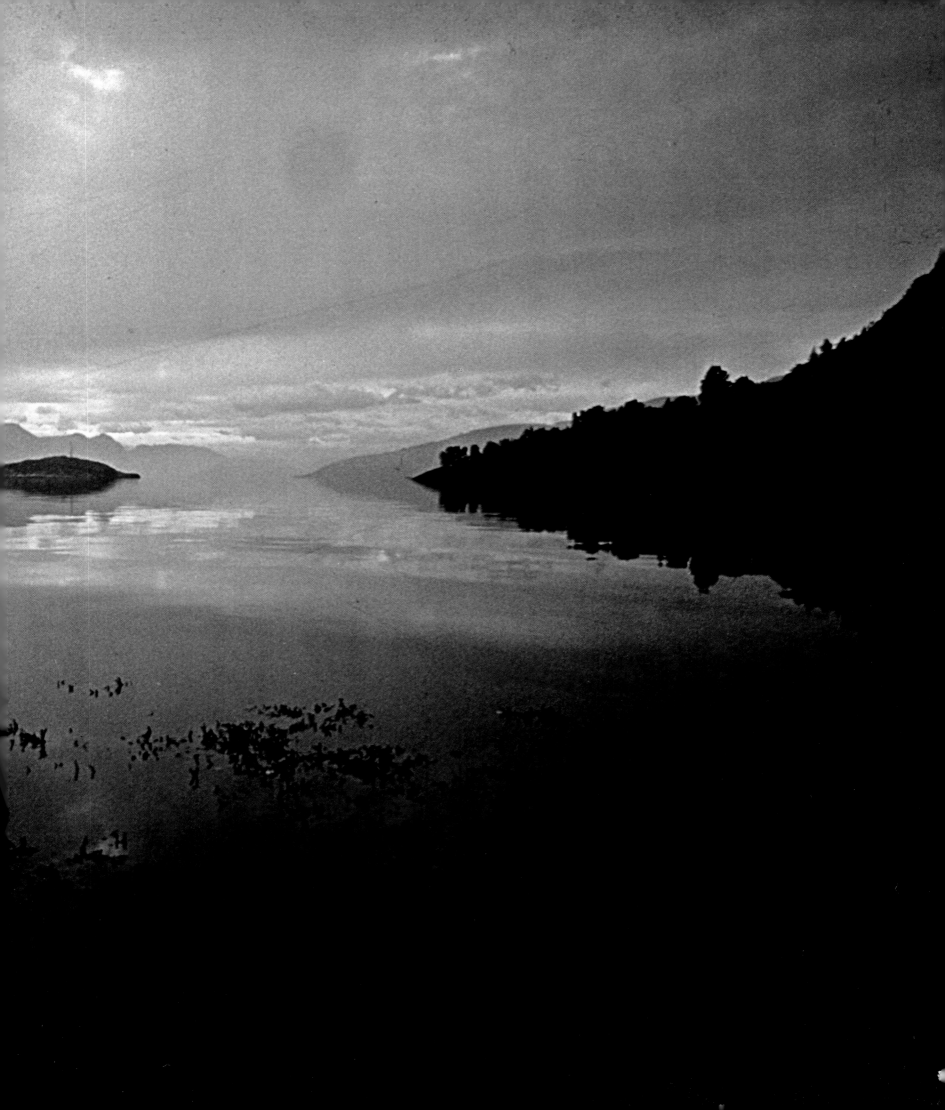

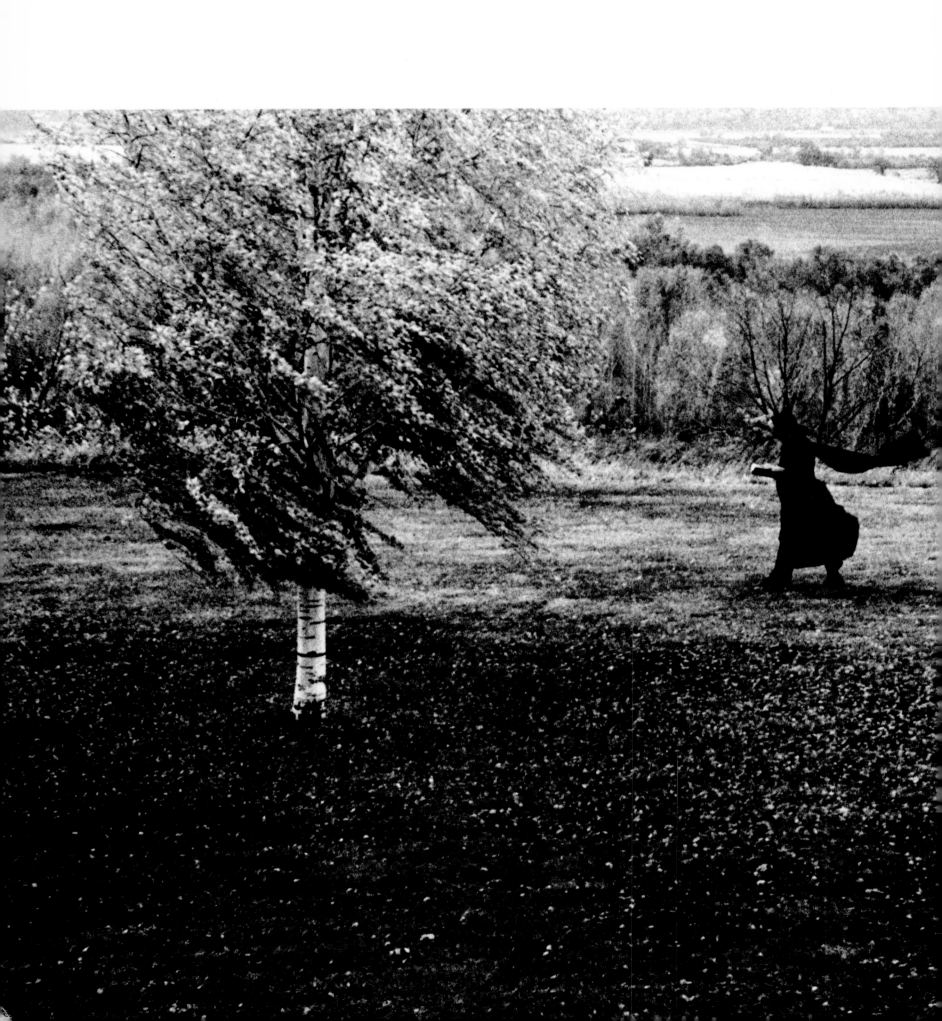

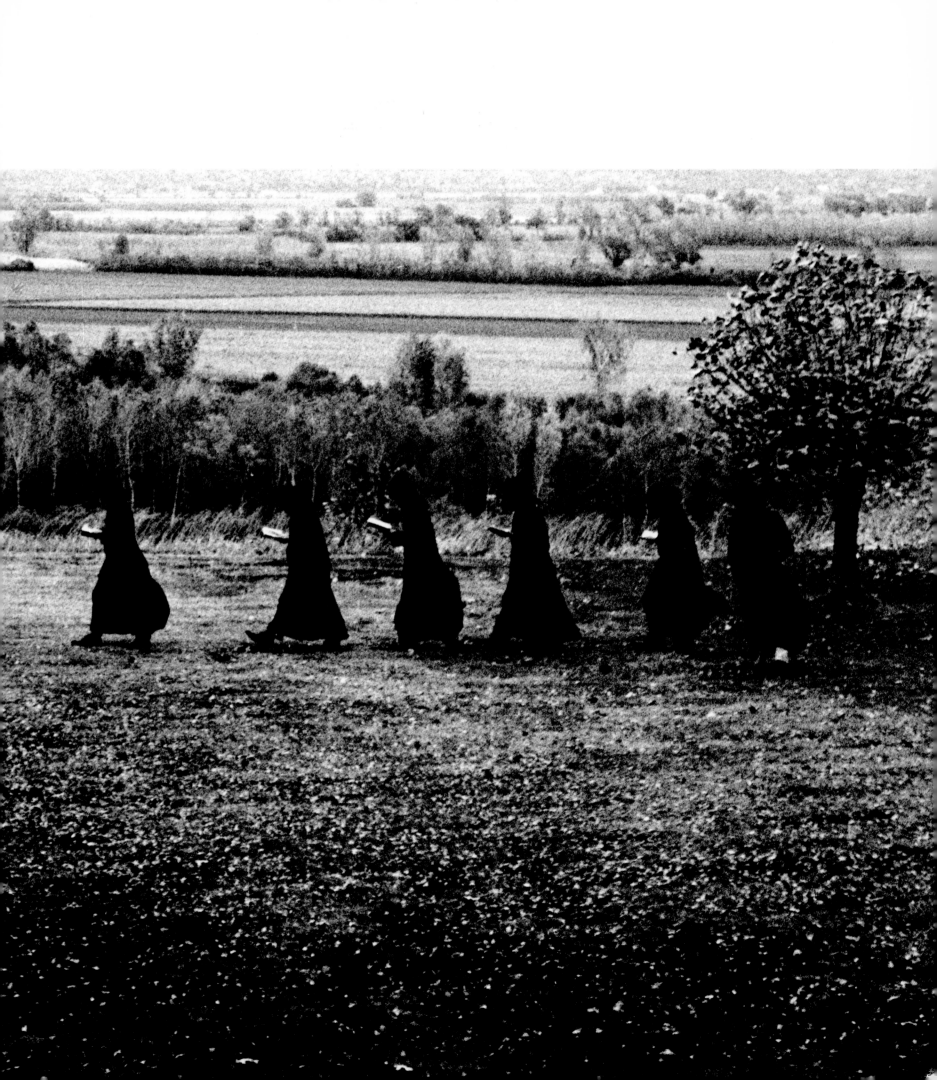

Shimmering a silver cross
In the dark of an ancient cathedral,
Where in towering moments
God's men sing His prayers.

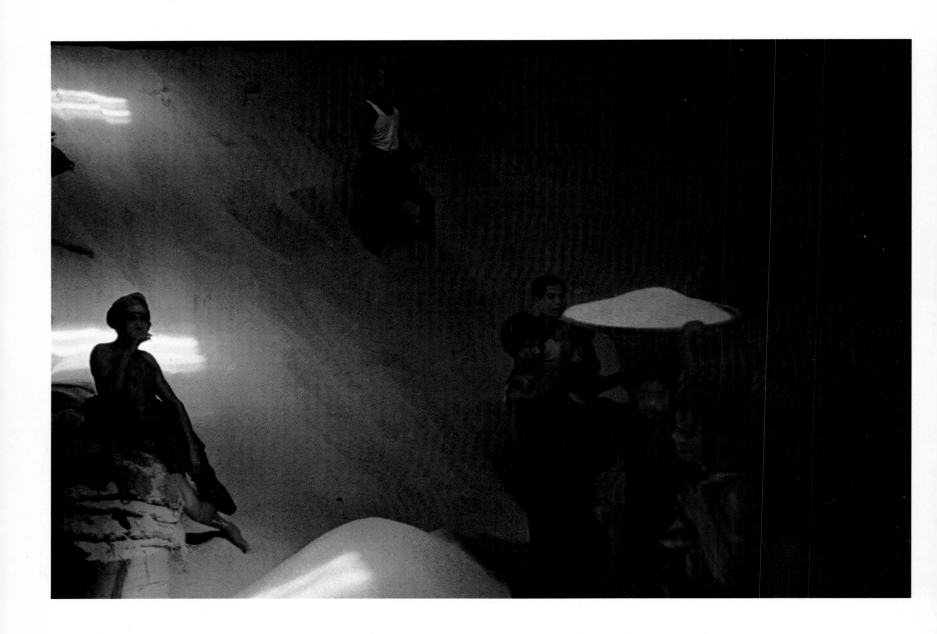

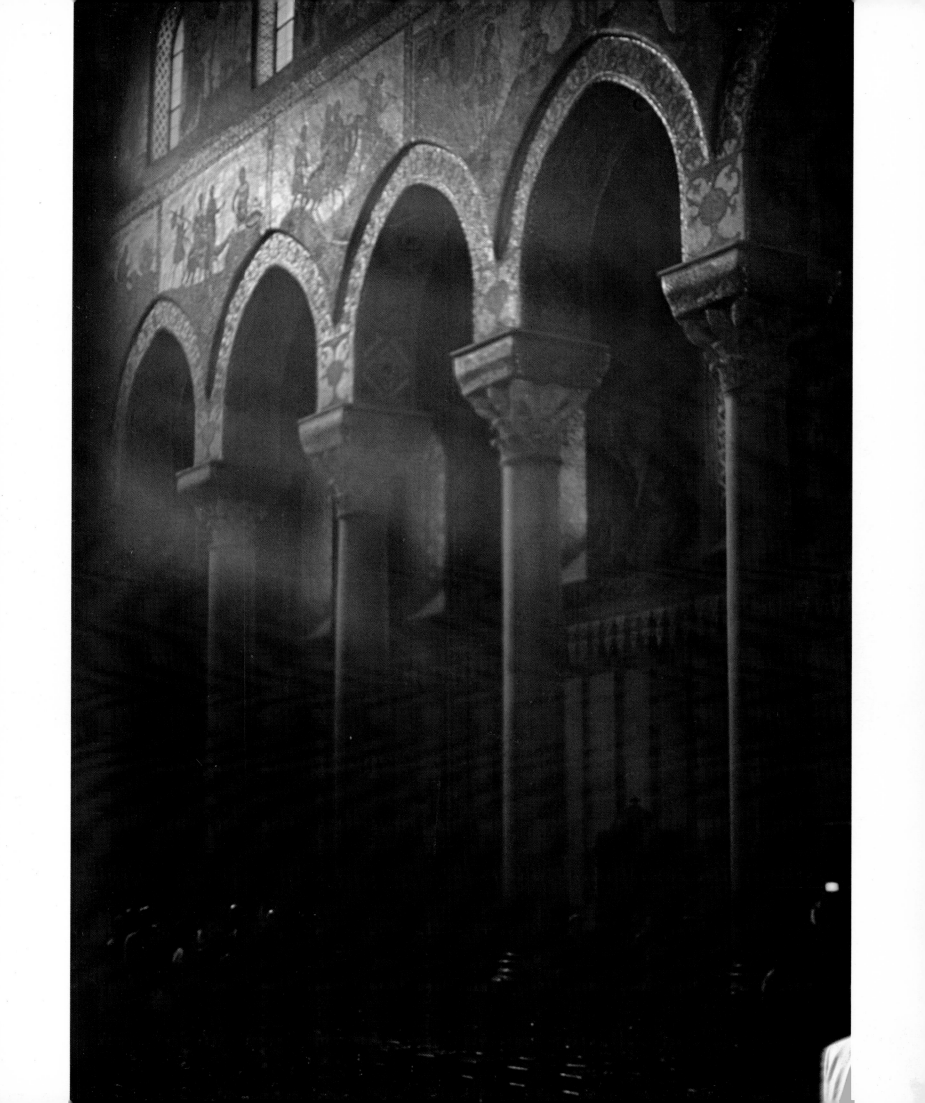

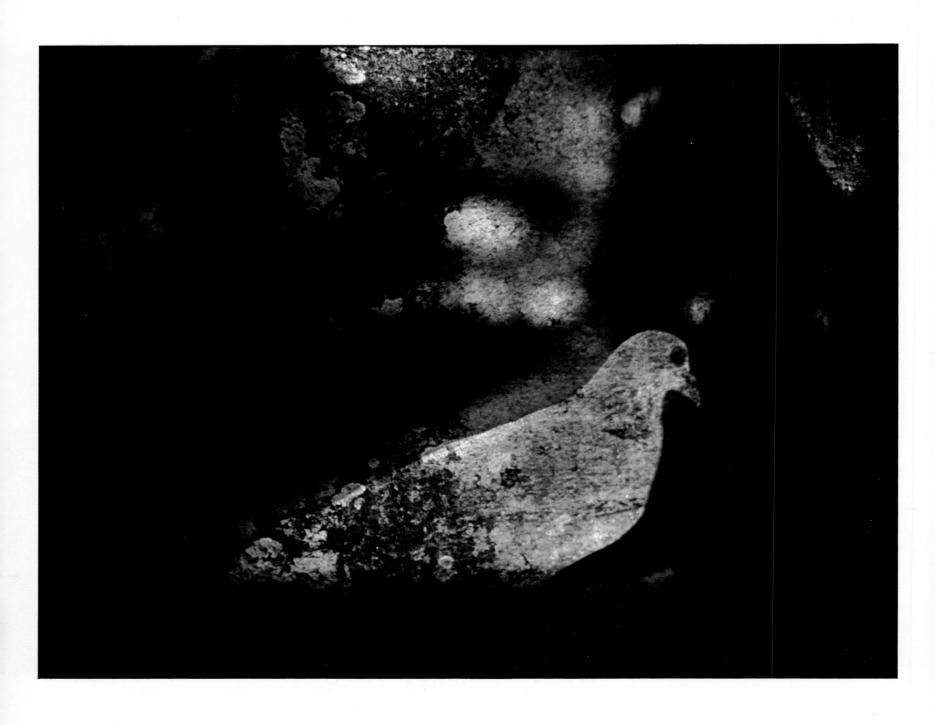

I recall a bridge
Of middle-age grace, strung
Like a harp across a river
Where men of pleasure sailed
And other men worked
The fresh-rot docks below,
Craning their scrawny necks
With eyes lifted to admire
The dazzle of summer sun,
Strumming the spider-web strings—
A gull's glorious height
Far above those awed voices.

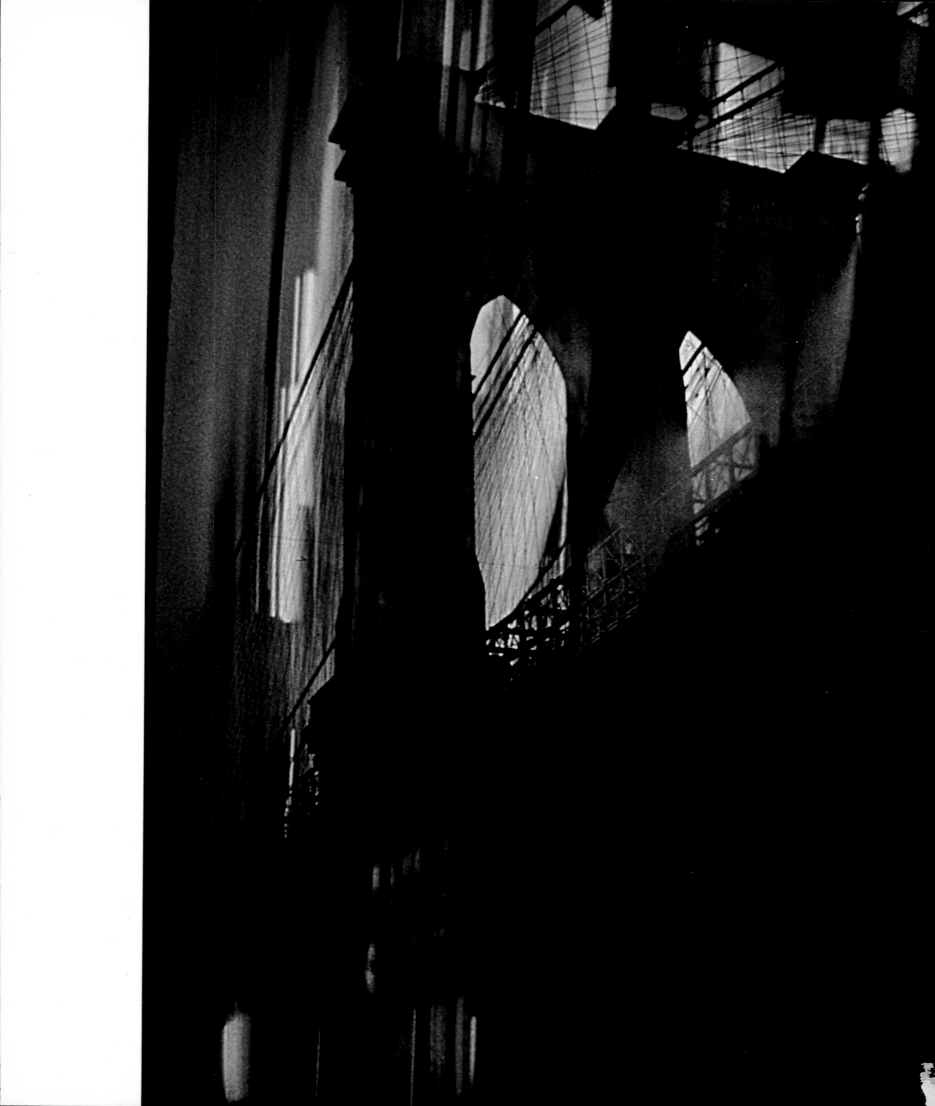

Looking at you, I think
Of a morning room outside Paris
Where, in the summer mirror,
You lay reflected, naked and gold
 in the nymph light,
Your slenderness cradled
In the bosom of a dream.

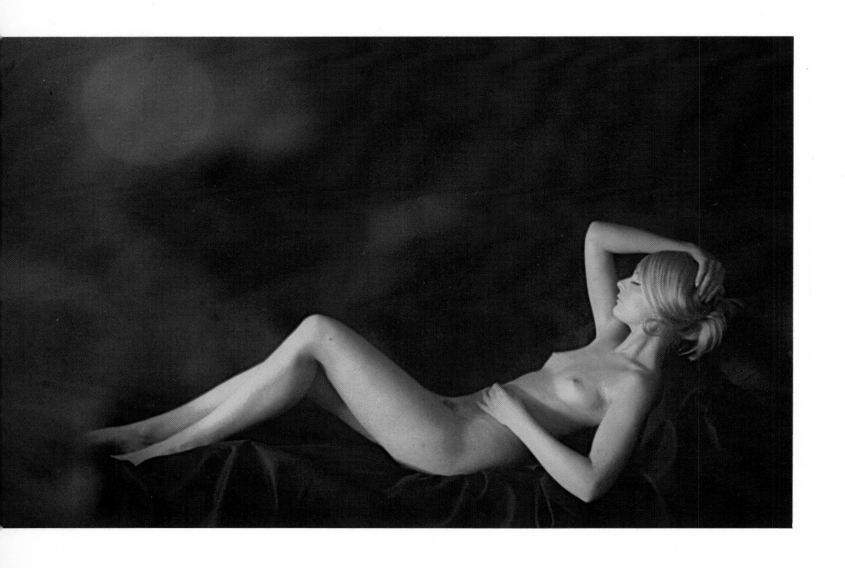

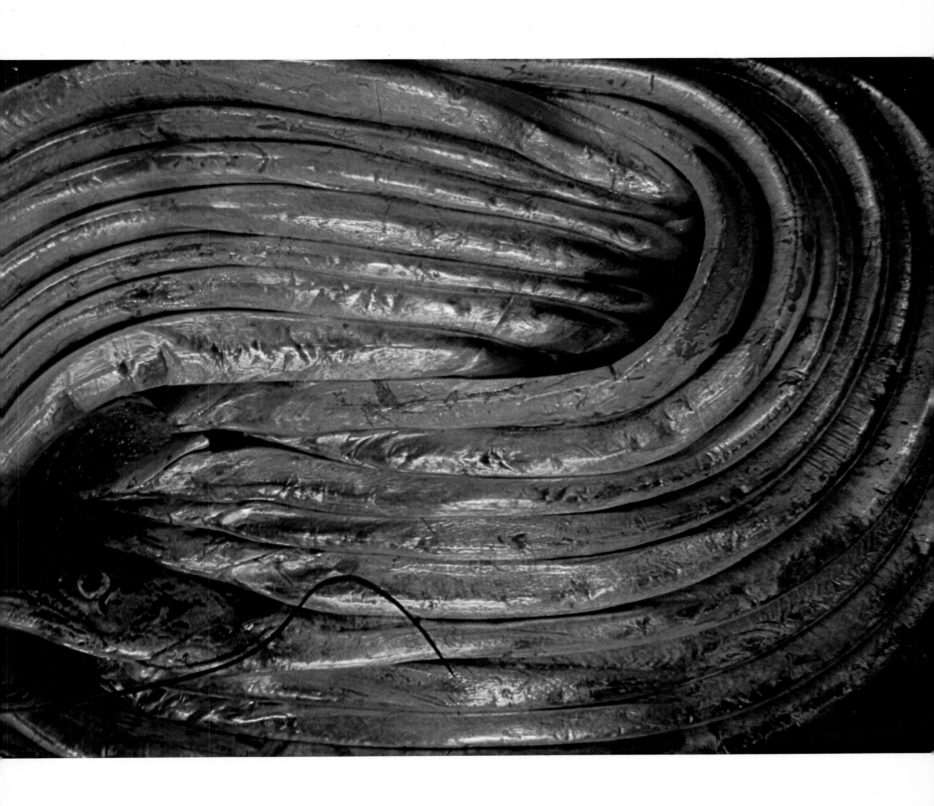

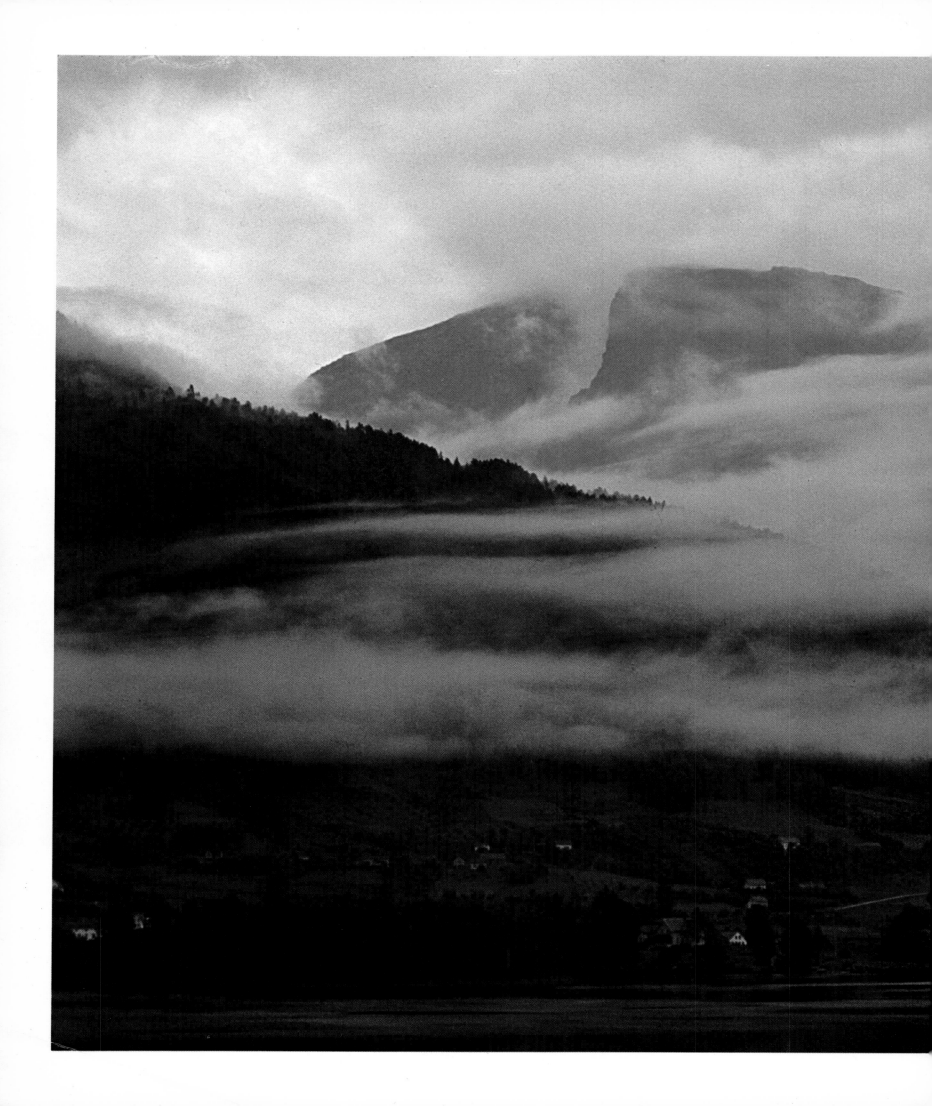

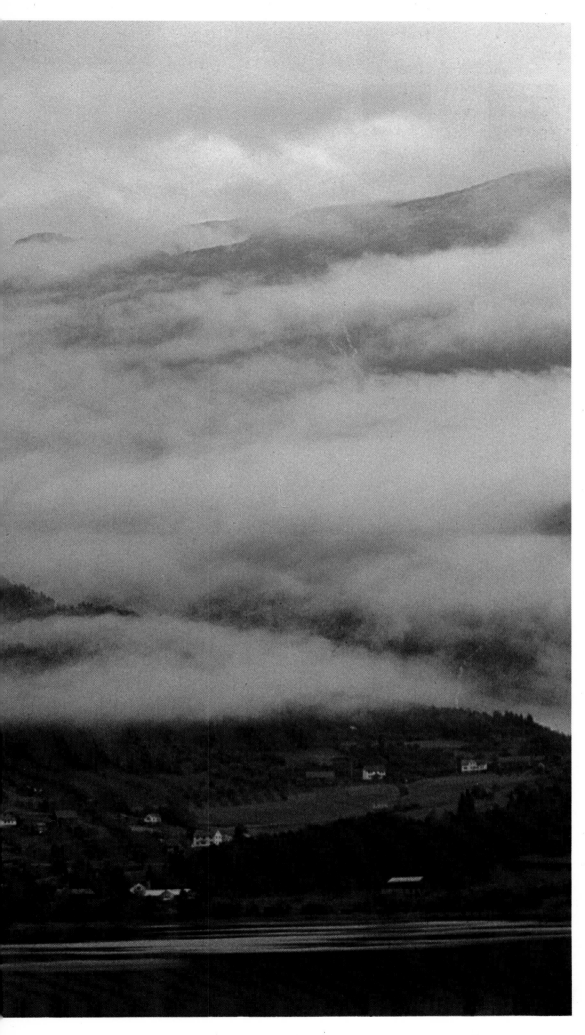

Do you remember
Our old shuttered house
Leaning indifferently
Down toward the north hill,
And the last echelons of wild geese
Flapping south through autumn woodsmoke?
Speak to me of rainfalls
At dusk, and how we walked
Hushed violet beds, listening
To the wing-brush of cicadas
 and
Doves complaining in the darkening trees.

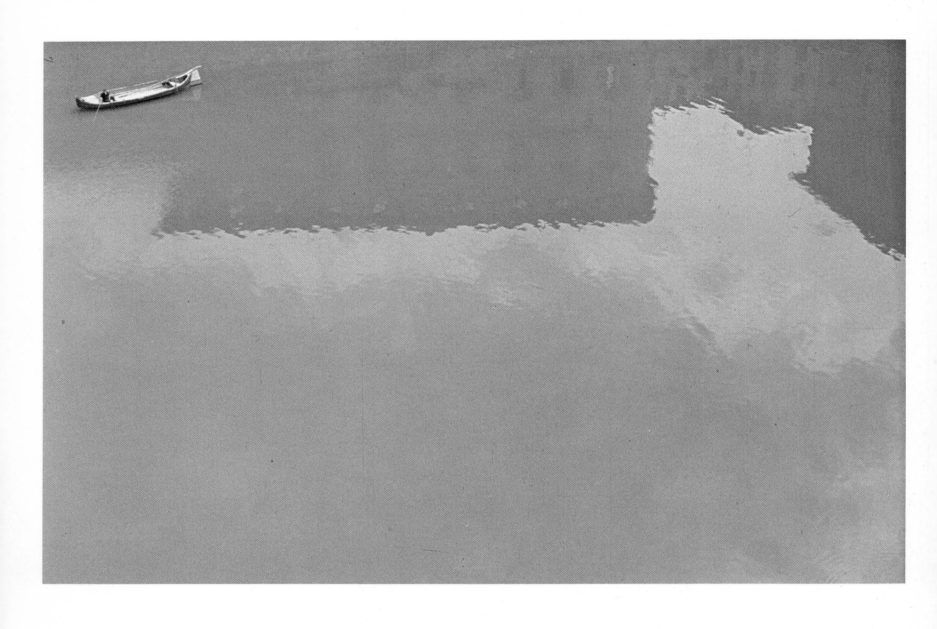

Let your voice
Run clear as mountain water
And turn a spring gone black
To rose and green again.

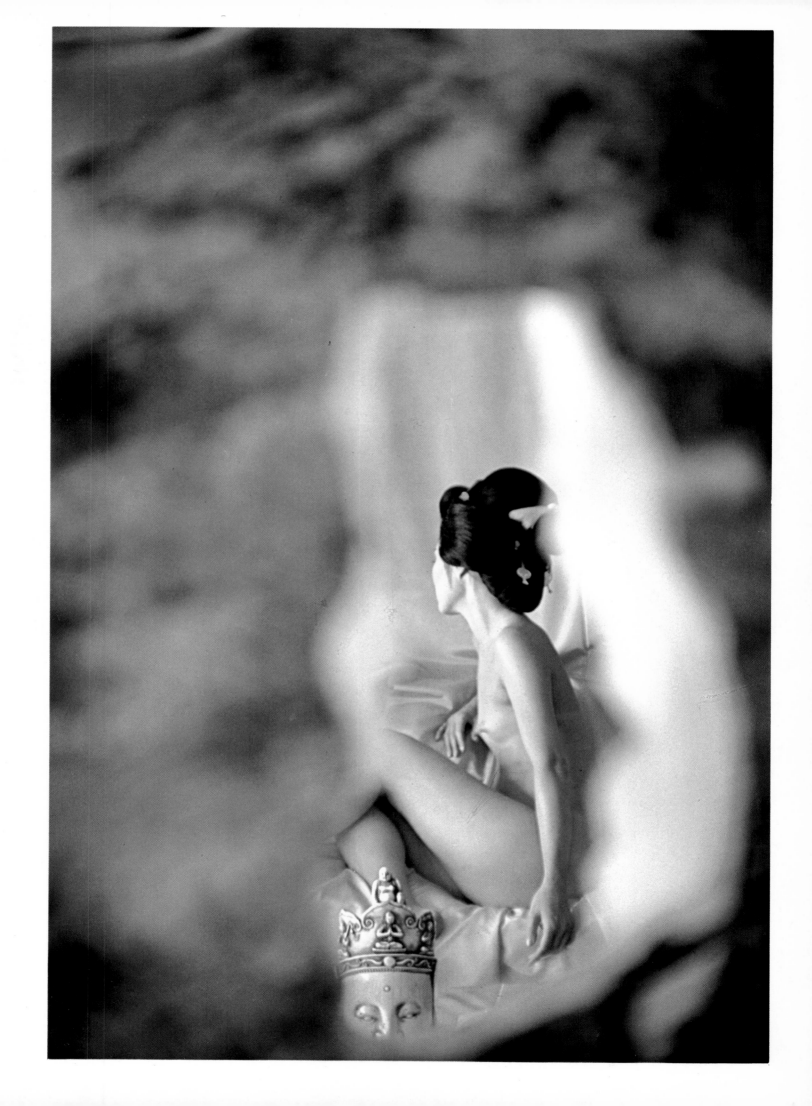

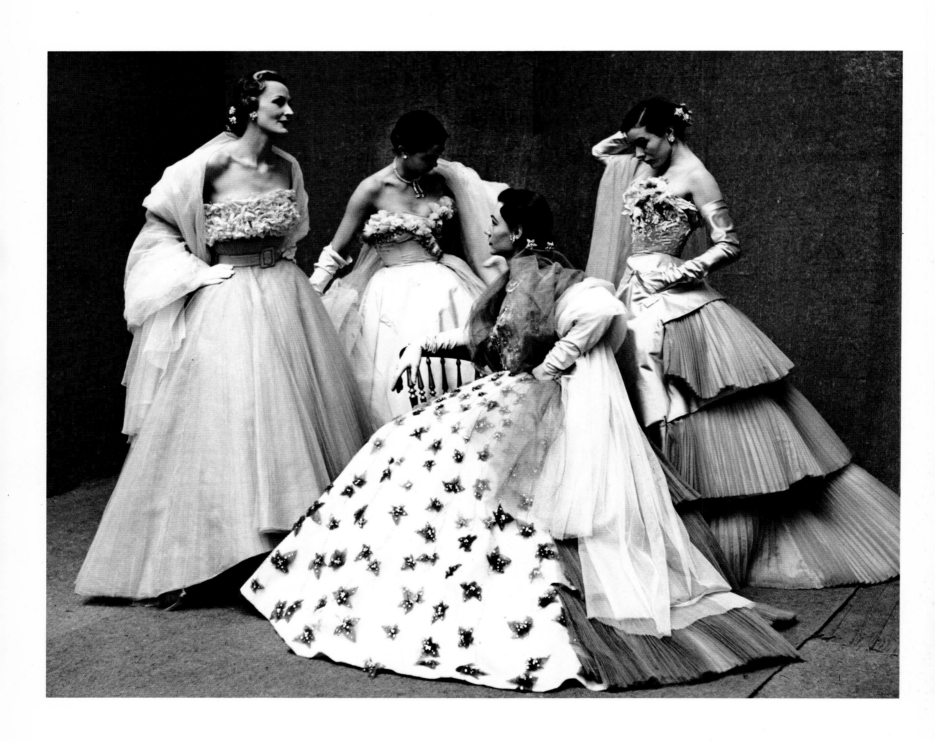

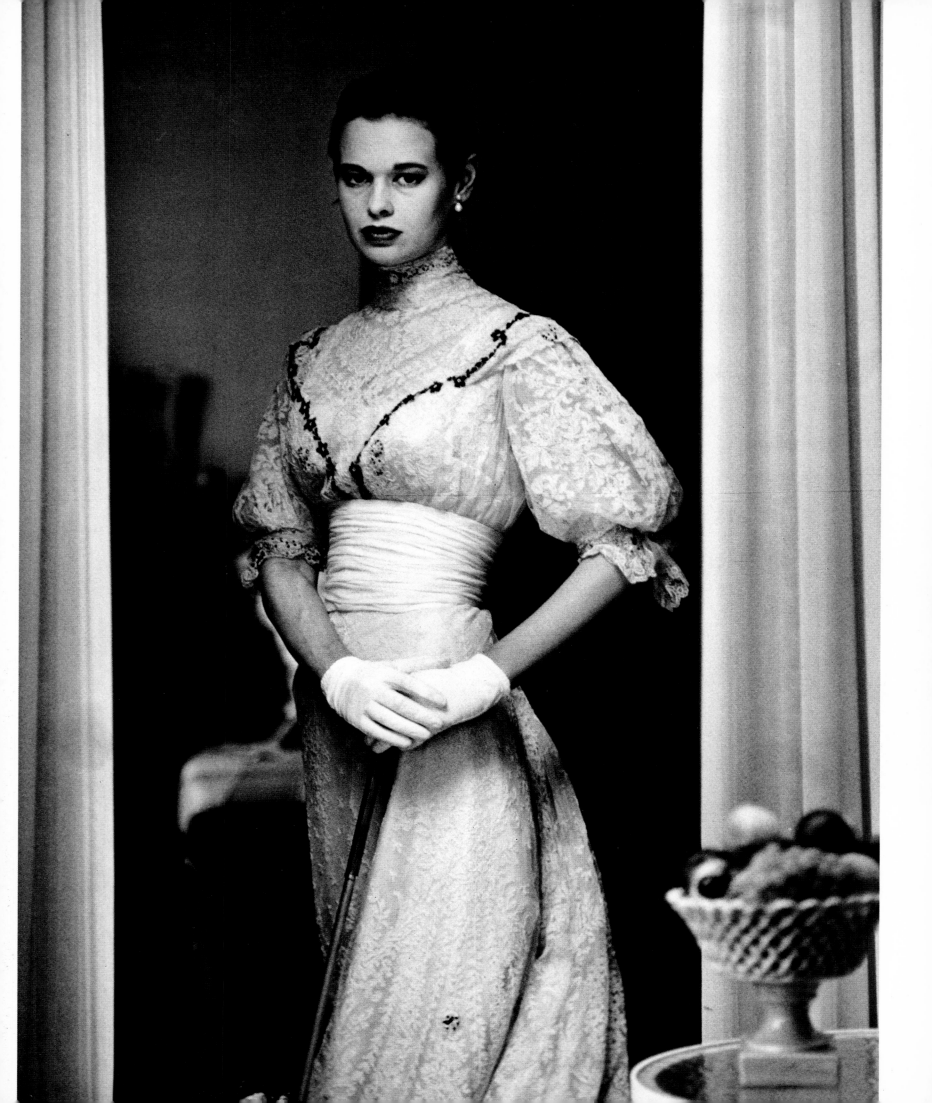

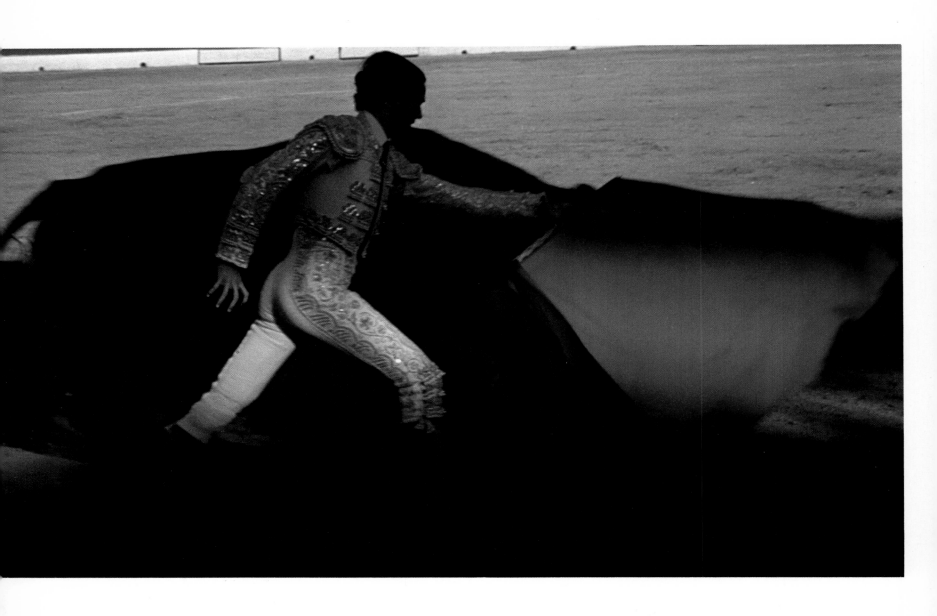

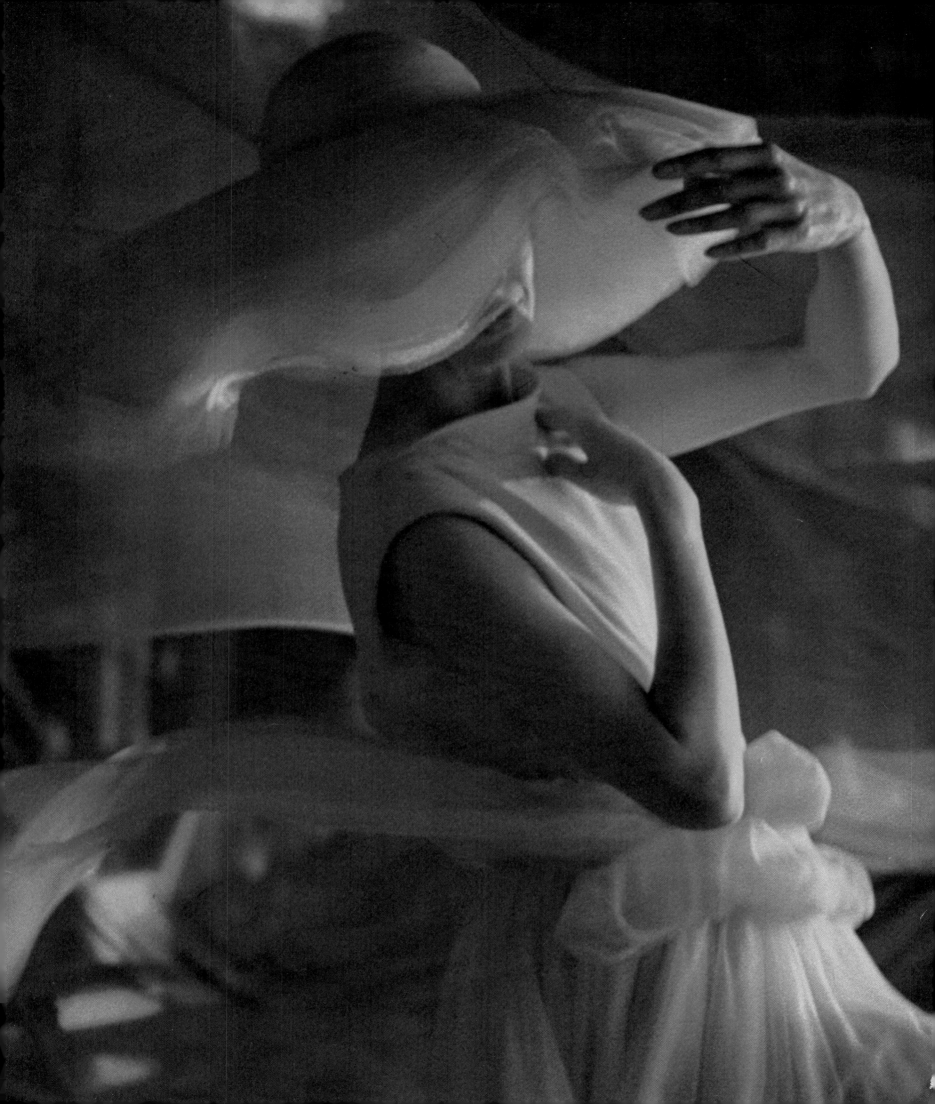

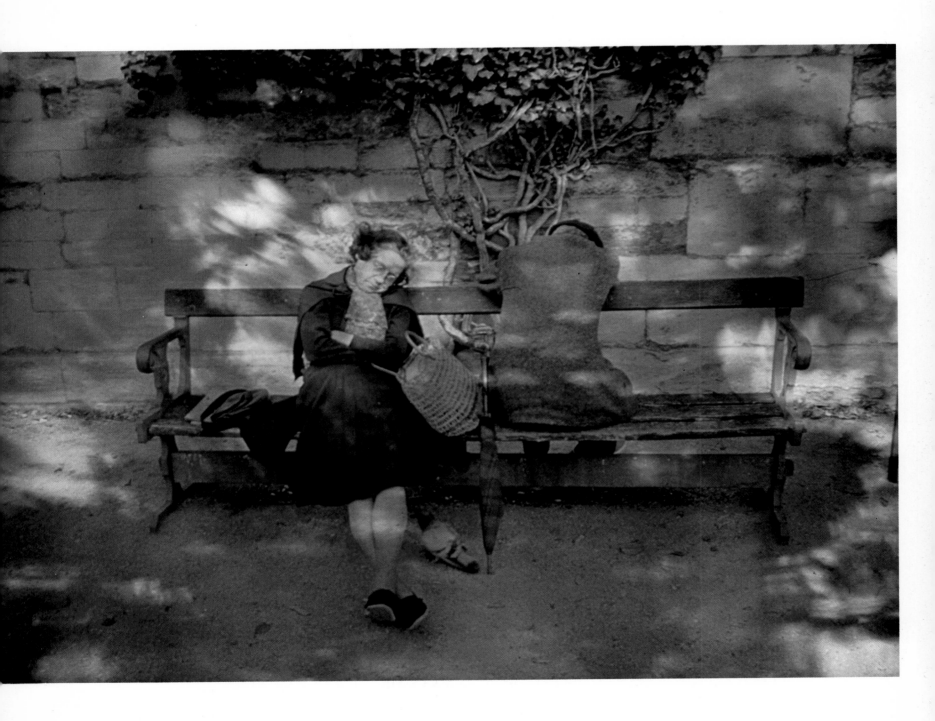

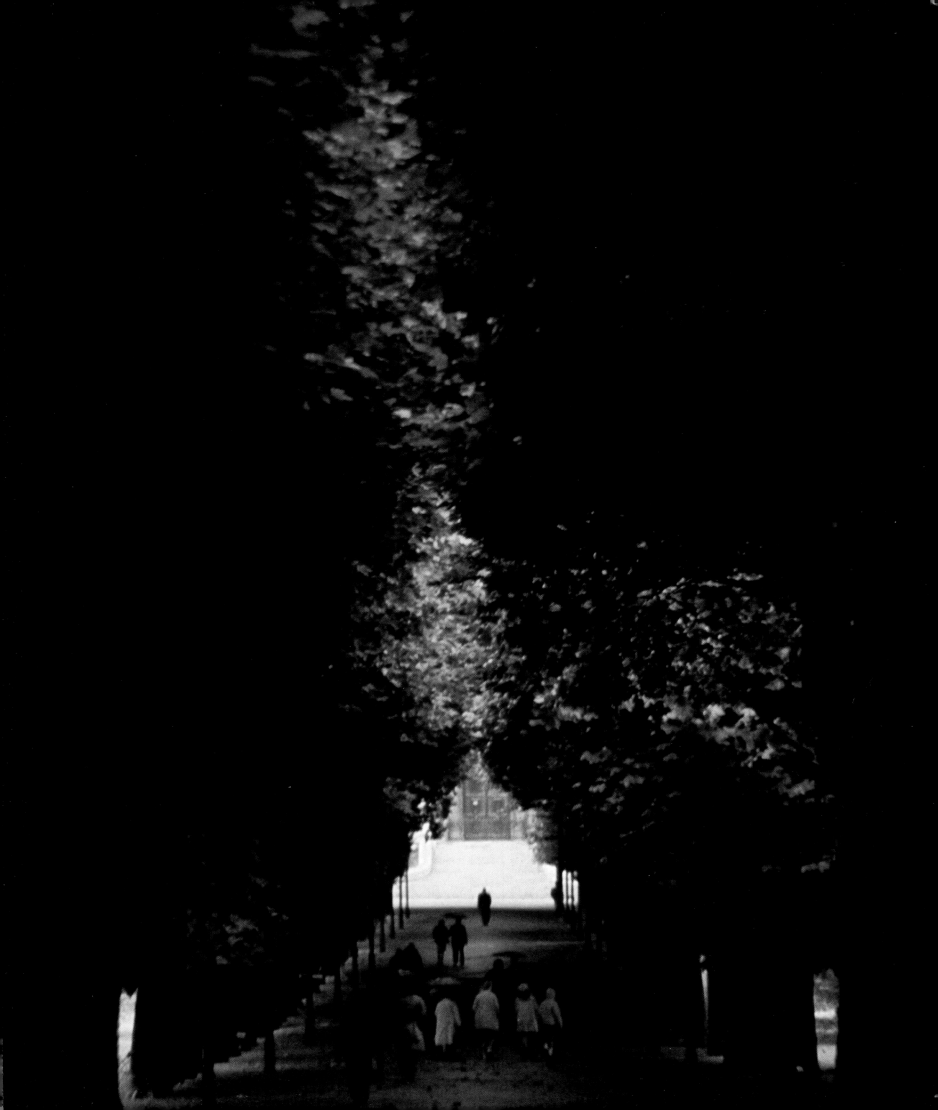

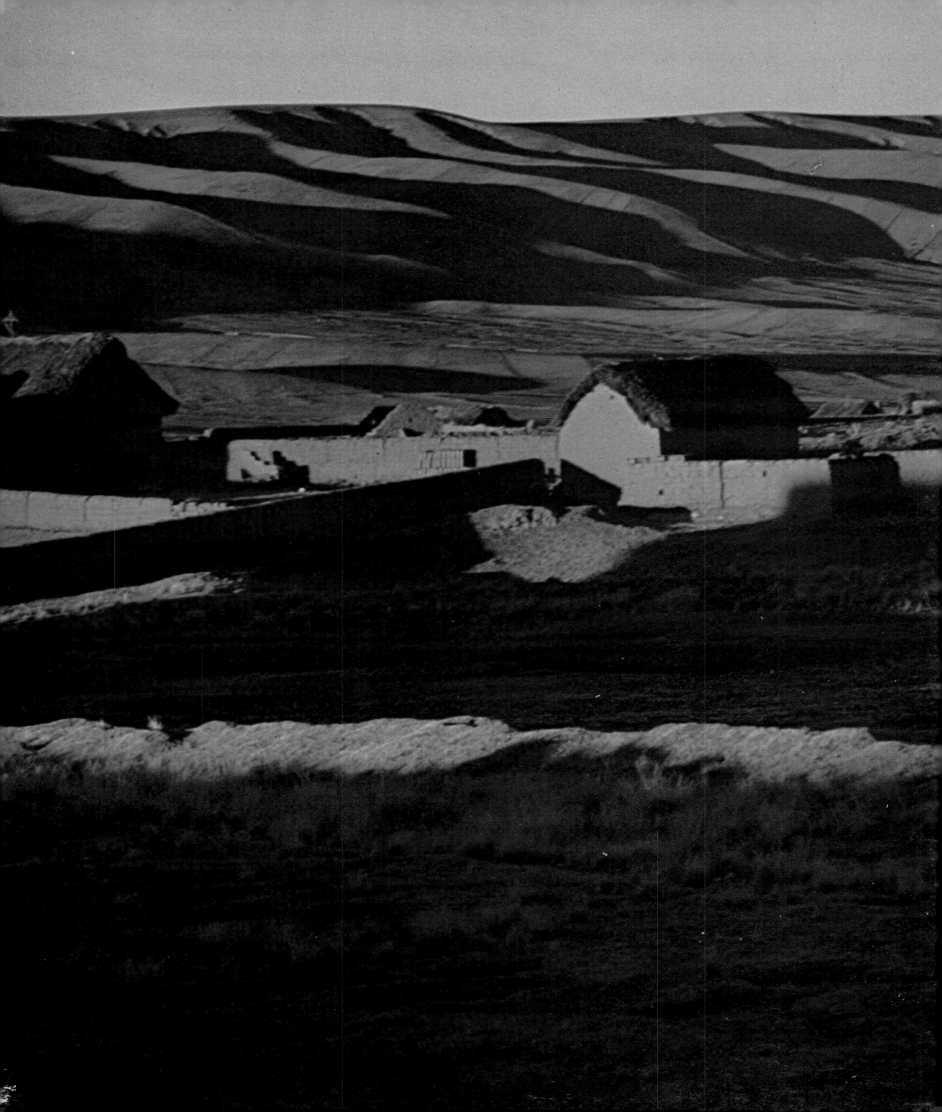

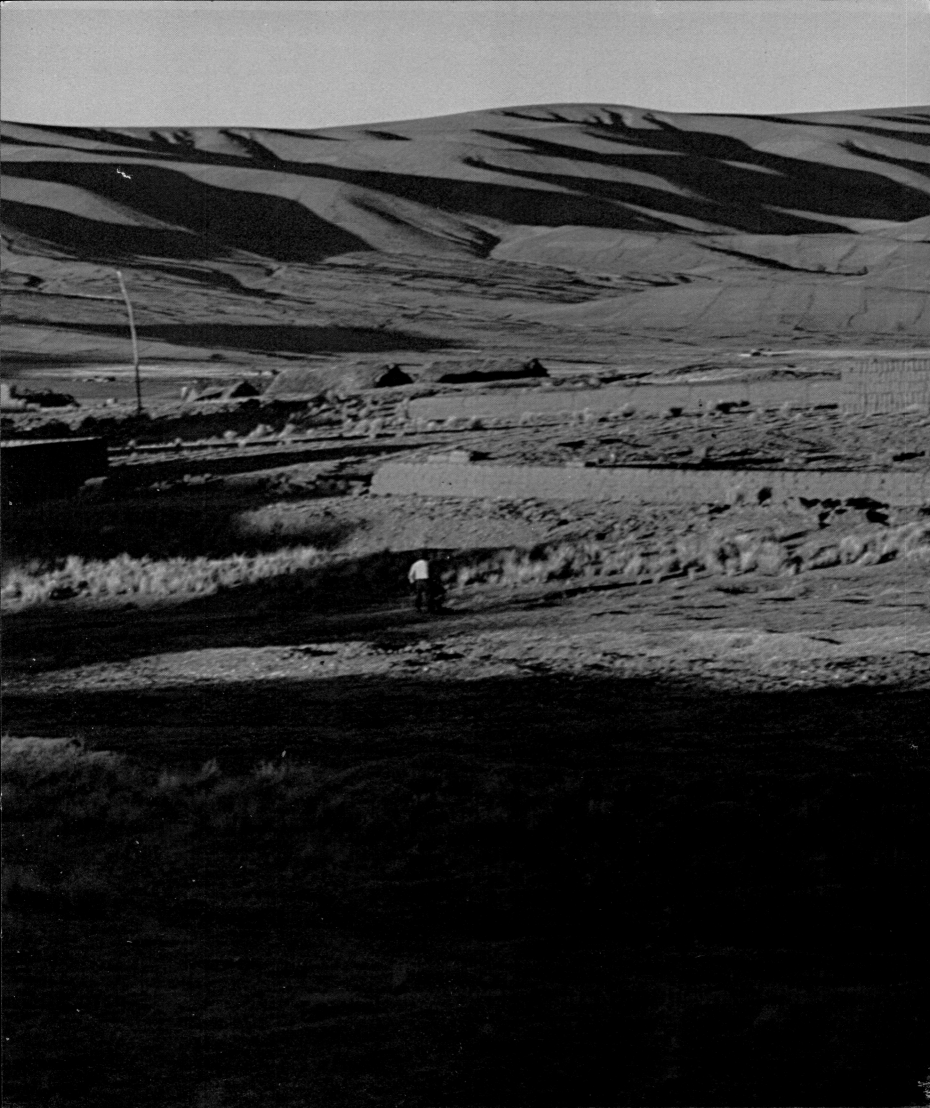

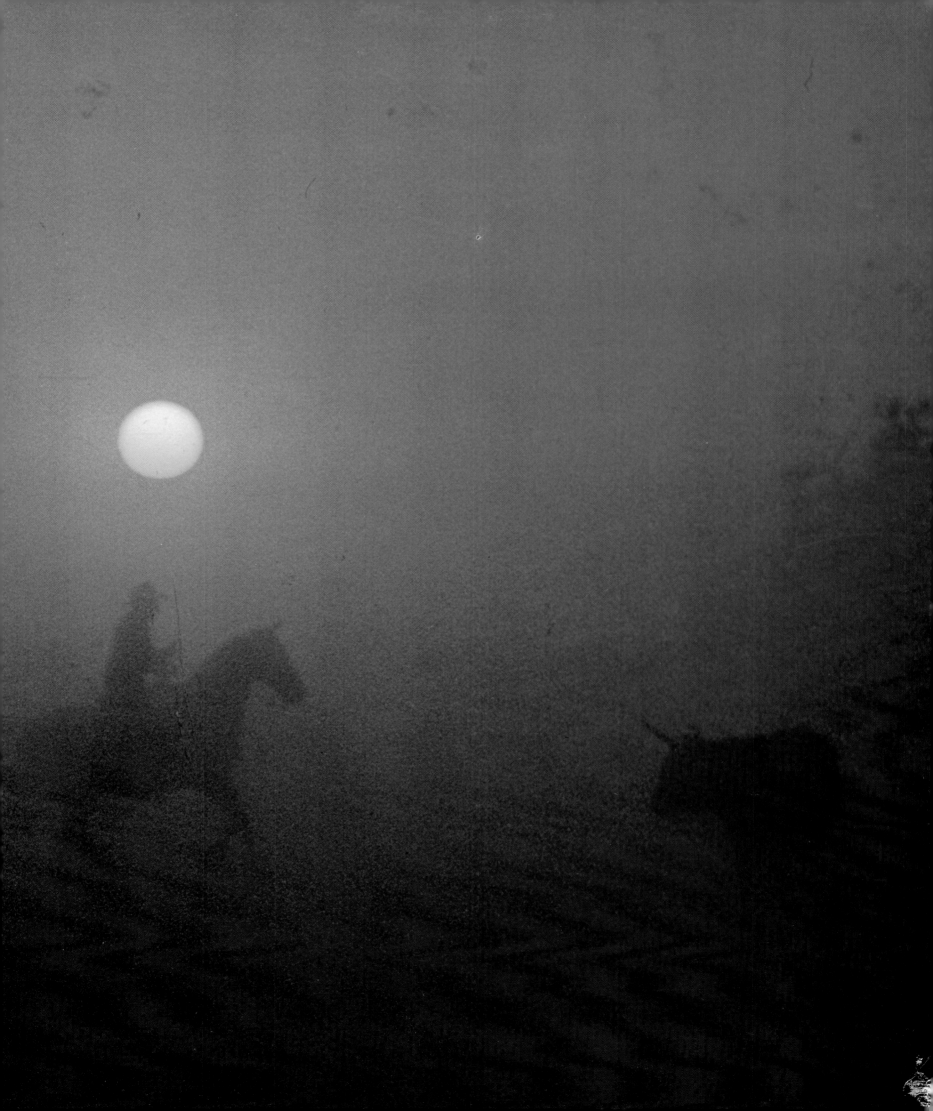

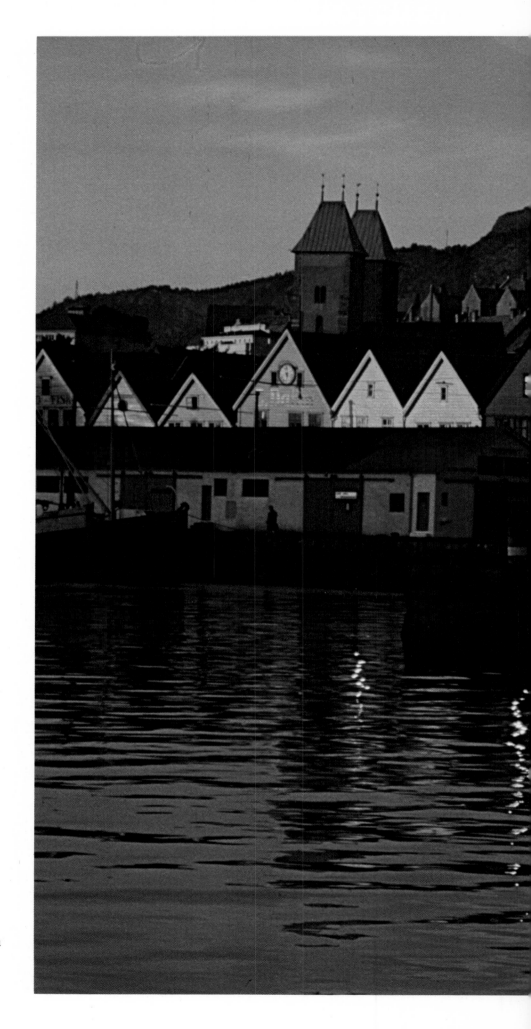

POSTLUDE

I journeyed the troubled road
Well into each shrunken evening,
Dreading the silence of darkness
So cold in the unbroken spell
That turned me homeward with a shudder,
My memory whirring to the chill
Of yet another morning on its way.

Then upon one certain dusk,
Upward through my window,
All was black—except for a single star
Striking its light against the sill.

I slept deep that night.

And I remember the walk I took at dawn,
Recalling, in the welcome brightness,
Those promises youth once whispered.
Quiet had come to the skies
And I spoke thanks for the turmoil gone
As the earth swallowed the blackness.
 Then,
While bitterness fled the fields,
I strolled beside mirrored rivers
Far beyond the pain of inward shores,
Living previous dreams, gently unraveling them
From tangled jungles of the past.

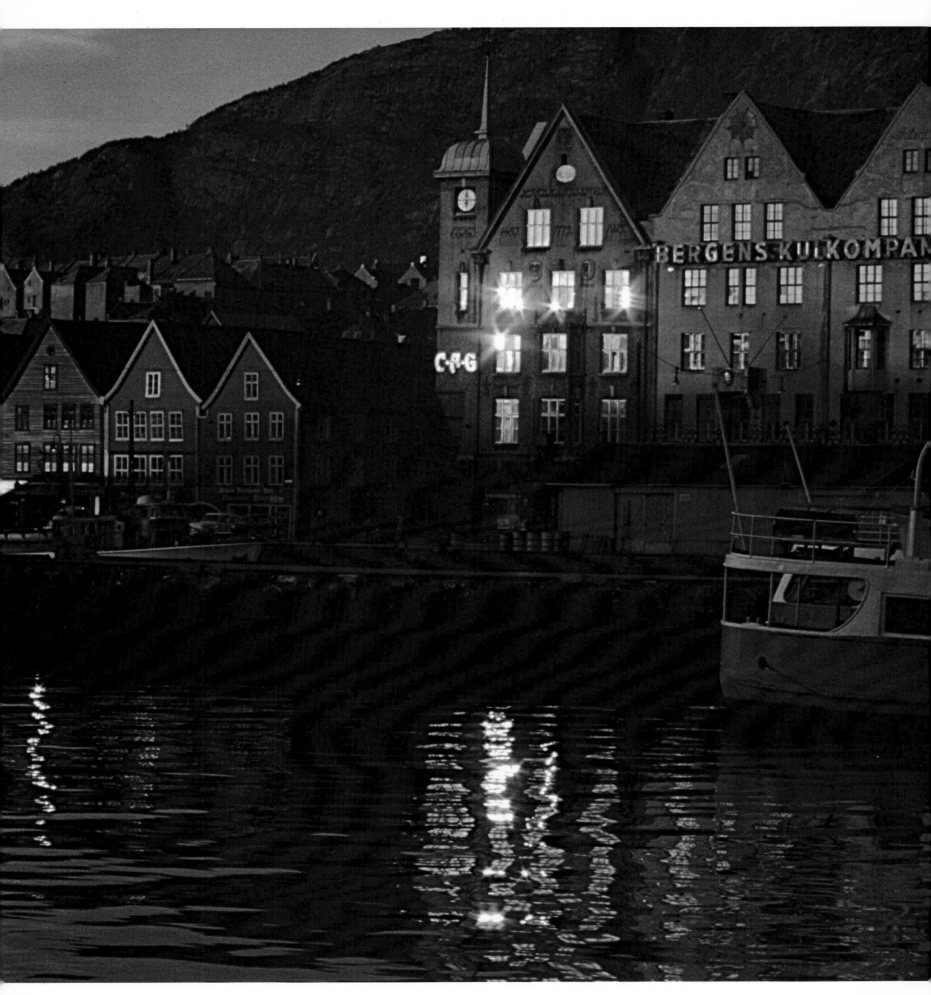

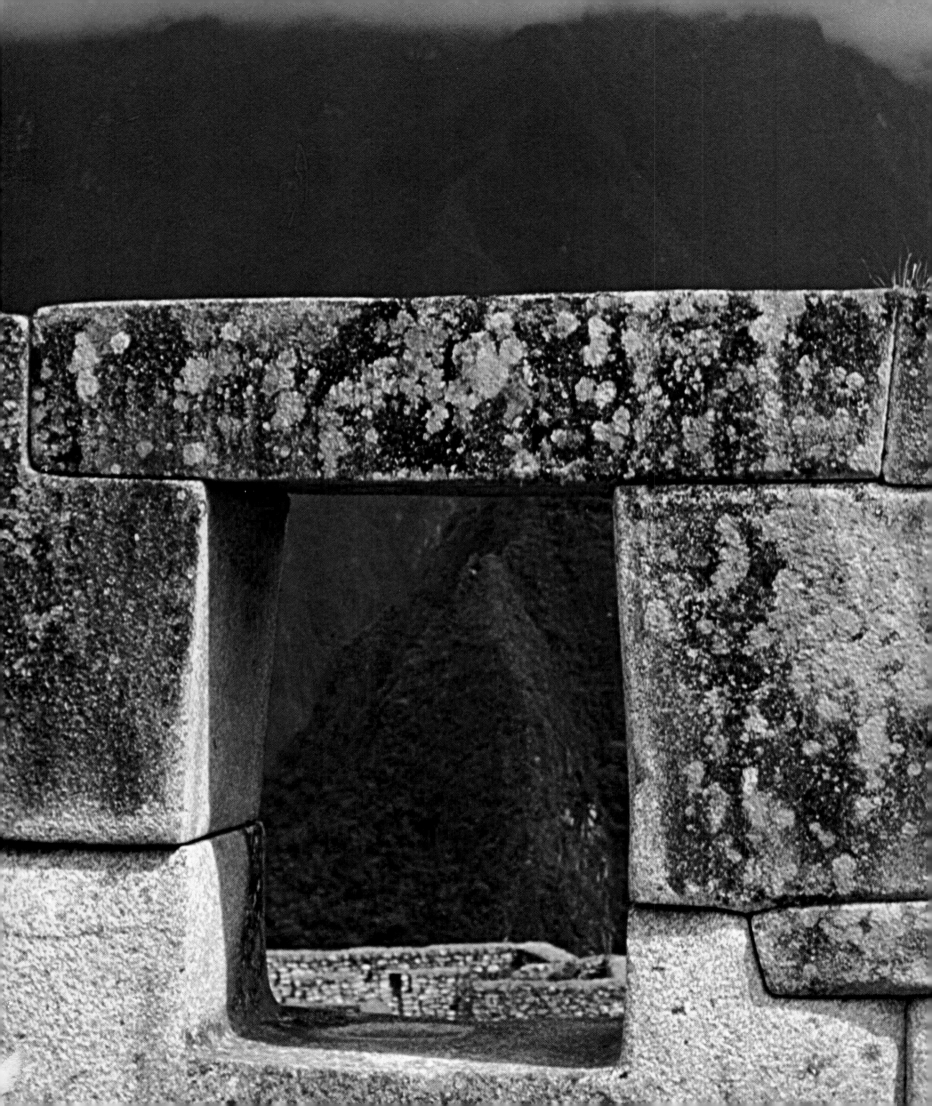

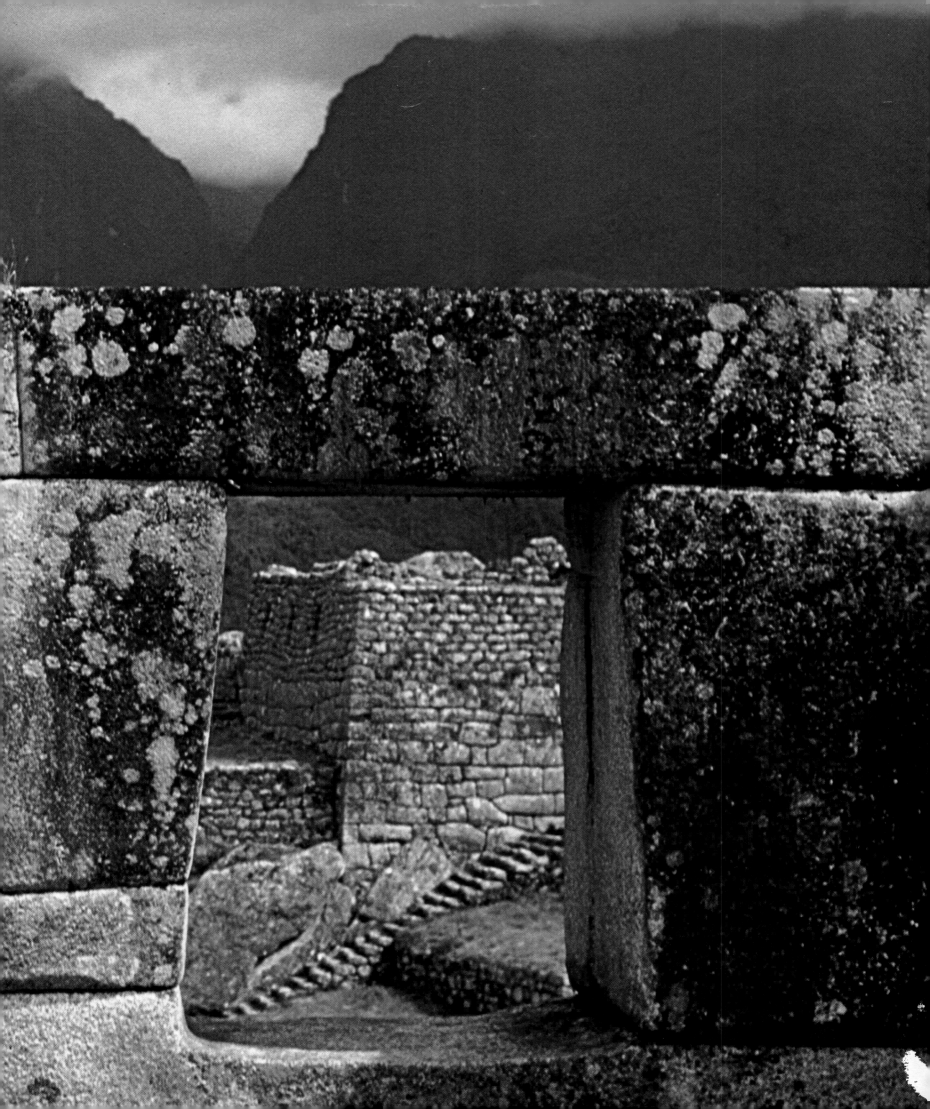

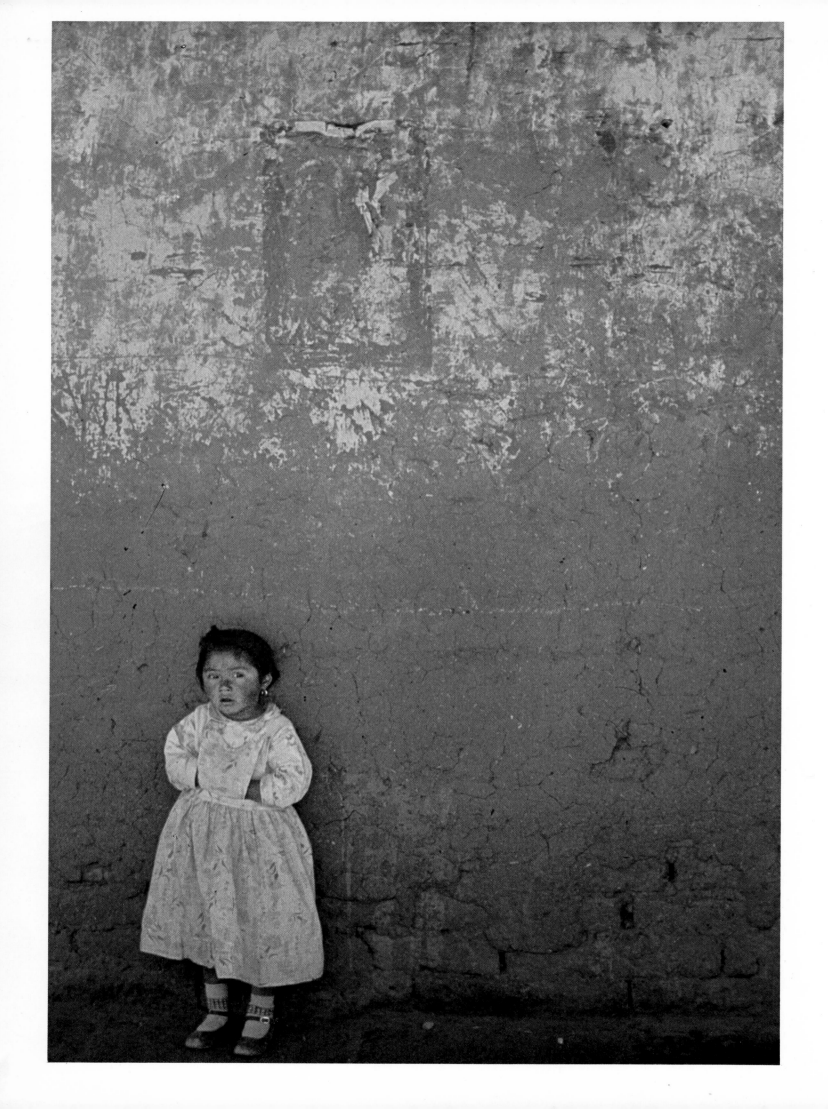